'Ireland is HEAVEN, everyone is so dotty
and delicious and none dreams of taking
anything seriously, except, perhaps,
the Horse Show.'

Mariga Guinness, writing to her mother about her newly adopted country

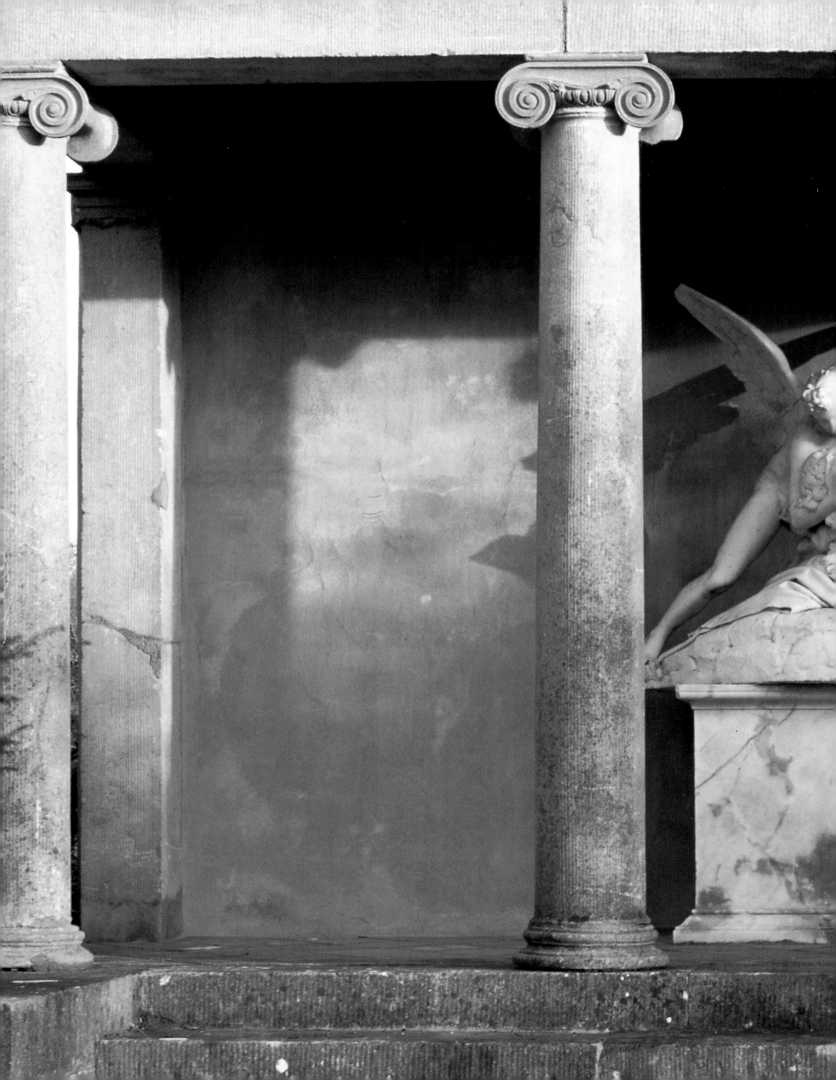

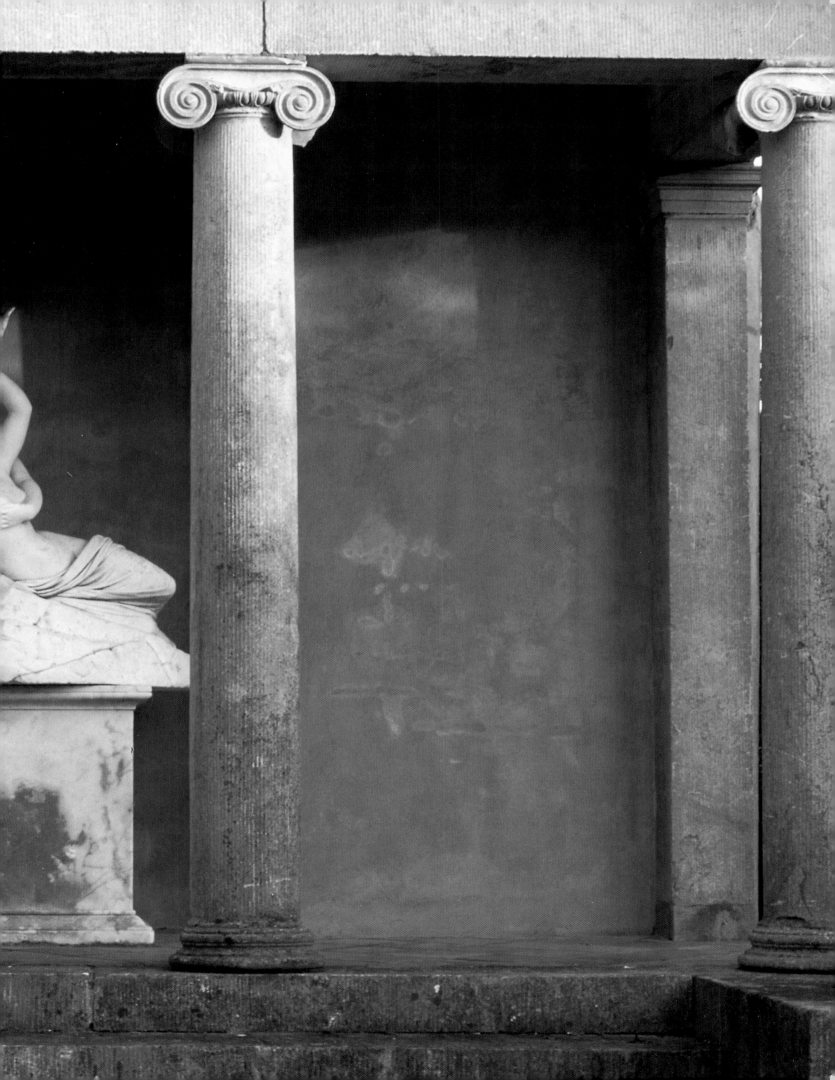

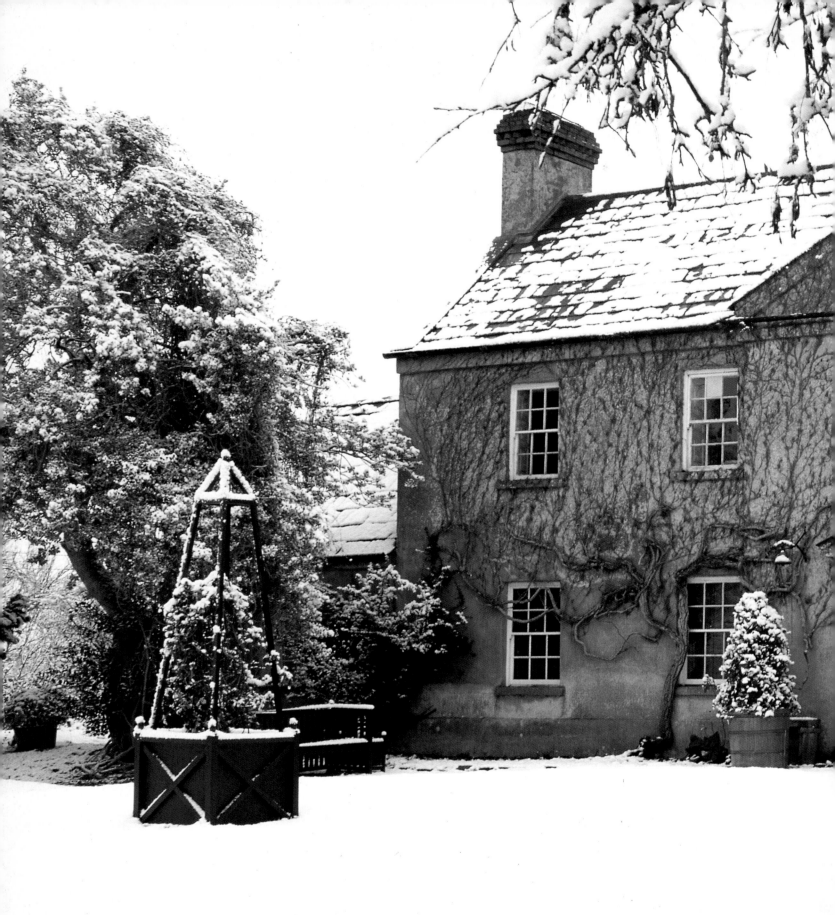

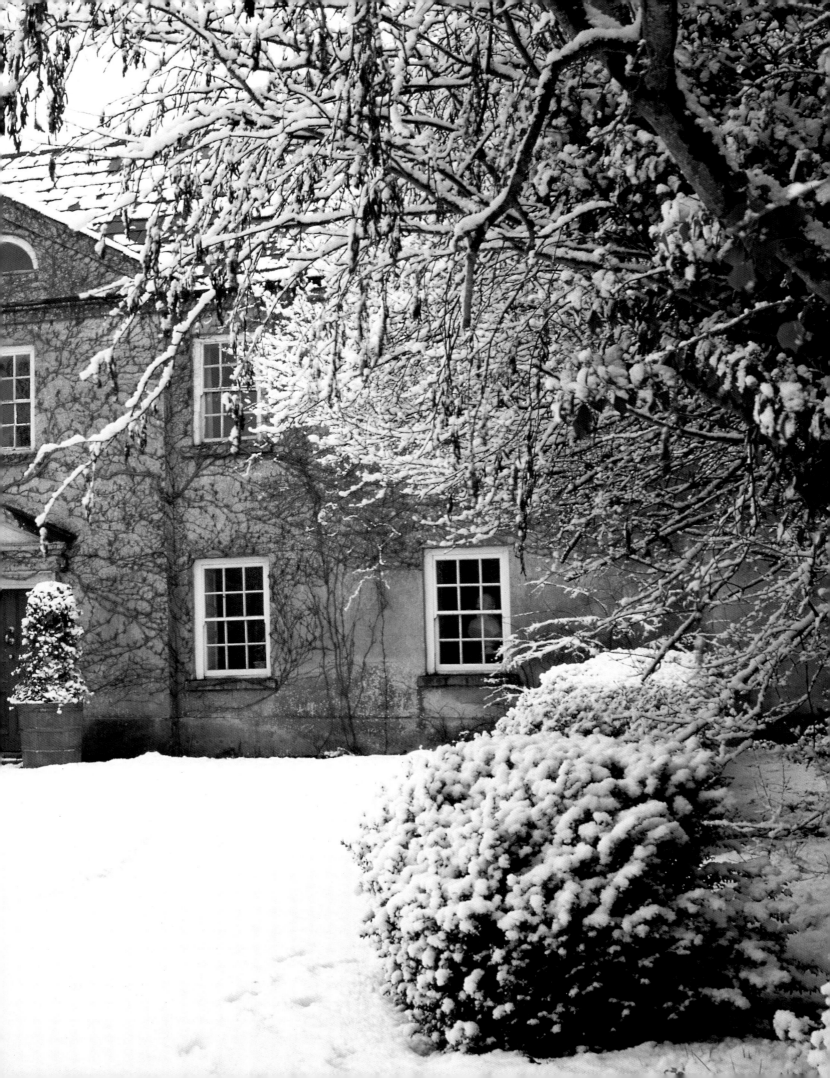

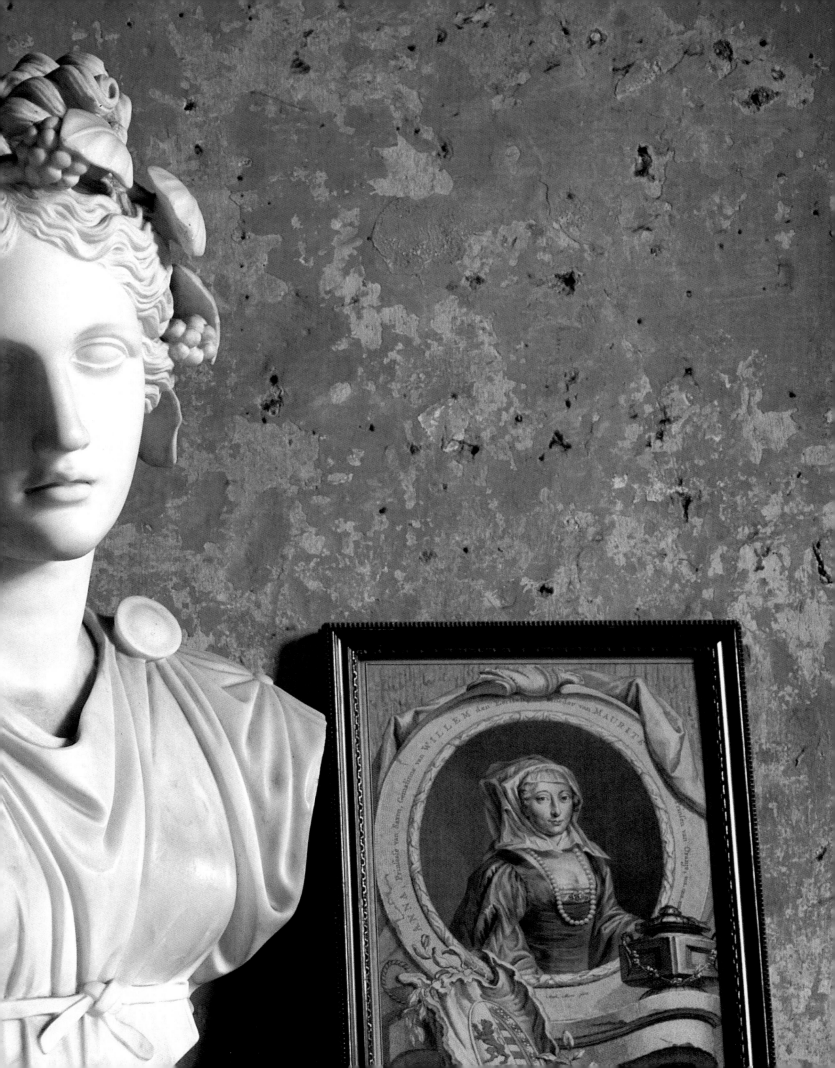

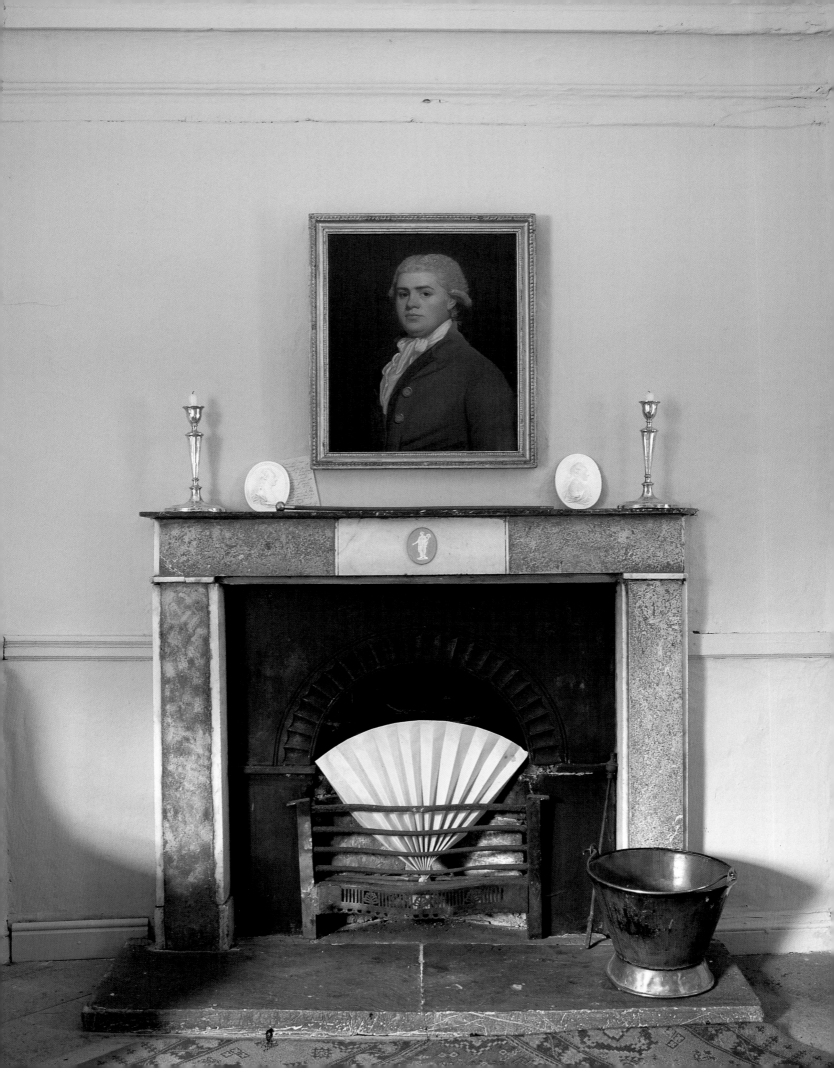

IRISH
GEORGIAN

HERBERT
YPMA

photographs by
BARBARA AND RENÉ STOELTIE

STEWART, TABORI & CHANG
NEW YORK

PAGES 2–3
Classical statuary adorns a temple situated in the gardens of Leixlip Castle. Often built for purely ornamental purposes, the temple, with its strong link to the ancient civilizations of Greece and Rome, was considered in Georgian times the queen of garden architecture. The interior wall reflects the 18th-century preference for bright, vibrant colour.

PAGES 4–5
Higginsbrook House, standing picture-postcard-perfect on a rare, snow-covered Irish winter's day, is a beautifully preserved example of a Georgian farmhouse. During the successive reigns of George I, II, III and IV (1714–1830), lessons in symmetry and proportion learned from the study of the classics governed the style of the utilitarian as well as the more grand house.

PAGES 6–7
A faded, crumbling wall in a Georgian townhouse in Dublin reveals the original colour of the distemper, a flat, water-based paint suited only for interior application. Despite the traditional association of Georgian architecture with white, blue was by far the most popular colour for interiors, particularly in the middle of the 18th century. Later in the century this fashion shifted to pea green.

PAGE 8
The fireplace was the focus of social and domestic life in Georgian Ireland, a source of light as well as warmth, and much time and attention was given to its beautification, particularly as the 18th century went on. Yet it posed a problem for designers of early Georgian houses, for there were no classical precedents to follow. Georgian architects devised a solution that remains a powerful design convention today: the sides of the fireplace were made to represent classical columns and the mantelpiece bridging them a classical lintel.

THIS PAGE
The shell, in this case carved in plaster, was a favourite decorative motif of the rococo trend in interior decoration that reached the height of fashionability in Ireland in the mid-18th century (1730–60). Shells are also quite often found adorning 'Irish Chippendale' furniture.

PAGE 12
This domed garden pavilion sits by the River Liffey. Conceived and commissioned by Lady Louisa Conolly, mistress of Castletown House and one of the great characters of Irish Georgian times, it was intended as the perfect summer room from which she could admire her beloved house and the river.

For Danielle

© 1998 Herbert Ypma

First published in Great Britain in 1998 by Thames and Hudson Ltd., London

Published in 1998 and distributed in the U.S. by
Stewart, Tabori & Chang,
a division of U.S. Media Holdings, Inc.
115 West 18th Street, New York, NY 10011

Distributed in Canada by General Publishing Co. Ltd.,
30 Lesmill Road, Don Mills, Ontario, Canada M3B 2T6

Library of Congress Catalog Card Number: 97-61976
ISBN: 1-55670-707-X
Printed in Singapore
10 9 8 7 6 5 4 3 2 1

CONTENTS

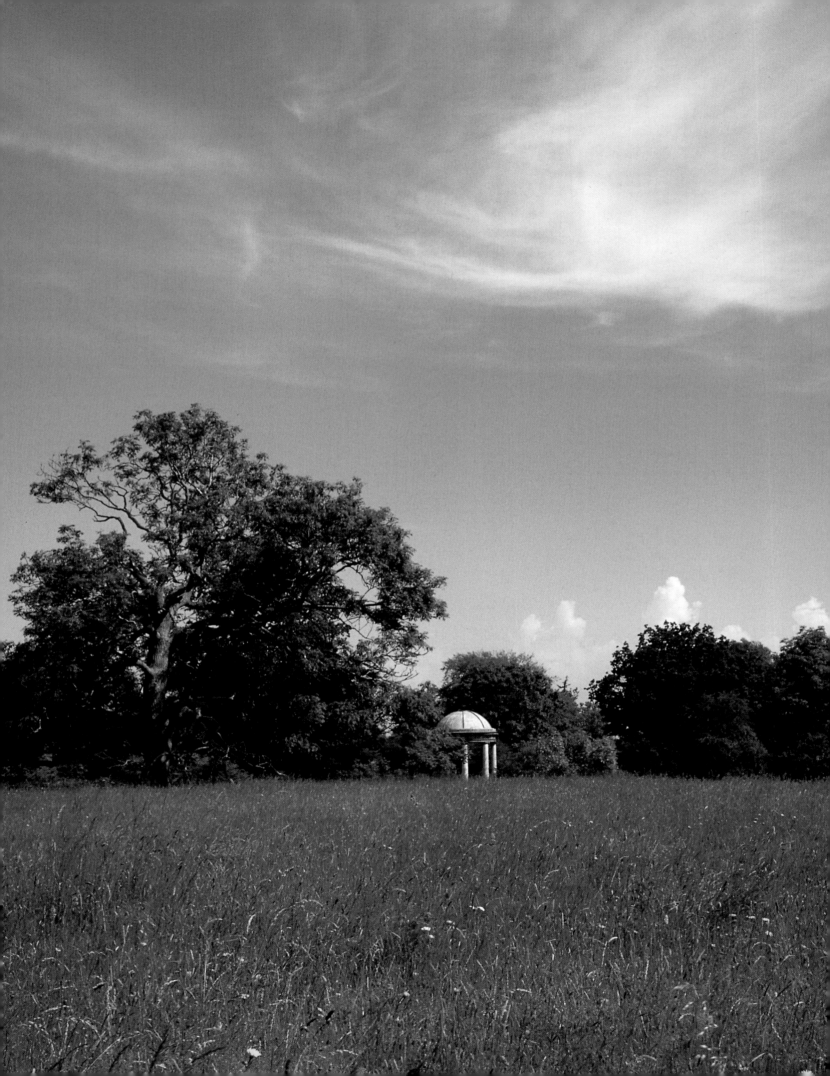

INTRODUCTION

Stylish and unfussy, grand yet informal and laid back, with an evocative historical air and a mood of fantasy ... the Irish Georgian style of today combines a serious interest in 18th-century Ireland with a passion for bold and vivid architecture and decoration.

During the successive reigns of Georges I, II, III and IV, Ireland enjoyed a period of enlightenment, a Renaissance to rival that of any of its European neighbours. Dublin, with its newly built architectural treasures, became known as the second city of the British Empire and in the countryside the landed gentry, enjoying peace and prosperity for the first time since the landing of the Normans in 1171, dared to build without reinforcement. In all areas of style, from architecture and landscaping to furniture, silverware, crystal, fabrics and even wallpaper, the Irish excelled, and became renowned far beyond their own mythical island state. To a degree, of course, they copied Georgian fashions from England, but not slavishly so. Less pompous and more ascetic than its English counterpart, Irish Georgian style was a simpler, perhaps purer translation of the classical heritage on which the Georgian 'rule of taste' was based.

The 19th century was a period of decline for Ireland. Devastated by the worst famine in western history, embroiled in civil war, and in conflict with England for independence, the nation endured a century of turmoil. It wasn't until the optimism and economic boom following World War II that Ireland embarked on a concerted effort to bring itself up to date. The rush to 'modernize', unfortunately, was also a rush to knock down everything belonging to the past. The country's impressive collection of Georgian buildings was of little interest to the independent Irish, to whom it represented no more than a symbol of English Protestant exploitation.

Luckily the grandeur of the Irish Georgian period was too powerful to disappear. Ireland's Georgian heritage is a magnificent legacy of man-made beauty that fits hand in glove with the astounding natural beauty of Ireland. The parkland settings, formal architecture, imposing scale, slightly tatty but comfortable furnishings, and unmistakably aristocratic collections of art and antiques are the ingredients of the contemporary Irish country house, whose style has inspired a host of enthusiastic followers. This is no mere nostalgic yearning for the past. The pervasive symmetry and simplicity of Georgian style is much more in line with modern taste than the fussy clutter of the Victorian period. Moreover, approaching the end of the second millennium we seem to have discovered a new appreciation for lasting quality and timelessly classic style.

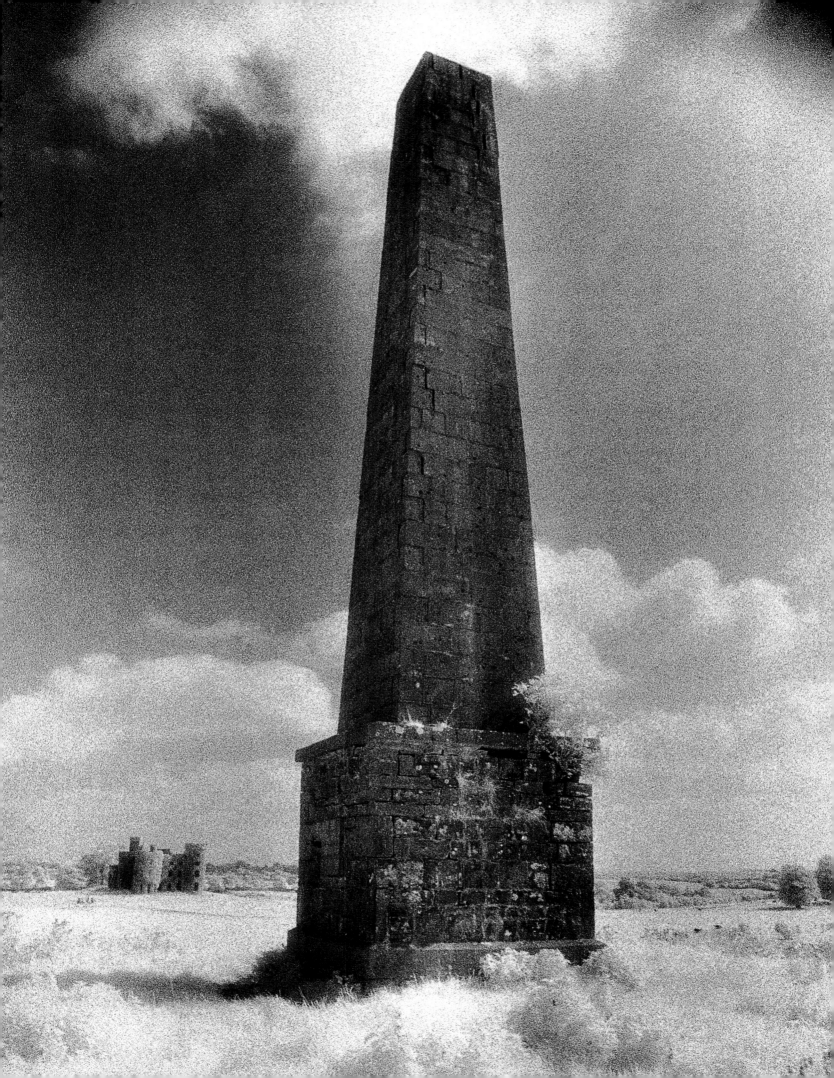

1

ORIGINS

Ireland's Georgian period was an age of enlightenment, and the most vivid, informative and inspiring mirror of this time is the grand Irish country house. The great houses of Ireland are rich expressions of social and artistic creative energy. Castletown House, the first, was also the most splendid of them all.

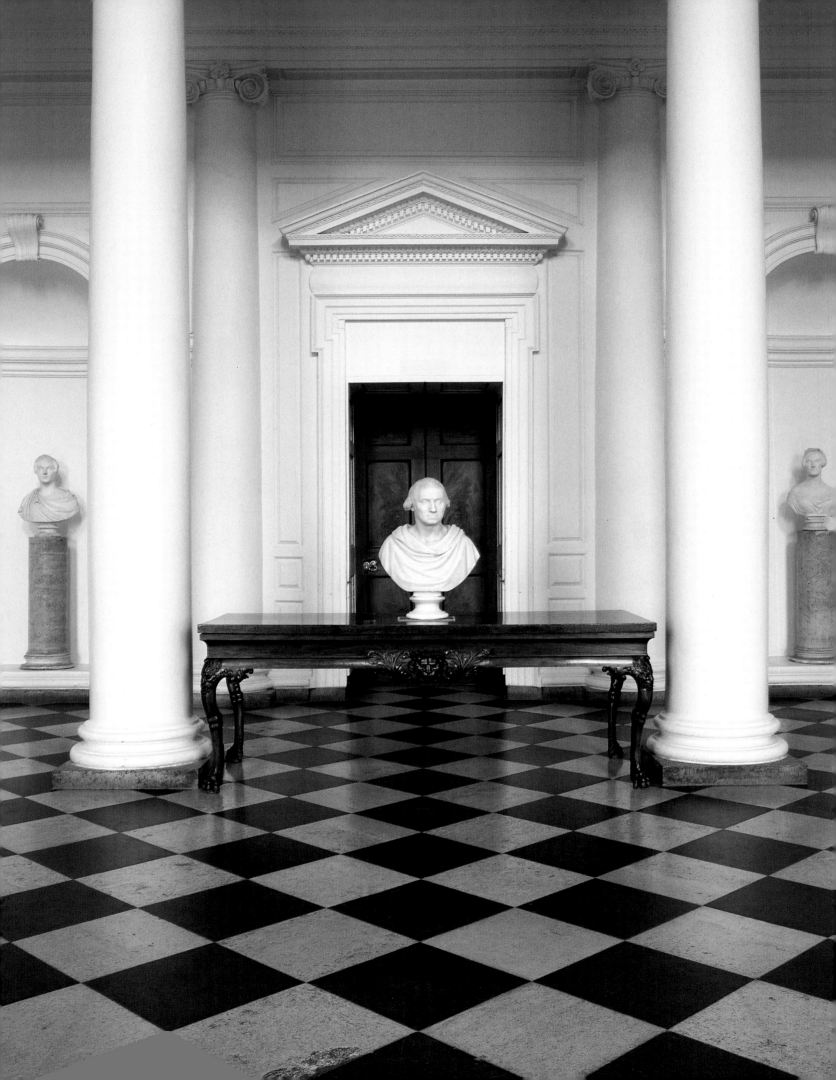

THE IRISH COUNTRY
HOUSE

In political terms, the Georgian era gave Ireland little to celebrate. Neither Mad King George (or Farmer George, or just plain George III, 1760–1820), nor the two Georges before him, were particularly sympathetic to the Irish independence cause and George III's solutions to upheaval, largely due to his own poorly chosen and inadequate council, were always the same … heavy-handed, brutal reprisals that certainly did not quell the deep-rooted unrest. Nor were the Irish Catholics, despite guarantees of equality from the English government, accorded anywhere near the privileges of the transplanted English Protestants.

Yet politics aside, in many ways the Georgian period in Ireland was one of great distinction, a time often referred to as the Irish Renaissance. Goods of remarkable and distinctive craftsmanship were being produced in disciplines as diverse as plasterwork, joinery, wrought iron, stonework, silver, glass, pottery and porcelain. The Irish were the first to experiment with copper-plate printing of cotton fabric and, although not widely acknowledged, invented *toiles de Jouy* years before the French village of Jouy under the direction of Monsieur Oberkampf came to be automatically associated with this style of fabric. Irish silver, at the time, was of a fine quality that led to a thriving export trade with mother England, and wallpaper workshops in Dublin were so numerous and prodigious in the printing of wallpaper that much of their production ended up being exported to America. And the much sought-after skill of mezzotint engraving was so dominated by an Irish group of engravers known as the Dublin Group (discussed in more detail on pages 139–144) that they are credited with raising the entire craft to new levels of refinement and expertise.

The catalyst and focus of this creative drive were the grand country houses of Ireland, the centre of Ireland's social and political life. In 18th-century Ireland, property was the manner by which status was established. Unlike in England or France, where blood line as well as wealth determined one's rung on the ladder, in Ireland it was more about show. The more (land) you owned, the higher your position in society, and it was the country estate, not the city house, that was the principal measure of prestige. Since the outward appearance of one's country demesne was of such importance, it is little wonder that the Irish landowners went to such extremes to impress. For more than a century, the 'Big House' drew upon the best craftsmanship and artistic

skills that Ireland had to offer. Yet to characterize the architecture of this period as merely a reflection of vast wealth and unbridled extravagance would be unfair, and more importantly, inaccurate. Despite the fact that many landowners were of English Protestant background they had in most cases been in Ireland for many generations, and whether they were conscious of it or not, the character of the country had certainly seeped into their tastes and preferences.

Compared to the architecture and design of Georgian England, Irish Georgian was simpler, purer and closer to the classical ideal. The grand Irish country house sits more idyllically in the landscape than its English counterpart and more often than not, in terms of quality, it is better built. Irish gentlemen, like English, often went on the Grand Tour as part of their education, but the lessons they brought back and applied to their houses were simpler and less pretentious. They studied Andrea Palladio of course, master-architect of 16th-century Renaissance Italy and the great inspiration of Georgian times, but they also referred back to the classical forms of Roman and Greek ruins, preferring to go straight to the original source of inspiration.

No grand Irish country house better encapsulates the history and story of Irish Georgian than Castletown House, the famous home of one of Ireland's most colourful families. The story starts in 1721, during the reign of George I, with William Conolly, Ireland's wealthiest man. The son of a Donegal innkeeper, Conolly had, through shrewd dealings in forfeited estates following the Williamite wars, amassed not just a substantial fortune but enormous political power as well. His election as Speaker of the Irish House of Commons in 1715 (a position he maintained until his death in 1729) was followed by his appointment in 1716 as Lord Justice. Fiercely proud of his Irish identity, Conolly's Castletown House was meant not just as an obvious manifestation of his wealth, but also as a symbol of Irish enterprise and innovation. He succeeded admirably in both objectives: not only is Castletown the largest and most splendid house in Ireland, but it is also the most important, for it introduced to Ireland the sophistication of Palladio and brought about a revolution in architecture.

PREVIOUS PAGE (16)
A bust of George Washington dominates the magnificent entrance hall of Castletown House. Believed to be an original by Houdon, it was auctioned off in 1965 along with the entire contents of the Castletown estate. It took Desmond

Guinness six years to retrieve the bust and return it to its rightful spot.

OPPOSITE PAGE
Originally intended by architect Edward Lovett Pearce as a space for grand, formal occasions, the Long Gallery at

Castletown House was redecorated by Lady Louisa Conolly in the 1770s in the 'Pompeian' style. It became the living room, a daring new concept for these grand houses, and was used for informal entertaining – staging plays, holding recitals, playing cards or serving afternoon tea.

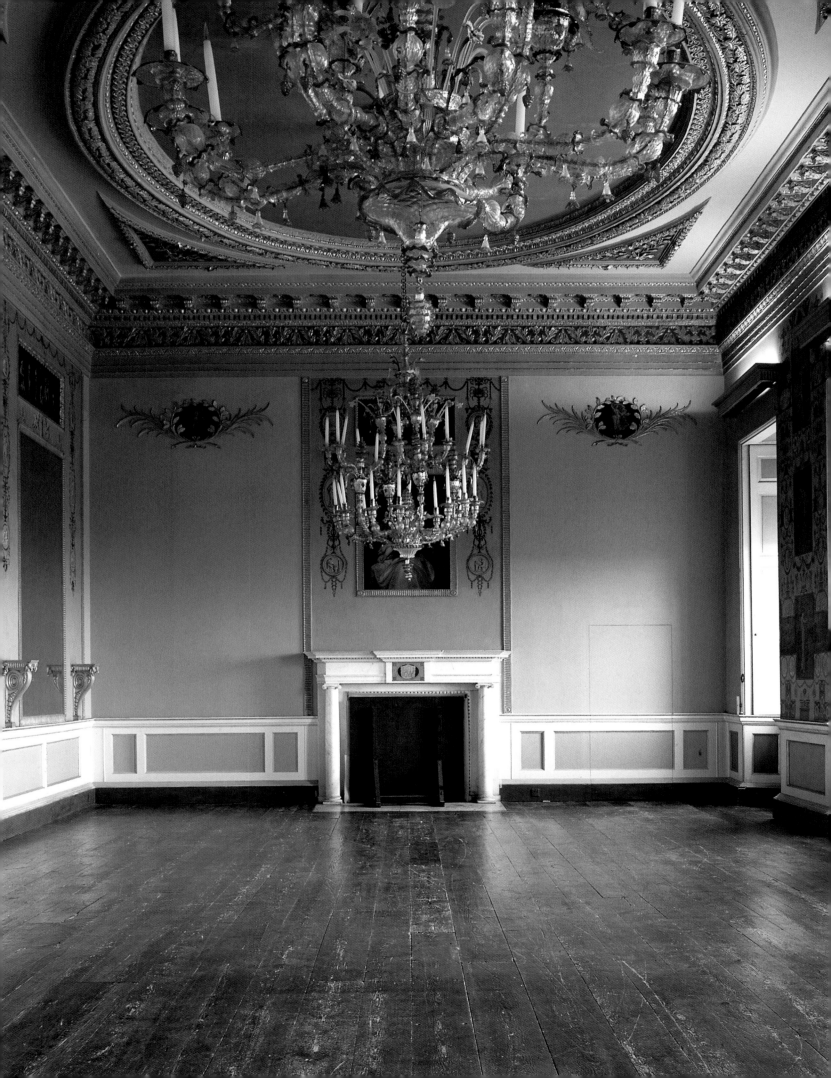

Conolly's decision to build in the Palladian style, with its emphasis on the ancient Roman principles of symmetry and harmonious proportion, was fashionably ahead of his time. His choice of architect was equally inspired. In 1719 he brought the Florentine, Alessandro Galilei, best known for his work on the Lateran Basilica in Rome, to Ireland to commence the design of Castletown House. Building work began in 1722 and in 1724 the project was taken over by Edward Lovett Pearce, then a precocious 25-year-old architect who had been studying the work of Palladio in Italy and who, through his cousin John Vanbrugh (another big name in Palladian architecture), was in close contact with Galilei. Thus, through a network of impeccable architectural connections, a house in far-flung Ireland was designed according to the finest classical principles of ancient Rome as interpreted in the Italian Renaissance.

Castletown, however, would prove to be more than the project of a lifetime for William Conolly and Edward Lovett Pearce, who both died before its completion. Even Conolly's widow, Katherine, who lived in grand style in the house until her death in 1752, never saw it finished. With the exception of the staircase, the architecture had been realized by that date, but the interior was not really tackled until 1758, when Conolly's great nephew Thomas Conolly moved in. Together with his new bride, Lady Louisa Lennox, the dynamic 15-year-old daughter of the Duke of Richmond, they set about completing the house.

Lady Louisa's boundless energy, enthusiasm and gift for organization (a vital quality in running such an immense house) was first directed at the staircase. She secured the services of the Dutch-Italian sculptor and stonemason Simon Vierpyl, a student of Sir William Chambers (another famous Georgian name) to create 'no ordinary' staircase. Vierpyl conceived a cantilevered masterpiece constructed of the finest Portland stone rising majestically along white-painted walls that were exquisitely decorated in carved plaster relief by the famous Swiss-Italian Francini brothers. Known as a 'flying staircase', this is a Georgian feature peculiar to Ireland.

Next on the decorating agenda was the print room, the only one that still exists in Ireland (see pages 108–113), followed in the 1770s by Lady Louisa's transformation of the Long Gallery. Eighty feet long with eight towering north-facing windows, the

(see pages 108–113)

OPPOSITE PAGE
Castletown House was the first of many Irish country houses to feature the distinctive 'flying staircase'. Constructed of stone steps cantilevered from the wall, *these staircases are unique to Ireland's Georgian architecture and are not found in any English houses of this period. The elaborate rococo plasterwork that decorates the staircase hall* *is attributed to the Swiss-Italian Francini brothers, Ireland's most famous and innovative stuccodores. Their work is easily recognized by its allegorical themes and classical figures.*

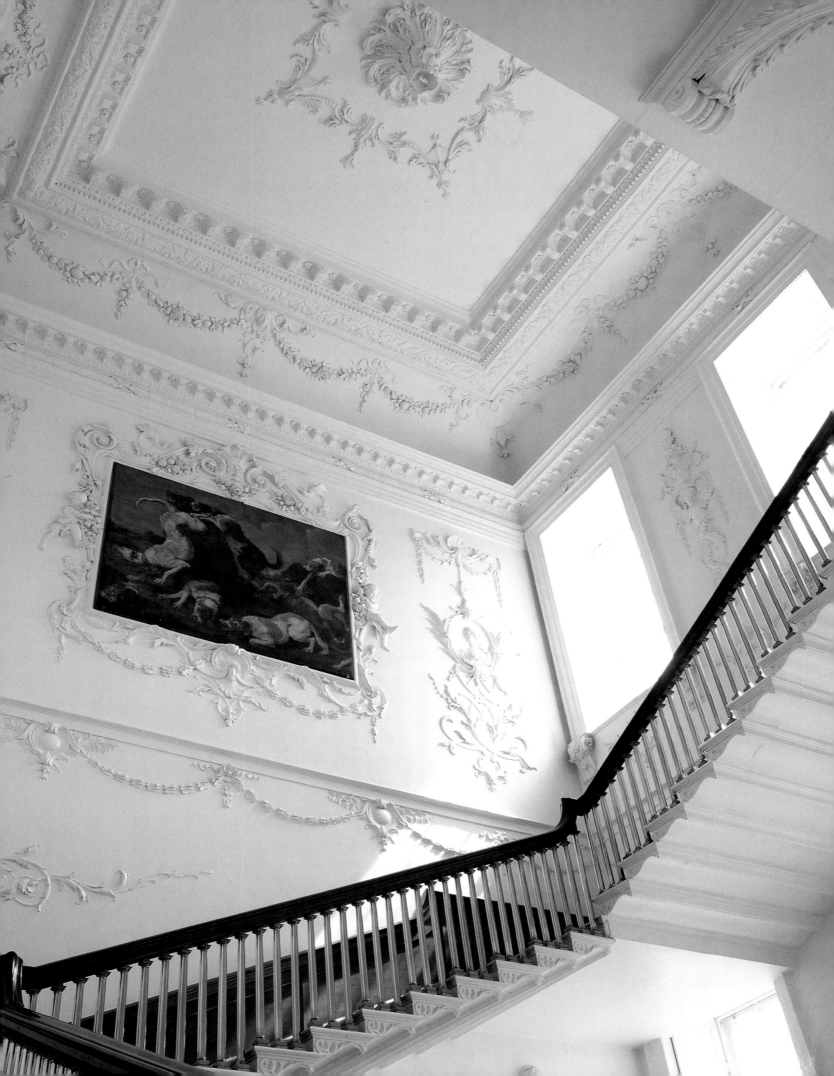

gallery had been conceived by Pearce almost fifty years earlier as a space for grand occasions. Times, however, were changing and Lady Louisa had other plans. With the help of her sister, Lady Sarah Bunbury, she turned the gallery into an informal living room. The originally bare and cheerless space was transformed into a 'painted' room; the old plaster panels were 'knocked off smack smooth' and replaced by 'Pompeian' painting by the English decorative artist Thomas Riley. The room was filled with French mirrors, bookcases, plinths with classical busts, and two magnificent Venetian chandeliers of blue Murano glass made specifically to match the colour of the room. No doubt aware of the growing fashion for neoclassical imagery, particularly of the kind utilized by the spectacularly successful Robert Adam, the two sisters set about choosing the subjects for the decoration of the Long Gallery. Sir William Hamilton's engravings of Greek vases and the French engraver Bernard de Montfaucon's book *L'Antiquité expliquée* would prove to be the main source of inspiration. When Louisa, Sarah and their team of decorators had finally finished in 1775 (three years later) 'not a square foot of wall was left uncovered'. Lady Louisa was delighted, writing excitedly to her sister Emily that it 'really is a charming room for there are such a variety of occupations in it that people cannot be formal.'

The 'stop-start' approach to the building of Castletown created a unique scenario. One house experienced almost all the decorative influences and fashions that came to the fore at different stages of the Georgian period. From the Palladian style of the architecture to the somewhat old-fashioned baroque layout of the ground floor rooms; from the rococo brilliance of the Francini brothers' plasterwork to the Adam-inspired neoclassical painting of the Long Gallery, Castletown House has survived as testament to the variety, quality and innovation of the Irish Georgian style.

As for Castletown, the story of this noble and extraordinary house ends (at least until the arrival of Desmond and Mariga Guinness, see pages 146–156) with a picture of Lady Louisa Conolly on her death bed, in a tent on the lawn, determined to die looking at the house she had loved so much. The year was 1821, the last George (George IV) was on the throne, and the curtain was almost down on this stylish era.

OPPOSITE PAGE

The wallpaper in the Long Gallery is in the 'Pompeian' style that was inspired by the frescoed rooms unearthed at Pompeii and Herculaneum in the mid-18th century and came to be widely applied to wallpapers, textiles and ceramics.

FOLLOWING PAGES (24–25)

As with most of the interior decoration projects undertaken by Lady Louisa Conolly at her beloved Castletown House, she had very precise ideas of what she wanted for the staircase hall, down to the last details. The themes she chose for its

plasterwork decoration were a reflection of her own personal priorities. The hunting scene that takes pride of place refers to her husband's passion for outdoor sports, while the man and woman facing each other reflect the great importance she placed on her marriage.

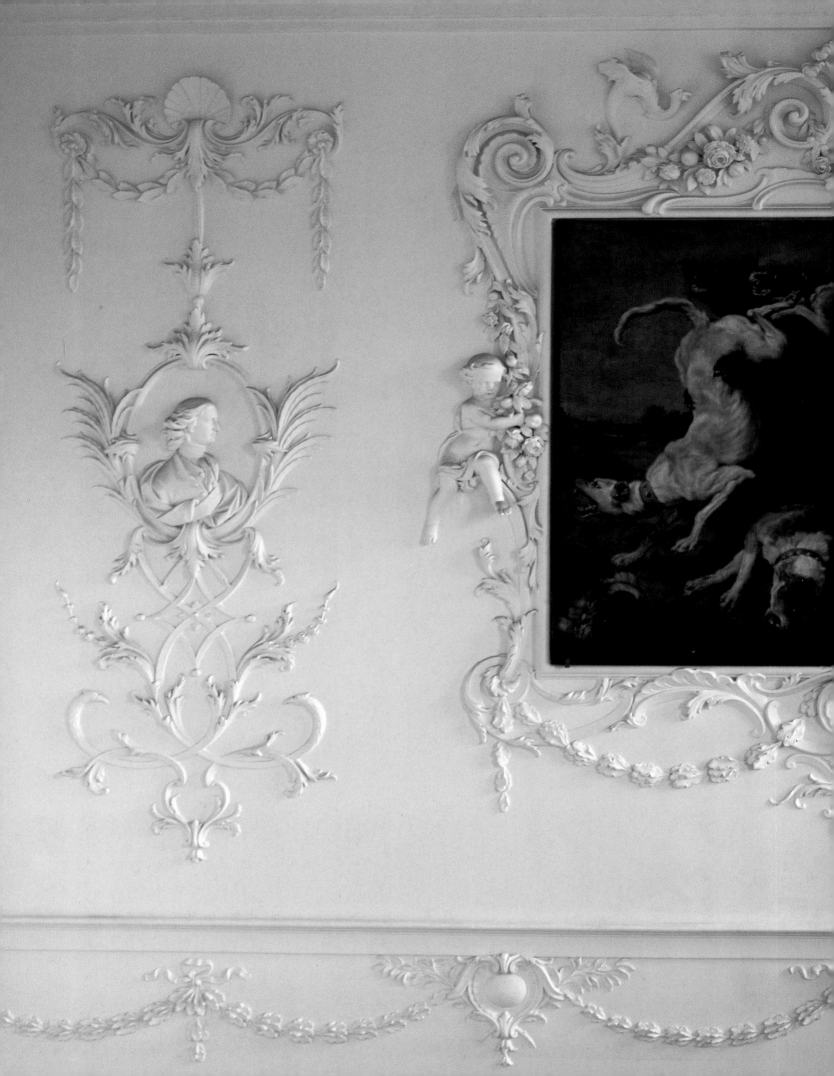

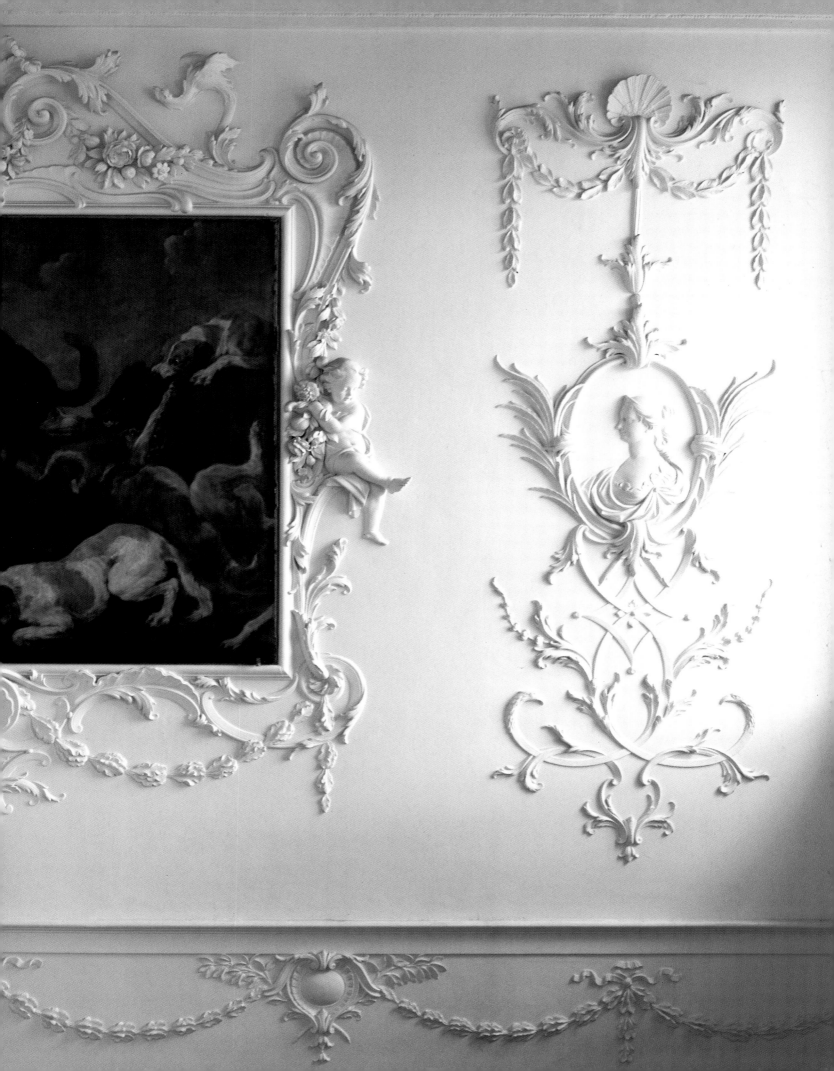

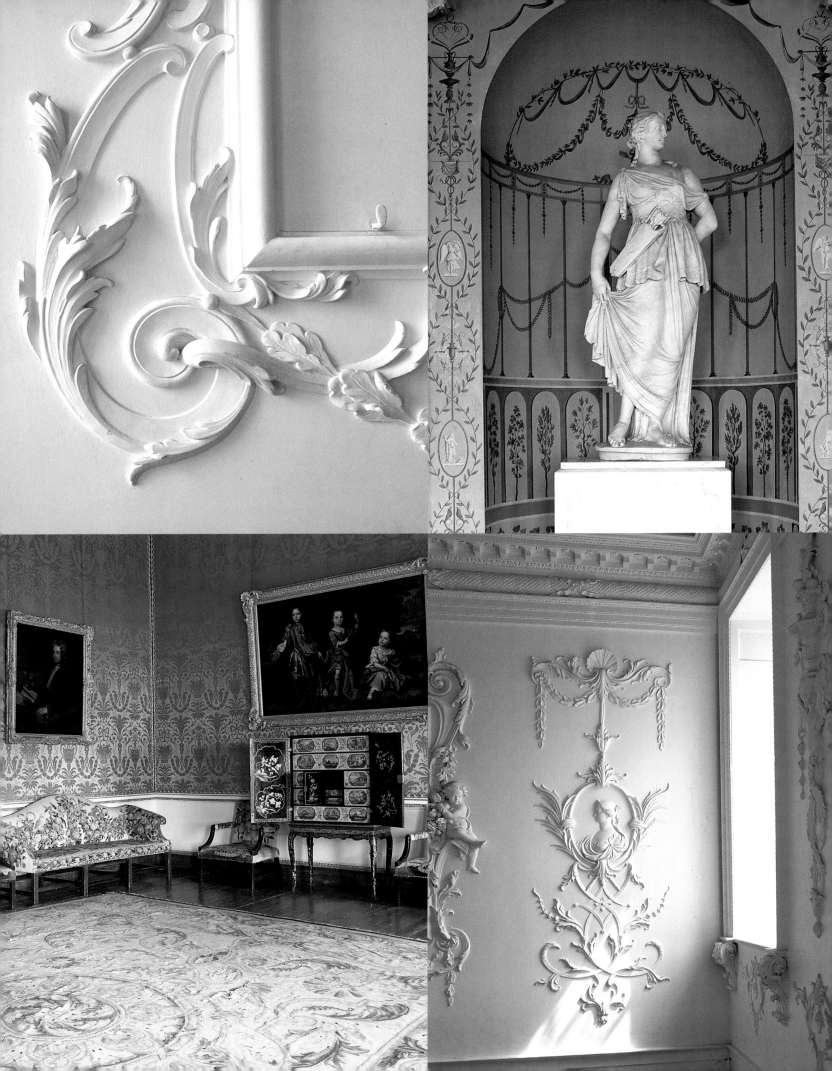

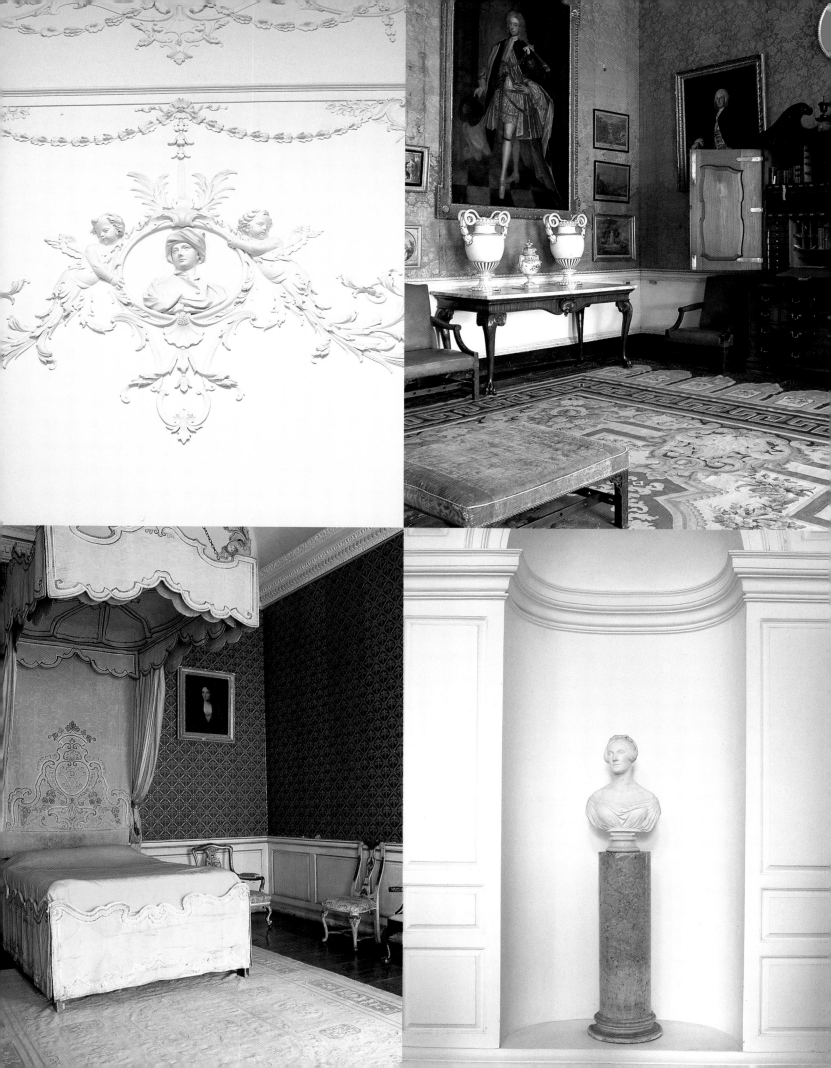

1

Prior to the Francini brothers' arrival in Ireland, plaster was often reinforced with hair, making it brittle and far less durable. The Francini brothers, Paolo and Filippo, were able to create more depth in their plasterwork through their introduction of marble dust to the plaster. This gave it more substance and allowed finer, more realistic detail.

2

A statue of Diana stands in the central niche of the Long Gallery, beneath a lunette of Aurora, the goddess of the dawn, derived from a ceiling decoration by Guido Reni.

3

The elaborate wall murals that were still popular in early Georgian times were eventually replaced by a preference for relief plasterwork. Painted in different shades of white to highlight the craftsman's skill, the themes for walls tended to be narrative while ceiling decoration was more geometric.

4

Redecorated in the mid-1760s in the style favoured by George III's architect, Sir William Chambers, the Red Drawing Room was one in a series of ground floor 'state rooms' used for important occasions. Following the formal tradition of the 18th century, furniture was arranged along the walls.

5

The Green Drawing Room, also known as the Saloon, was another principal reception room redecorated in the 1760s by Louisa Conolly. Born into English aristocracy and accustomed to a life of privilege, Lady Lennox (her family name) used her impeccable connections to stay up to date with all the latest fashions. No wonder then that her Castletown interiors reflect the styles of William Chambers (the Red and Green Drawing Rooms and the dining room) and of Robert Adam (the Long Gallery), the two leading names of the latter half of the 18th century.

6

Although often described as baroque (i.e. excessively and extravagantly decorative), the Francinis' plasterwork at Castletown House actually follows the rococo influence, an interior style that was at its zenith at the time the staircase was completed in 1760.

7

The State Bedroom of Castletown House was primarily intended for formal occasions, and in Georgian times was never slept in. The presence of a State Bed was a symbol of the owner's rank in society, and for a guest to be received here was an indication that he was of the highest importance.

8

A signature of Edward Lovett Pearce's work, also found in his other Palladian houses (Bellamont Forest for example, featured on pages 62–69), is the niche to house the classical busts that would usually have been brought back from the proprietor's Grand Tour.

O

PPOSITE PAGE

The green silk that gives the Green Drawing Room its name was woven for Louisa Conolly in France. A detail of the wall reveals how it was attached. Nailed onto thin wooden battens framing the outer edges of the wall, the nails were then hidden by a gilded ribbon. The grotesque mask was an enduringly popular decorative icon of Georgian times.

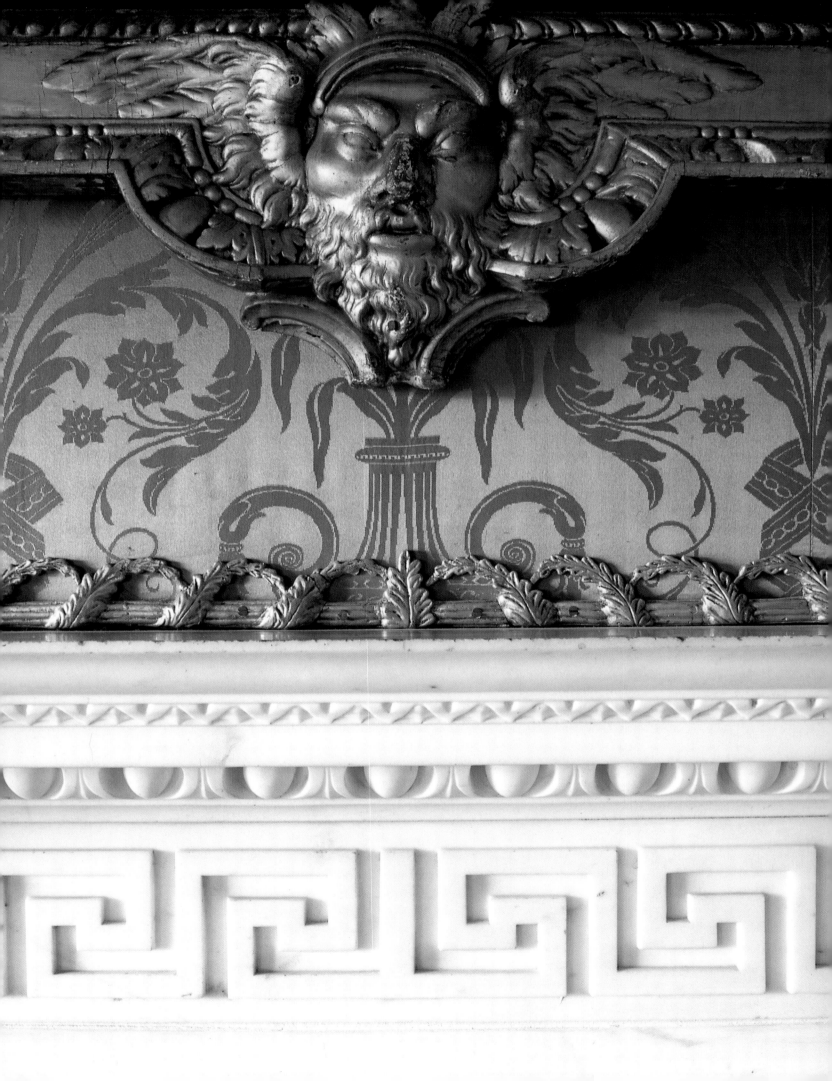

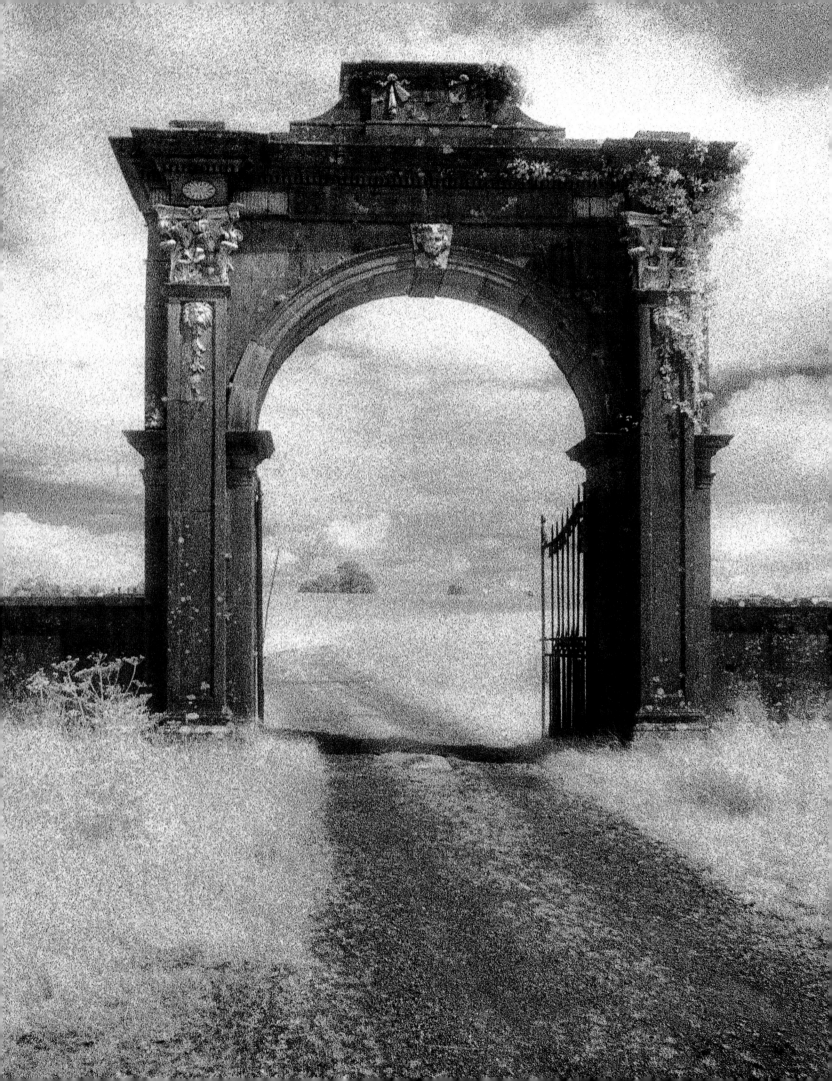

2

INTERIORS

Irish gardens are wild, but Irish interiors are all symmetry and proportion, with selective room arrangements that have much in common with the Modern Movement in their avoidance of clutter. The slightly shabby but unmistakably aristocratic style of the grand Irish house is the epitome of civilized taste.

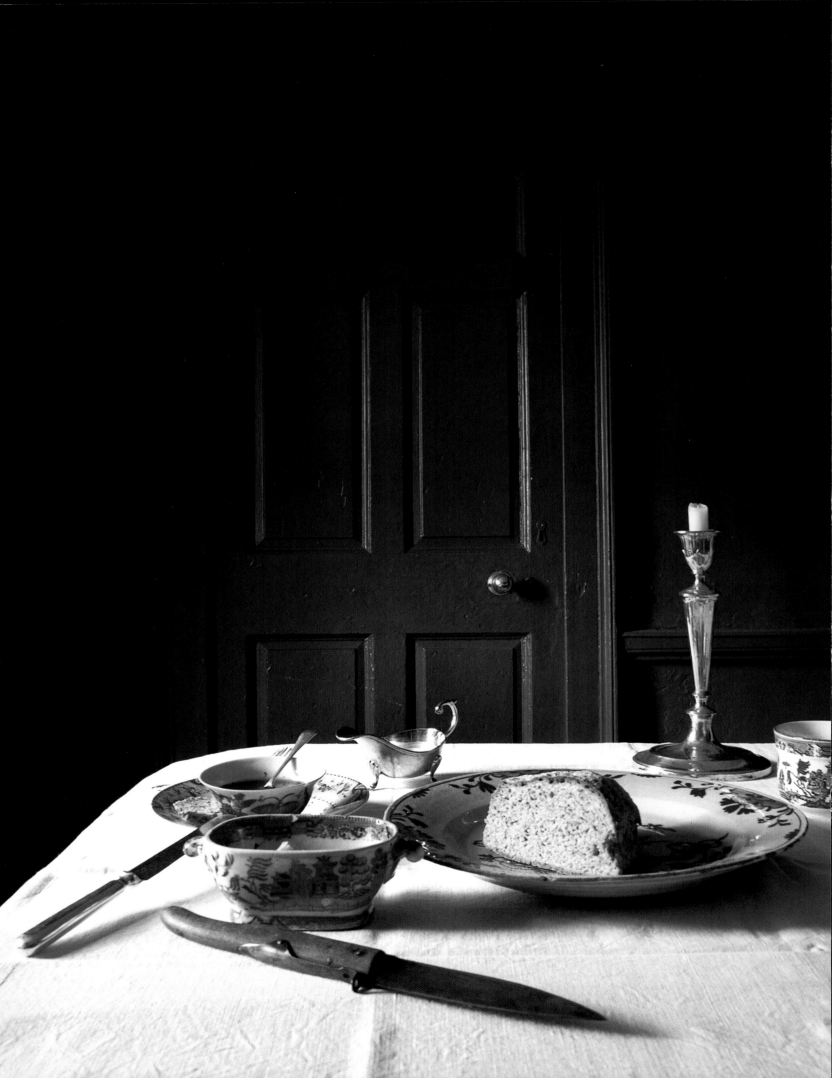

IRISH GEORGIAN

FARMHOUSE

The Georgian desire for a degree of dignity and neatness, for a respectable house with some elegance, did not exclude the farmer and his humble farmhouse. Early in the 18th century, the farmhouse began to conform to the classical pattern – to what was known as the 'rule of taste'. Like many small Georgian houses it featured a symmetrical, two-storey, five-window front, with four rooms to each floor and a small entrance hall and staircase in the middle. The farmer, in common with other members of the emerging middle class, sought to emulate the Palladian mansions of the aristocracy, and, judging by Goede's observations in *The Stranger in England* (1802), did so with some success. 'The farmhouses seem as though just built ... the pleasing impression produced by invariable neatness and order, increases the admiration of the stranger, who will often mistake the dwelling of the plain farmer, for the residence of an independent gentleman.'

Classical shapes and proportions affected every aspect of the Georgian house, not only its architecture, with the result that everyday articles were all well designed, whether they were kettles, pokers, door handles, knockers or drinking vessels. The sense of sight was obviously a source of joy to the people of the Georgian period: just give us plenty of beautiful objects, they seem to have thought, and that will compensate for all that is unsavoury in our lives.

And even a farmhouse would, if possible, have everything new. It was not fashionable to mix in the odd antique as we do today. Furniture makers, taking great care with every detail, looked forward to their work being admired, and they could not accept the eventual fashion for floor carpets and window curtains, which obscured their craftsmanship. Hence the Georgian house, particularly the more practical and modest farmhouse, was not cute, kitsch or cluttered in the way we might imagine; in fact it was rather minimal, but none the less quite charming due to the congenial proportions of the rooms. Following instructions from pattern books printed in the city (Dublin or, more likely, London) craftsmen also endeavoured to supply their rural clients with copies of chairs and tables admired in the city. A typical inventory for an 18th-century farmhouse parlour would be 'one table, eight chairs and two stools'.

Thus by Georgian standards the parlour at Higginsbrook House (sparsely and simply furnished as it is) is already more elaborately furnished than it would have

been in the 18th century. The selective room arrangements of the Georgian period were in fact a lot more like the modern interior in their avoidance of clutter. It all conformed to the rule laid down by Abraham Swan that 'there must be sufficient spaces left plain so that the ornament in proper places may be more conspicuous and may have their desired effect.'

These classical Georgian farmhouses, which certainly at first would have looked slightly incongruous in the midst of rustic 'farmery', took some getting used to. Within a short time after moving in the 18th-century farmer and his wife would start cluttering the small rooms, using them to store lard, raw and dressed meat, oil, oil colours, impure wool, sweaty saddles, tallow, foul linens, saffron and even hops. These not only rendered the rooms unwholesome but also barely habitable. The farmer and his wife, in effect, reverted to living in one room just as they had before the 'symmetrical revolution'. Thus, the prosperous farmer's new way of presenting himself was often no more than a veneer over long-established and tenacious habits.

By the time 150 years or so had passed, Georgian farmhouses were in bad and often ruinous shape, and very few contained any furniture to speak of. It is, ironically, only in the present day that these Georgian houses are for the first time being treated in a manner respectful of their neat and elegant design.

Higginsbrook House in County Meath is a perfect example. At first glance, its interior seems a well-preserved example of Georgian life, a museum, perhaps, to how Georgian houses were lived in … but nothing could be further from the truth. Higginsbrook is the part-time residence of a Dutch avant-garde couple, Barbara and René Stoeltie – a writer and photographer who happen to have a passion for design, decoration and architecture, and who cannot resist the temptation of classically inspired beauty. With Higginsbrook they stumbled on to what is, architecturally speaking, probably the best-preserved Georgian farmhouse in Ireland. Situated on the banks of the River Boyne, and surrounded by two-centuries-worth of impressive trees, the house and the setting proved too enticing a combination to resist.

PREVIOUS PAGE (32)
A Georgian breakfast table attests to the values and fashions of the day. Candles and tea were so expensive that only the finest silver and china were considered appropriate. Tablecloths were invariably linen, one of Ireland's burgeoning industries in the 18th century.

OPPOSITE PAGE
Utter simplicity is the hallmark of Georgian interiors, particularly in more modest houses. The corridor of Higginsbrook House in County Meath, an early Georgian farmhouse now belonging to writer and photographer Barbara and René Stoeltie, is a truly inspiring example. Dutch kitchen chairs (18th century), a brass lantern (originally suspended above the entrance), a French Comtoisse clock and an 18th-century oil portrait are accentuated by the scrubbed pine floors and the colour of the painted walls (which changes from room to room, in true Georgian fashion).

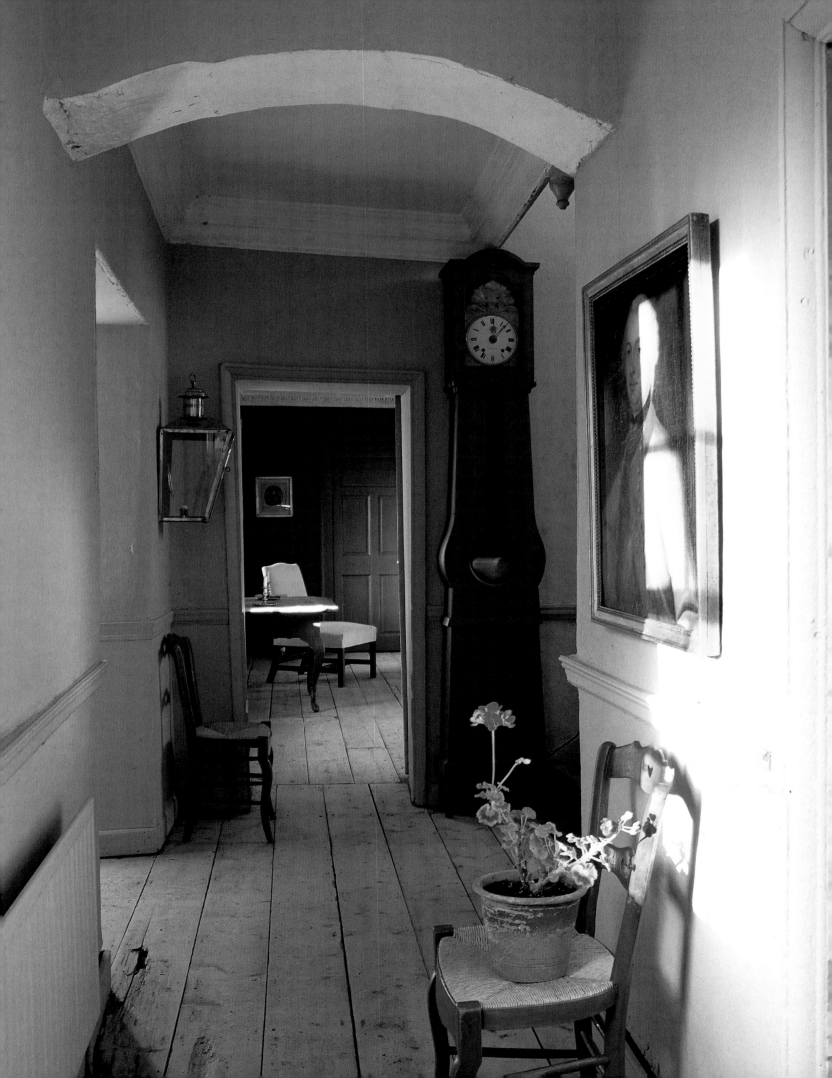

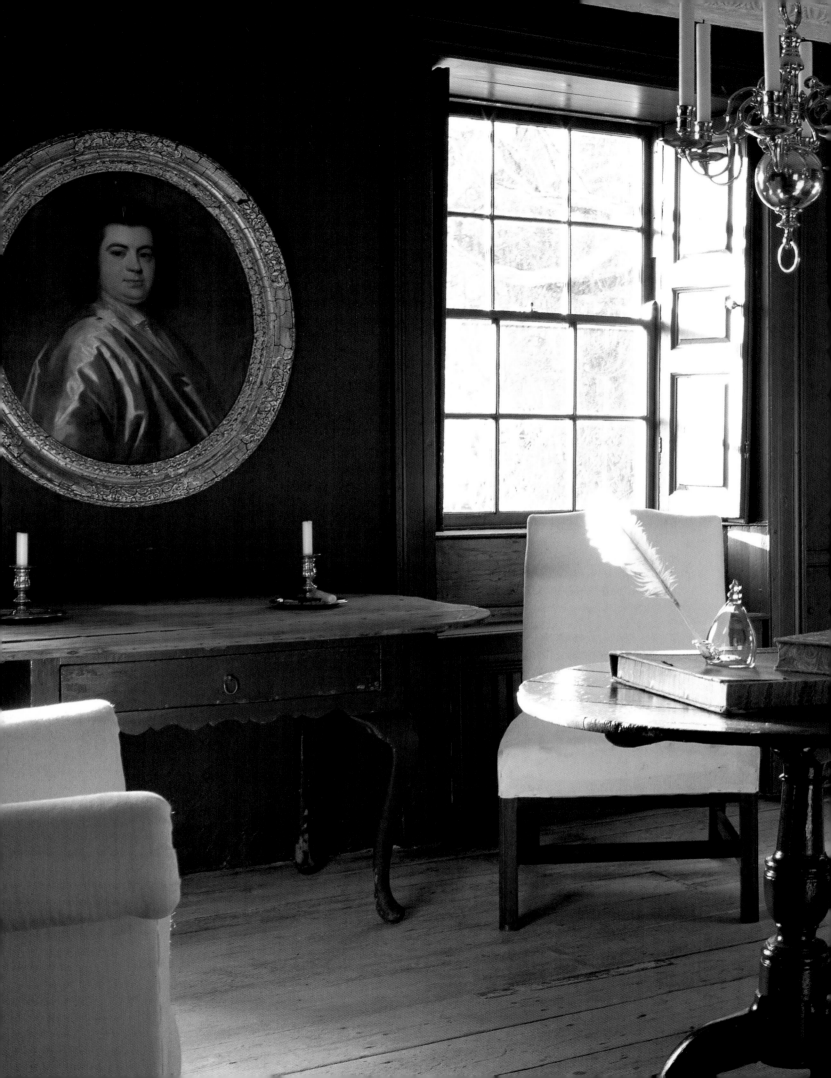

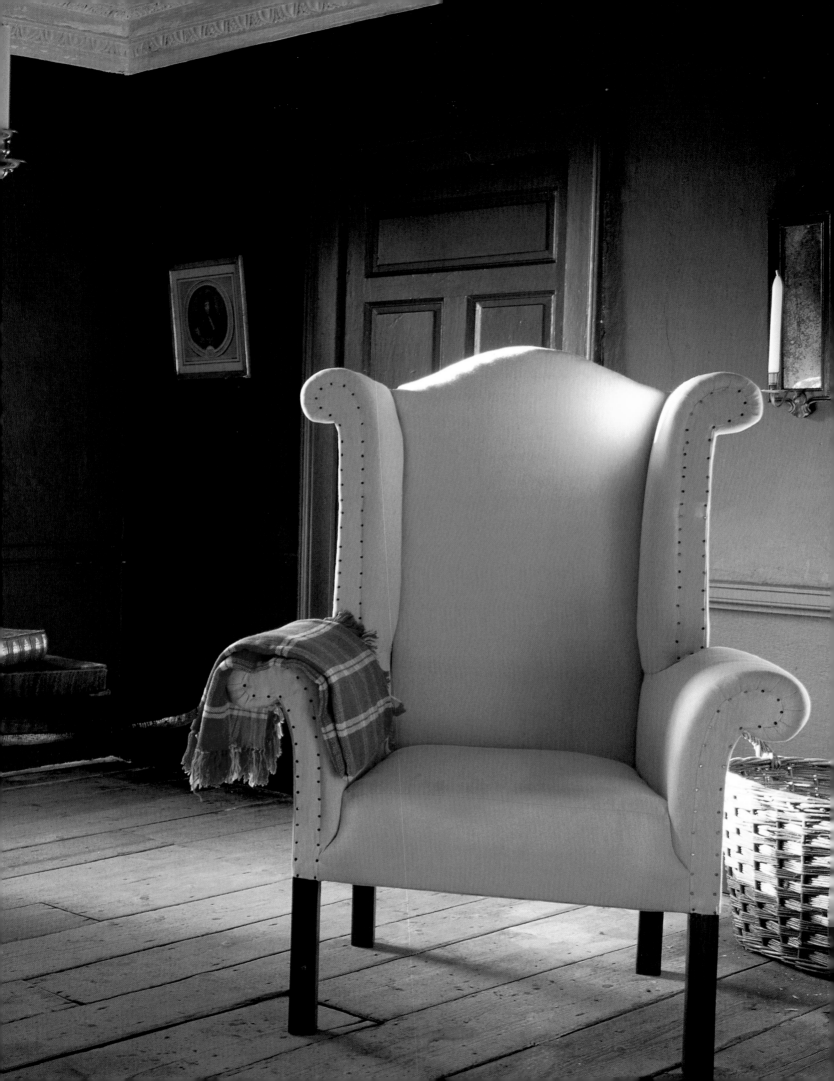

The interiors, as they found them, were another matter altogether. Somewhere along the way the original simple spaces that are the hallmark of Georgian architecture were lost to banal, irrelevant and nostalgic clutter. With no particular guidelines beyond a love of simplicity, the Stoelties replaced the boy scout banners, bad Victoriana and inappropriate William Morris furniture with a refined collection of simple but beautiful pieces. English and Swedish 18th-century oil portraits, French farmhouse chairs, 17th-century Dutch tables and cupboards, Sheffield silver candlesticks, simple striped and checked linens … although diverse in their origin these all evince a strong sense of common style and simplicity. Next came the colours, which René mixed himself. His striking shades of blue, green and grey are not an attempt to be historically precise; they are purely the shades that seemed to suit each room the best. The guiding factor was how this couple wished to live in the house, and yet by the time it was all done they had created one of the most sympathetic interiors an Irish Georgian house has ever had. The spirit of the Georgian age, with its emphasis on symmetry and elegance, restraint and neatness, resounds in this interior. It is a strong and exciting testament to the remarkable suitability of Georgian style to our times.

'Never let authenticity get in the way of good taste!'

Mariga Guinness's relaxed approach to historical style

PREVIOUS PAGES (36–37)
The living room of Higginsbrook House is furnished in a manner sympathetic to the Georgian preference for restraint. A pair of wing chairs, a Dutch brass chandelier and a rare Friesian pine table with cabriole legs all support the Georgian idea that items should be given space so that they may be seen. The rich dark green of the walls is a typical Georgian colour, popular for the saloon or main reception room.

OPPOSITE PAGE
To keep out the cold, the 18th-century bedroom almost always contained a curtained four-poster bed. Bedrooms were even more sparsely furnished than sitting rooms but at the beginning of the Georgian period an effort was made to give beds and bedroom chairs a warm and inviting appearance by covering them with fabric. Checked linens in shades of blue and green were a particularly popular choice.

FOLLOWING PAGES (40–41)
Plenty of brass pots and containers, some with taps for dispensing water, as well as glass decanters, often for storing vinegar, wicker baskets of all shapes and sizes, and the odd antler (trophy of the hunt) are the ingredients that make the traditional Irish country kitchen so attractive. Displayed on plain table tops of scrubbed pine they epitomize our idea of what a cosy country kitchen should look like.

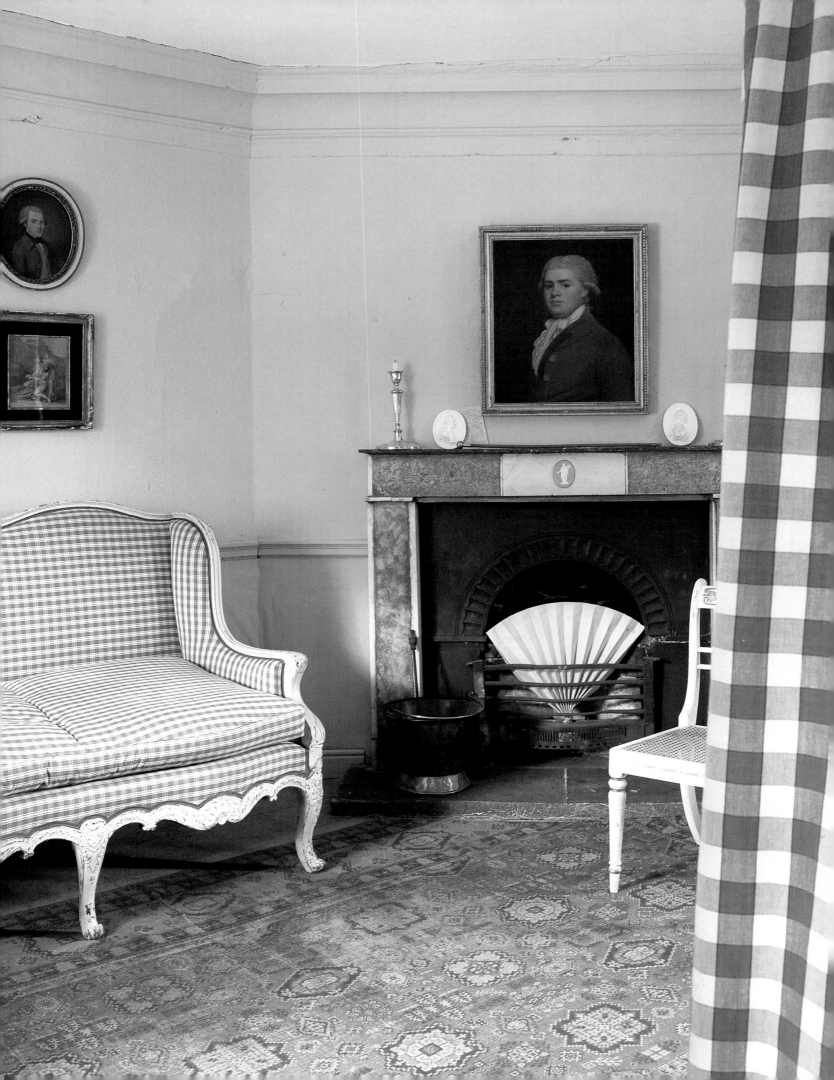

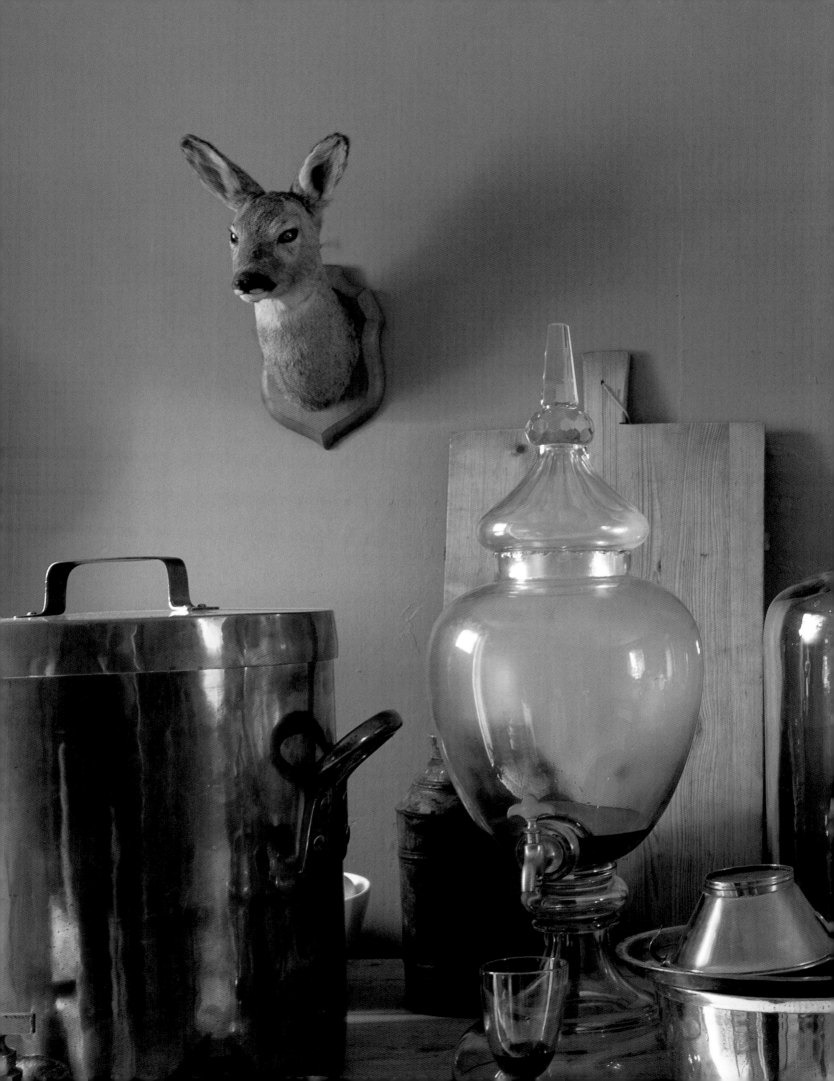

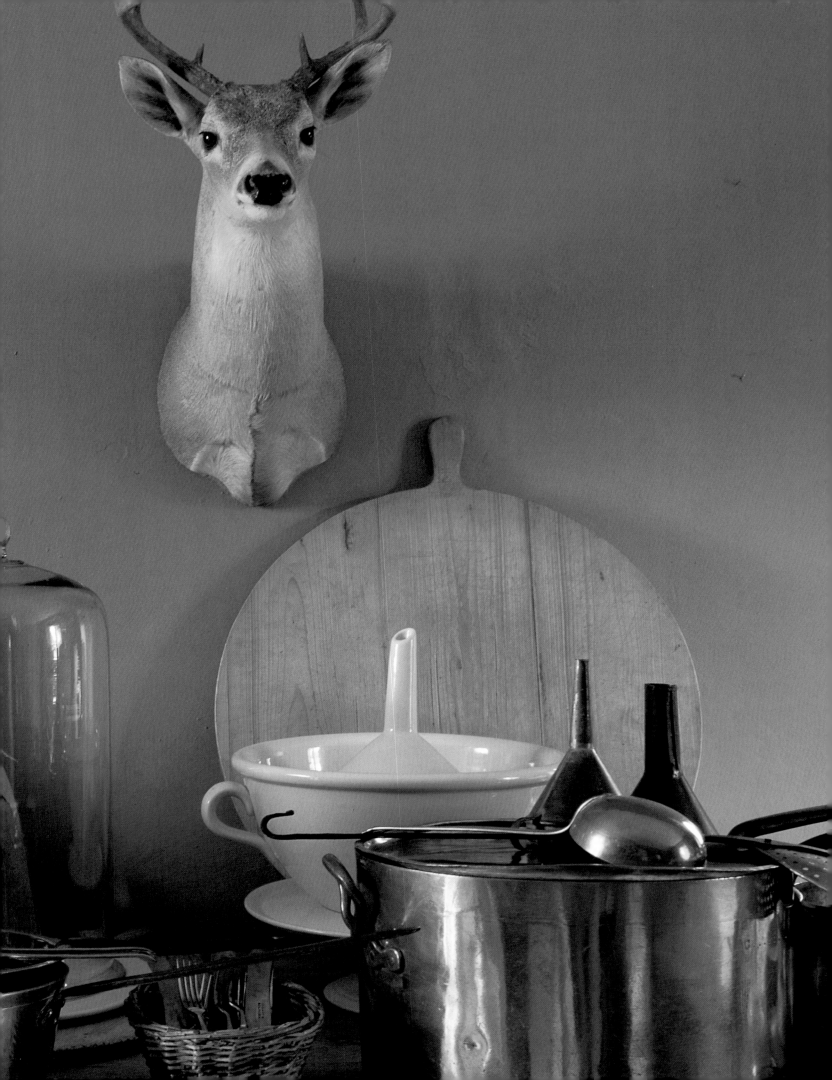

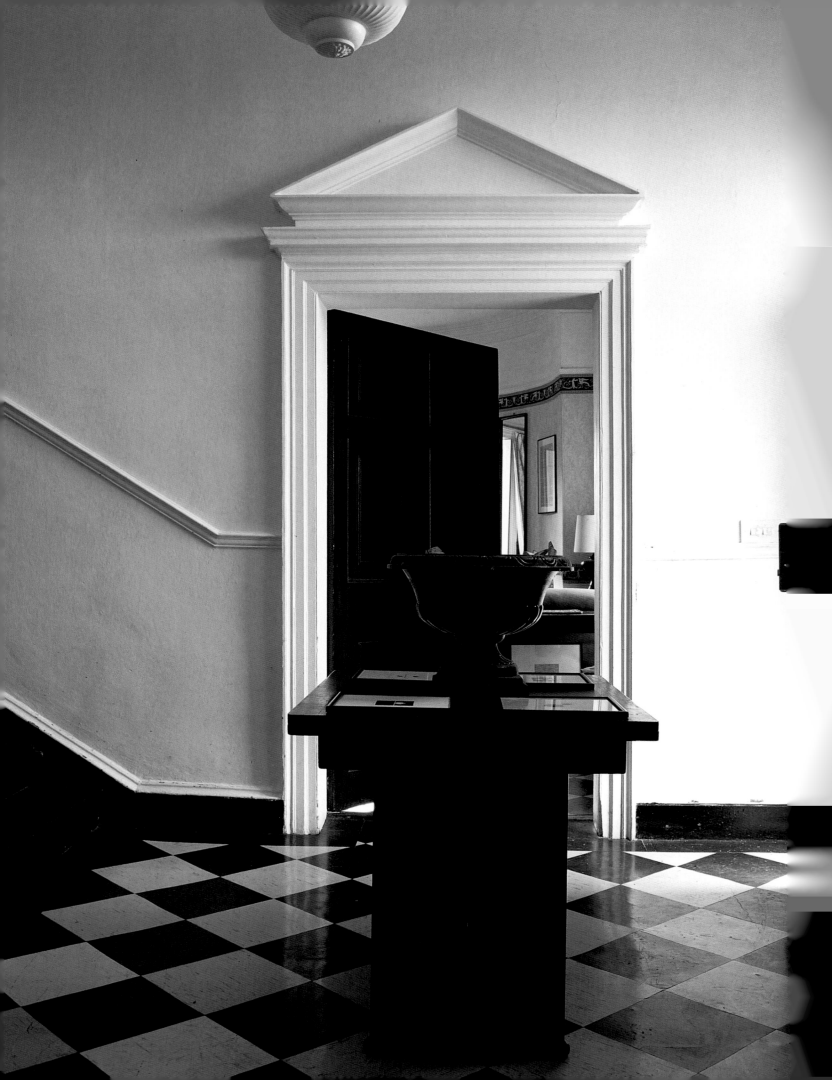

IRISH GEORGIAN

MANOR

The true beauty of the Irish Georgian aesthetic is often best found in the less grand country house. By the 1750s the general prosperity of the times was reflected in a growing middle class, who, anxious to distinguish themselves from the labouring classes, built modest classical houses. Like their owners' perfectly symmetrical powdered wigs of horsehair, these houses revealed the desire to demonstrate at least some control over their immediate surroundings. Copying the Palladian mansions of the aristocracy, and with the help of widely distributed pattern books, the middle classes ironically ended up building houses that were closer to the Palladian ideal than they could possibly have known. With their graceful restraint, these houses tended to flatter their occupants and benefited from one characteristic missing from the grand mansions – namely, they were comfortable to live in. Andrea Palladio's interpretation of classical Greek and Roman work emphasized 'human convenience' as much as 'pleasure of the eye', and in his *Quattro libri dell'architettura* (1570) Palladio wrote: 'Relate everything in a house to a human frame.'

It is doubtful that the average craftsman, particularly out in the countryside, had read Palladio's *Four Books of Architecture*, but the builders of these compact classical houses, even without the benefit of Palladio's advice, certainly gave consideration to comfort and convenience. Rooms were easily warmed by fireplaces on either side of the centrally positioned staircase; all internal doorways and dimensions were based on the size of the human frame; and doors were placed so that, according to Palladio, 'one may see from one end of the house to the other'. Even the façade took account of Palladio's opinion that architecture should enhance people's dignity; that people should never be confused or belittled. Georgian houses, particularly in the countryside, feature a prominent, centrally placed front door. The outward appearance of these classical houses was in fact so pleasing to the eye that in the 18th century it became unfashionable and downright unappealing *not* to have a classical façade. Perhaps the sense of symmetry is instinctive: a child asked to draw a house will almost certainly draw a Georgian house, one with windows on either side of a central door.

It was perhaps this seductive symmetry that drew artist Timothy Hennessy and his wife Isabelle to the classically proportioned Prospect House in County Kildare. An American artist, born in Missouri to the Irish-French family of Cognac fame, Hennessy

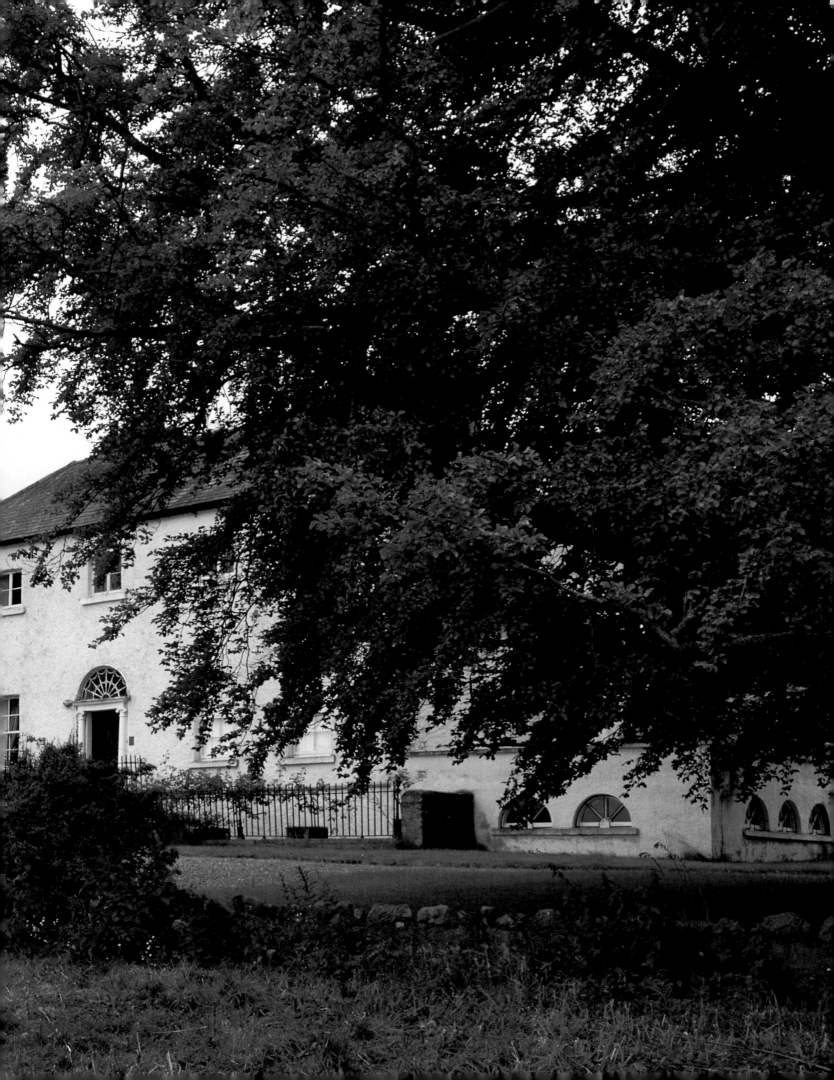

is today recognized as the father of 'pattern painting'. Long before artists such as Keith Haring made a name with art based on the inventive use of a repeated motif, Hennessy had captured the attention of the Parisian art world of the 1940s (and in particular of Cocteau, who it is said was smitten by him) with his signature pattern paintings.

As with most artists, his work was shaped by the experiences of his own cosmopolitan life. His now-famous house on the Greek island of Hydra and his time spent in Venice, where he met and married Princess Adriana Marcello di Veneto, eventually surfaced in his work in the form of banners and his now well-known cypress trees, cut out of his signature pattern repeat.

Lured to Ireland by an invitation to participate in ROSC, Ireland's quadrennial contemporary art exhibition, Hennessy stayed on and for the first few years lived in extraordinary circumstances as the only resident, in a top-floor apartment, of Ireland's greatest country house, Castletown. It was because of his residency at Castletown that he discovered Prospect House which, as chance would have it, is situated en route between Dublin and Castletown. Intrigued by the setting of Prospect House, which from a distance resembles a view lifted straight from an 18th-century landscape painting, he acquired this modest Georgian gentleman's manor and set about the task of making it a home. Originally in a very poor state of repair, Timothy and his wife Isabelle, who used to work for the Parisian designer Marcel Rochas, restored and furnished the house in the simplest fashion, true to its Georgian heritage. Walls were painted white, the stairs were painted black and the floors were either stripped to bare boards or, in the hall, covered in black-and-white tiles.

But there is a great deal more to his creation of the interior than the application of a classic black-and-white colour scheme. While living in Ireland, Hennessy's art began to concern itself with the Irish nation's outstanding literary heritage and he incorporated his oeuvre into the very architecture of the house. And as artists are often able to do, he picked up on the real spirit of Georgian architecture and then

PREVIOUS PAGE (42)
AND OPPOSITE PAGE
When the artist Timothy Hennessy first came across Prospect House in County Kildare it was in a derelict state. The restoration was achieved with a simple but very effective use of black and white. A modern sense of classicism was created with an arrangement of black-painted

urns and white plaster plaques (made by the artist) set against simple geometric wall panelling and a traditional black-and-white tiled floor. This arrangement reflects the owner's belief that 'classic architecture is very much related to literature,' a conviction that became the driving theme of his art while resident in the house.

PREVIOUS PAGES (44–45)
Set in surrounding parkland reminiscent of an 18th-century landscape painting, the house fits perfectly the ideal of a modest Georgian gentleman's residence. Once owned by the Earl of Milltown, the estate was in its day a self-contained world, complete with its own dairy, stables and kitchen garden.

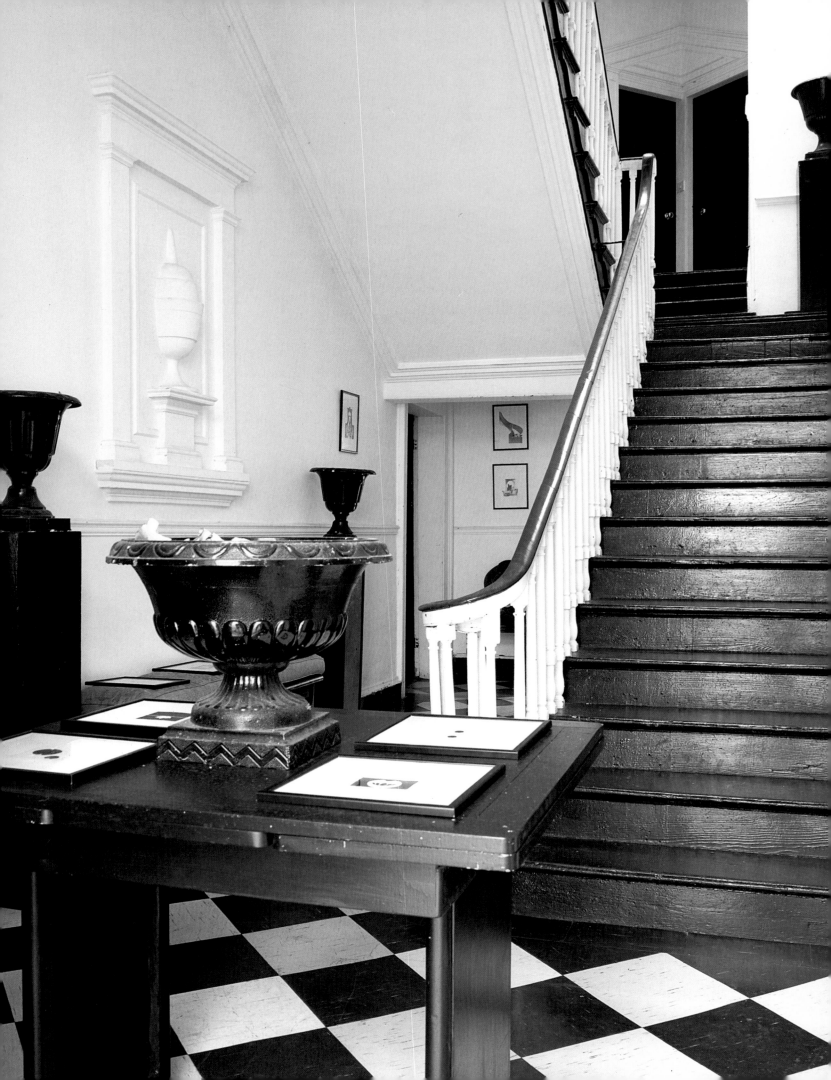

treated the house accordingly. As Marianne Heron observed in her book *In the Houses of Ireland*, 'the house reflects his views on art – that classic architecture is very much related to literature. There are many examples both seen and unseen of Hennessy's theory regarding literature.'

In step with Ireland's powerful literary tradition, Hennessy embellished the house with words. Strips and fragments of text from classics such as James Joyce's *Ulysses* are contained in urns and jars spread throughout the various rooms of the house: an expression of the belief that words have a life of their own, a separate existence in space and time. Words by Yeats are buried under the floorboards of the library, Proust and Joyce in the drawing room, Plutarch in the morning room and Aristotle in the kitchen. In a sense Hennessy renovated Prospect House to create what he felt was an appropriate environment for literature. In a country where Joyce still dominates the shelves of book shops and where most can recite the last paragraph of *The Dubliners*, this is very appropriate indeed.

Hennessy's art also focused on the tragic indifference towards Ireland's Georgian heritage. Hanging in the barn, a mammoth collage laments the four thousand or so Irish houses that have been lost – demolished, burned down or allowed to dilapidate beyond repair. Timothy Hennessy came to Ireland and saw this magical place through the eyes of an artist. He was captivated by Ireland's natural beauty and saddened by the inability of most of the people to see the great country houses as works of art. 'Castletown,' he said, 'is the Acropolis of Ireland, yet no one sees it that way … it is a kind of Emperor's clothes in reverse.'

OPPOSITE PAGE
The library of Prospect House is the artist's favourite room. Words by Yeats are buried beneath its black-and-white tiled floor, and it is furnished with a collection of Fortuny cushions (a reminder of Hennessy's tenure in Venice), velvet Fortuny curtains and an assortment of French Art Nouveau vases. This absorbingly unpredictable mix of family pieces, flea market finds and auction bargains is testament to Hennessy's belief that 'rooms are also a form of art: to be arranged as paintings are composed.'

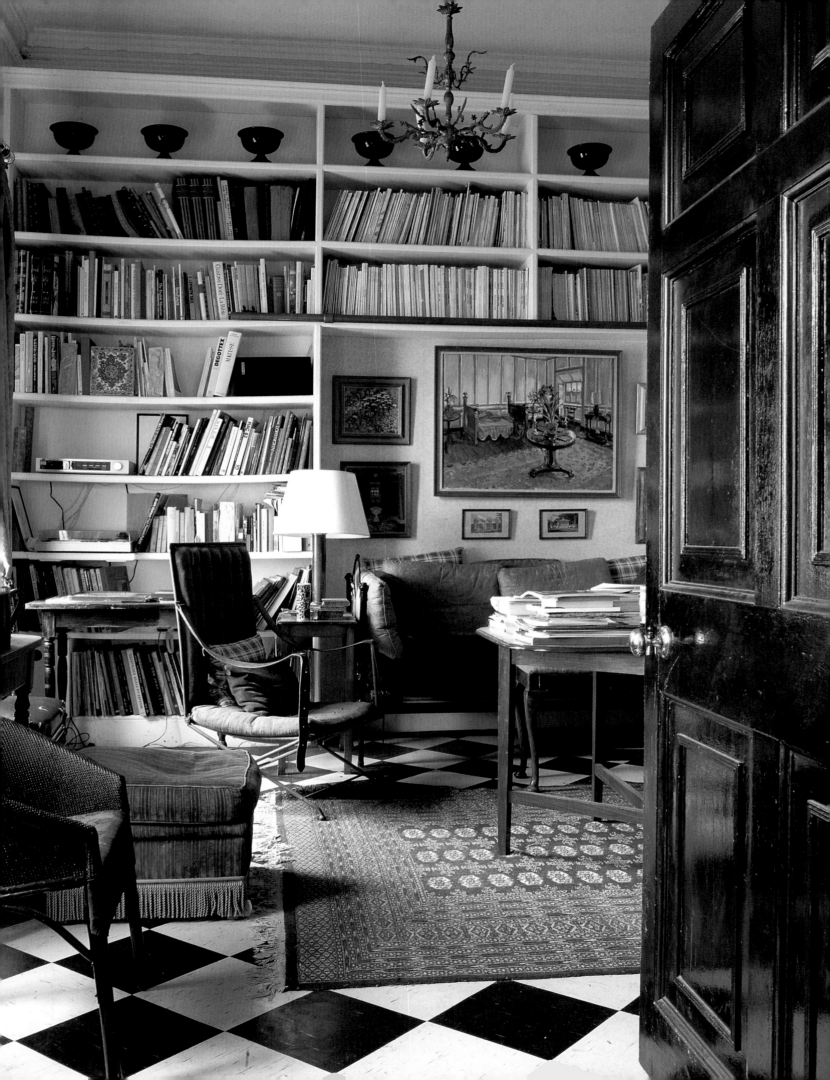

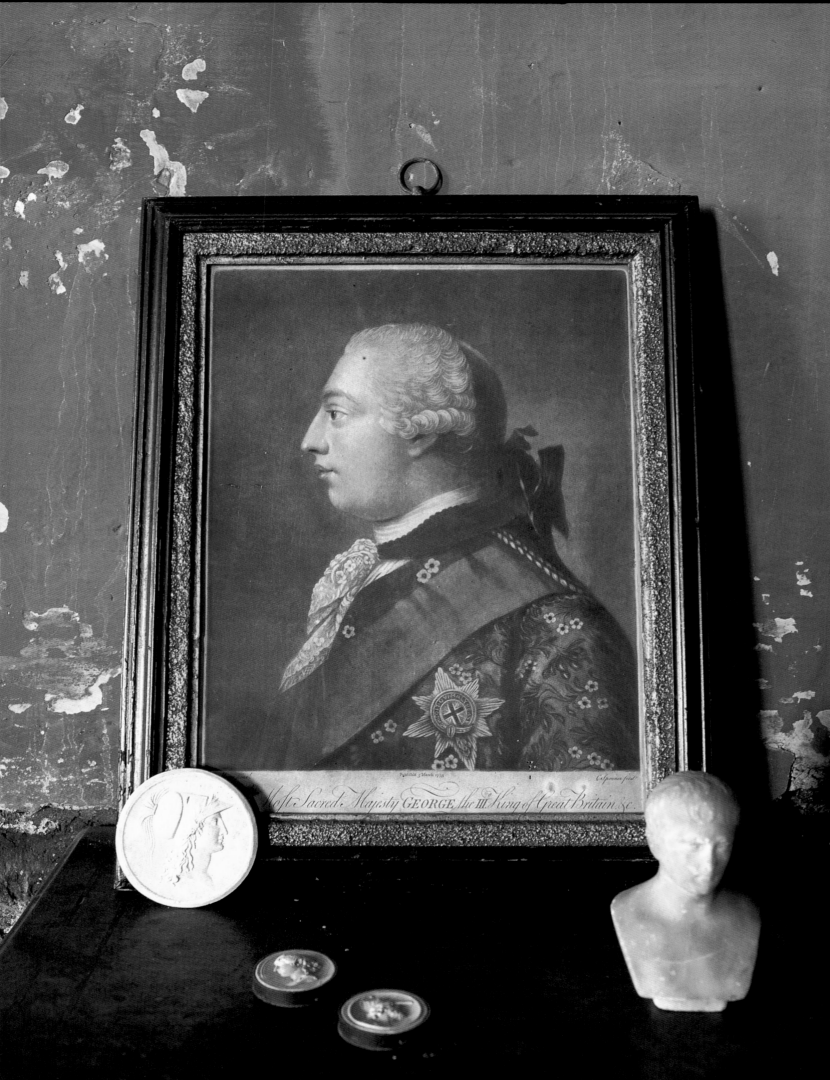

IRISH GEORGIAN
TOWNHOUSE

The 18th century in Ireland produced an unparalleled spate of building, both public and domestic. The Protestants were in the ascendant, having consolidated their claim to lands granted in the previous century by the English monarchy, and now began to venture away from the castle genre with its turrets and towers, daring for the first time to build dwellings that were not fortified. There was prosperity and confidence, and Ireland's capital began to involve itself in a long-running process of beautification.

Dublin, known as the Empire's second city, was distinguished not only by its growth and prosperity but also by its fine architecture. It was here, for instance, rather than in England, that the first Palladian-style public building was built. Designed by Edward Lovett Pearce and begun in 1729, Irish Parliament House is a monument to the quality that Dublin made its own in Georgian times. In fact, so impressively time-less was Pearce's design that one hundred years later Irish Parliament House would serve as the model for the design of the British Museum in London.

The city of Dublin may have been the seat of this new Palladian-style Parliament House, but Ireland's real power base remained rural. For the ruling class, the country estate was still the premier address in an era when a gentleman's rank and influence were measured by the size of his landed property. It was here, at the 'Big House', that most entertaining was done, and, in order to protect or further their own interests, most large landowners were involved in politics. When parliament was in session (the Irish parliament, independent until the Act of Union of 1801) they could be found in Dublin. The Irish country gentleman's need for accommodation in the city, therefore, was partly responsible for the beautification of Dublin. During the second half of the 18th century, known as the Irish Renaissance, townhouses sprang up piecemeal on beautiful Georgian boulevards (their proportions enforced by the Wide Streets Commission of 1757) largely as the result of property developers catering to influential families who wanted to be close to the centre of power. The resulting Georgian heart of the city, taking in such areas as Merrion Square and St Stephens Green, became a prestigious and sought-after address. But in those days, Henrietta Street, on the south bank of the River Liffey, was the most prestigious of them all, lined with enormous four-storey mansions built between 1720 and 1750 for bishops, earls and viscounts, and more the size of palaces than the term townhouse suggests.

These city dwellings, like their country counterparts, were designed to impress. Once again, extraordinary stucco work adorned the massive ceilings and walls and the very best of Irish craftsmen were employed to create magnificent floors, staircases, mantelpieces and furniture to complement the owners' collections of paintings, busts, tapestries and fine fabrics brought back from Paris, London and the Grand Tour. Like the country manor, although on a slightly smaller but still impressive scale, they also featured the peculiarly Irish Georgian signature of a flying staircase, which, predictably, would ascend a magnificent hall.

Life in these city houses, particularly for members of parliament, was dominated by formality. Comfort was entirely secondary. Entertaining was done during daylight hours and visitors' importance was reflected by the room in which they were received. As a general rule, the closer one came to the 'state' room (i.e. the master's bedroom), the more important one's standing in society. These rules followed closely the intrigue of the French and British courts of the day, with the bizarre conclusion that a visitor of the highest status would be received in the smallest room – the 'cabinet' or closet-bathroom attached to the state room. Hence the modern practice of referring to a prime minister's or president's closest aides as the 'cabinet'.

The passing of time, however, was not kind to Henrietta Street. With the Act of Union of 1801, the Irish Parliament ceased to exist, taking away the primary reason for the landed gentry to maintain sumptuous dwellings in the city. Thereafter, Dublin and Ireland went into a gradual economic decline that was further exacerbated by the Great Famine of 1845–49, which was responsible for the death of at least one and a half million Irish people, as well as the emigration to the United States of the same number again. Dublin did not see another period of economic growth until the dawning of the 20th century, by which time the pampered lifestyle of Ireland's wealthy landowners was a thing of the past. The great country houses and the elegant town-

PREVIOUS PAGE (50)
A portrait of King George III in formal dress. In reality, he preferred the attire of the country squire, earning him the nickname 'Farmer George'.

OPPOSITE PAGE
The library of this Georgian townhouse on Henrietta Street, Dublin, is the first in a series of interconnected, first-floor formal reception rooms. A black Kilkenny stone fireplace is the focal point of the room and the portrait of Archbishop Hort above the mantelpiece follows the tradition of Georgian times of placing either an oil portrait or a mirror above the fireplace. Untouched by any attempts at renovation, the patches of blue on the walls reveal the original 18th-century colour.

FOLLOWING PAGES (54–55)
Looking towards the main staircase, this view of the same library features a large portrait of Charles XII of Sweden wearing his plain soldier's uniform, a marble Grand Tour bust (a copy of a Roman original), and a set of 19th-century hand-coloured prints showing Austro-Hungarian heroes from the reign of Franz Josef.

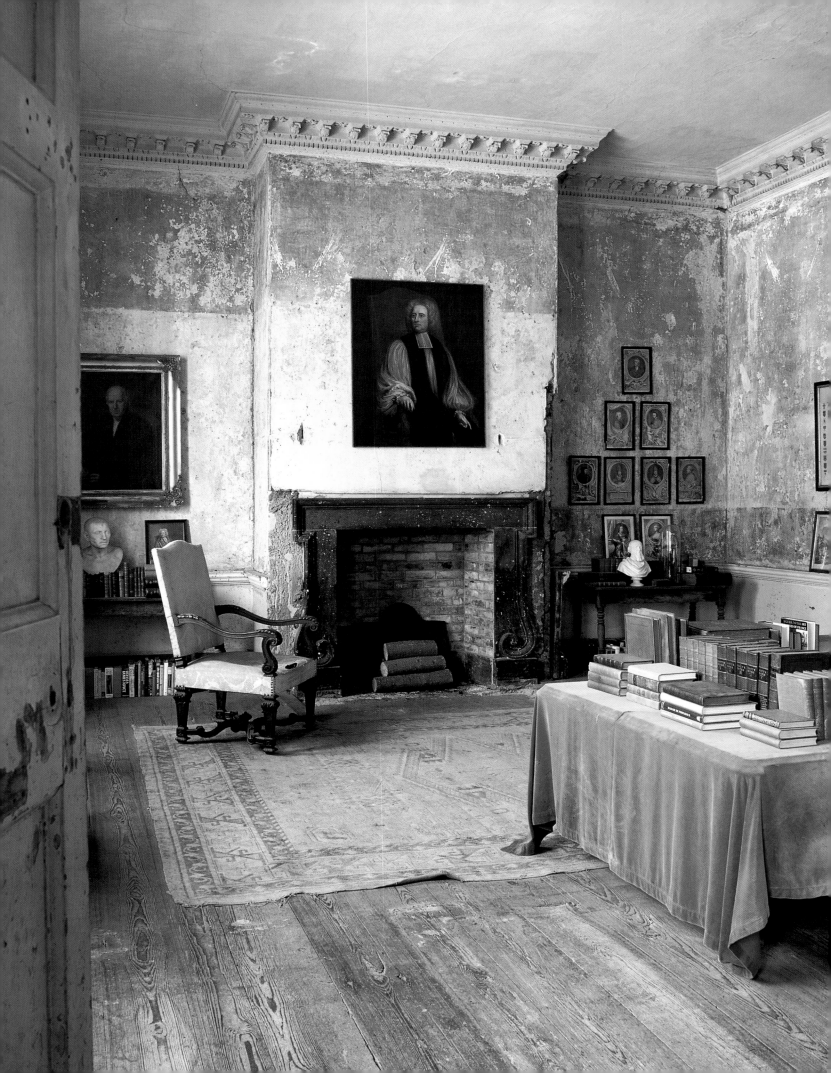

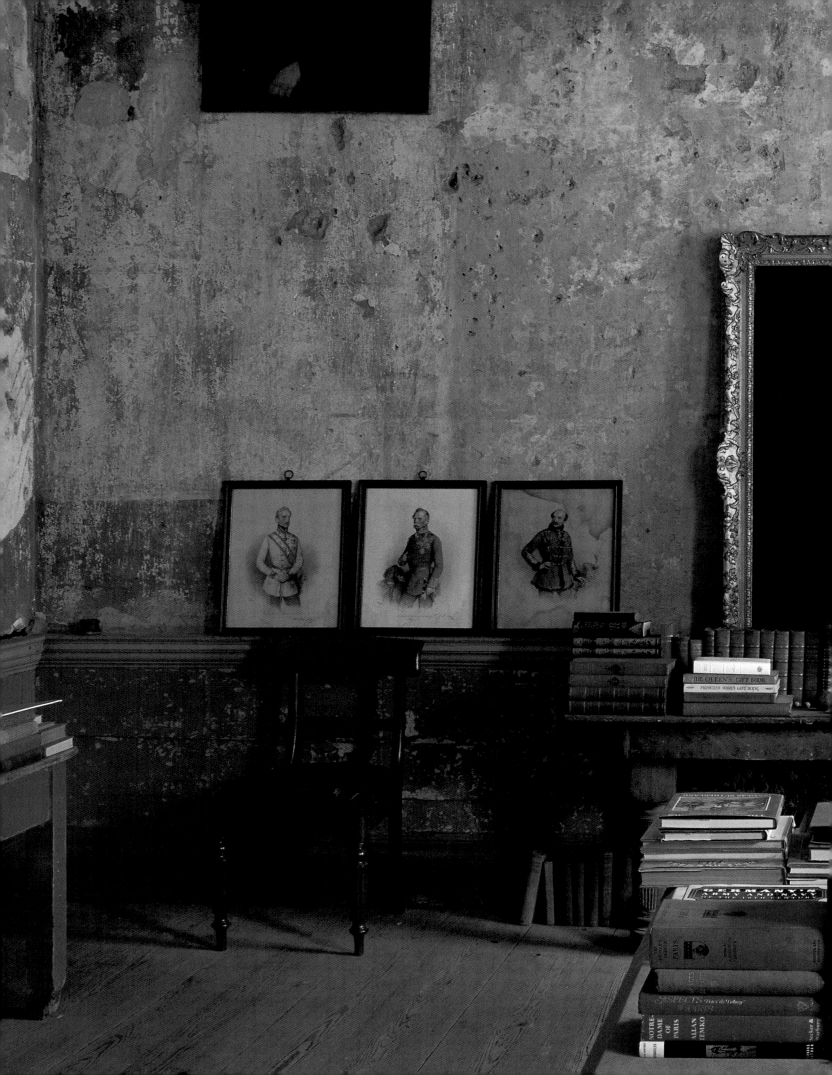

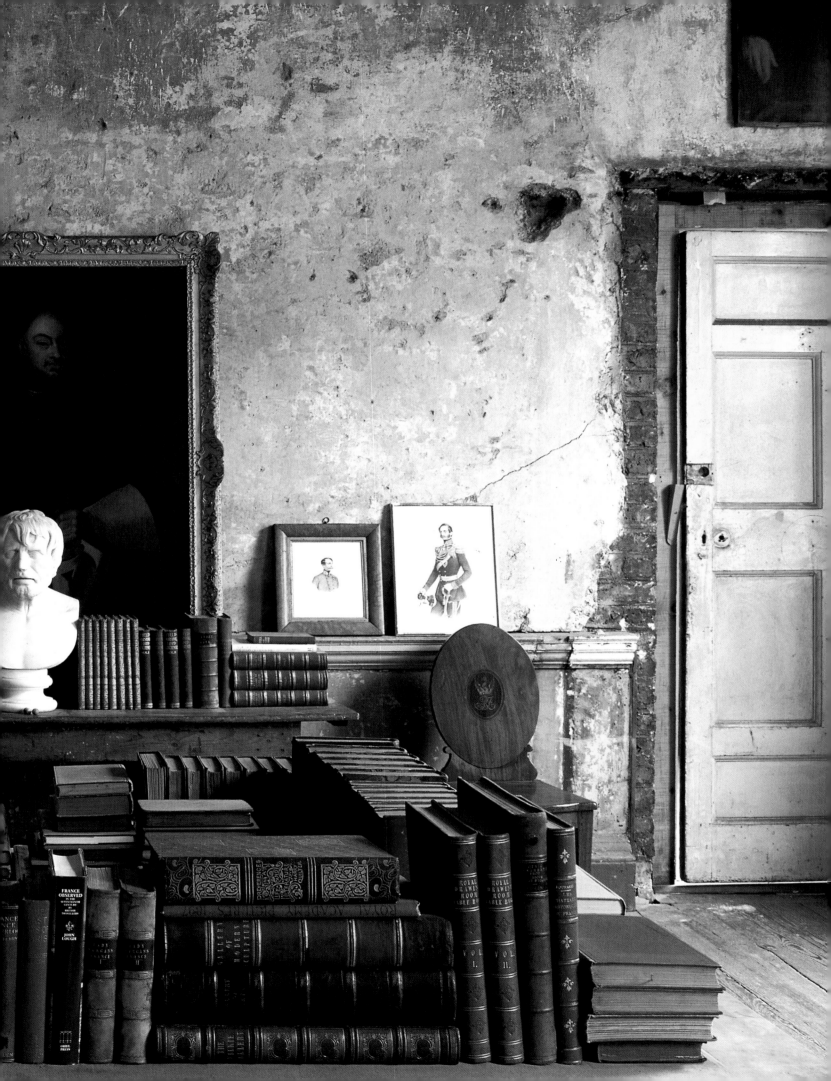

houses of Georgian times were no longer relevant in a newly democratic age, and the general antipathy of the population towards what they saw as symbols of oppression and servitude hastened the pace at which these architectural treasures disappeared.

By the late-19th century, the grand Georgian townhouse at 13 Henrietta Street had declined into a slum tenement. When Georgian enthusiast Michael Casey and his wife Aileen managed, with the help of the Irish Georgian Society, to buy the house in 1974, there were thirty-six families living in decaying conditions under one roof. Yet remarkably little damage had been done to the important architectural features. The ongoing restoration of the house is being undertaken according to the most historically correct agenda imaginable. Limited by budget and by the very scope of the task at hand, the work appears not to have progressed very much in the twenty plus years that the Casey family has been in residence. Yet as Michael Casey, a dedicated enthusiast of the culture of Ireland's Georgian period, points out, individual projects such as the building of an entirely new flying staircase, similar to the one at Castletown, are unimaginably labour-intensive and time-consuming. It is easy to forget that even in a time when this kind of house was the fashion, and all the finest craftsmen, from stone masons to stuccodores and highly specialized carpenters, were employed to build it, houses of this nature still took the better part of a decade to complete.

In a peculiar way, the present state of the house draws attention to the qualities that were most valued in Georgian times, namely those of the interior architecture. The volume, proportion and symmetry of the spaces are impressively grand despite needing to be painted, filled or rendered. Even though the staircase is unfinished, the staircase hall is breathtakingly grand. The lesson to be learned is one that Desmond and Mariga Guinness preached throughout their campaign to save Ireland's Georgian heritage (pages 146–56): it is quite possible to live in a historic house, even an unrenovated one, provided it is beautiful, as No. 13 Henrietta Street clearly is.

OPPOSITE PAGE

Clockwise from top left: a large plaster cast of Medici's Hermes taken from the 'antique'; a plaster bust of Tiberius inside a chimney piece fashioned from Portland stone; a marble bust from a 19th-century collection of Irish gentlemen in Roman dress on a black scagliola pedestal; and a plaster bust of Caesar, standing in the fireplace of the upstairs state bedroom.

FOLLOWING PAGE (58)

An early 18th-century portrait in an oval frame, a simple wooden chest from the St Michael & John's Burial Society, and a large plaster bust of George IV decorate the antechamber to the State Bedroom. The panelling dates the room to the early Georgian period; changing fashion had led panelling to be virtually abandoned by the middle of the 18th century.

FOLLOWING PAGE (59)

On a wall showing the original paint colour, this early 18th-century portrait is framed by the heavy curtains of the State Bed.

FOLLOWING PAGE (60)

To be received in the State Bedroom was an acknowledgment of a visitor's importance; only a private meeting in the smaller adjoining 'cabinet' was an indication of greater prestige.

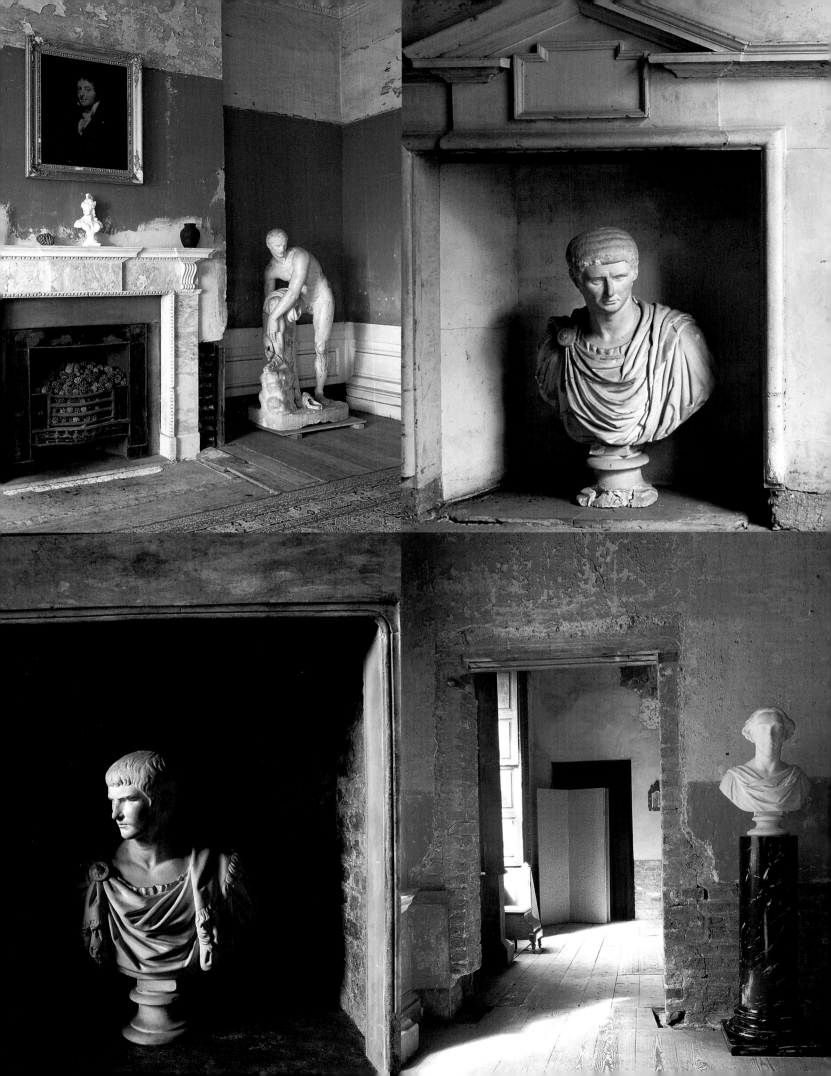

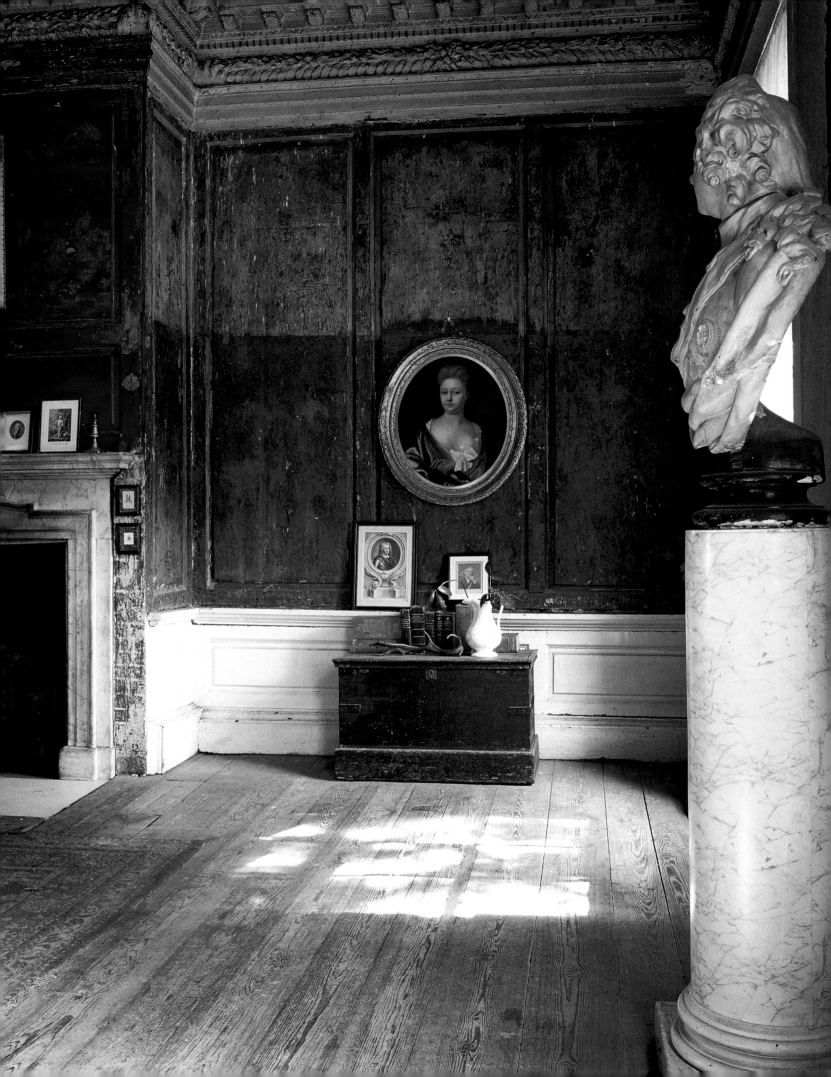

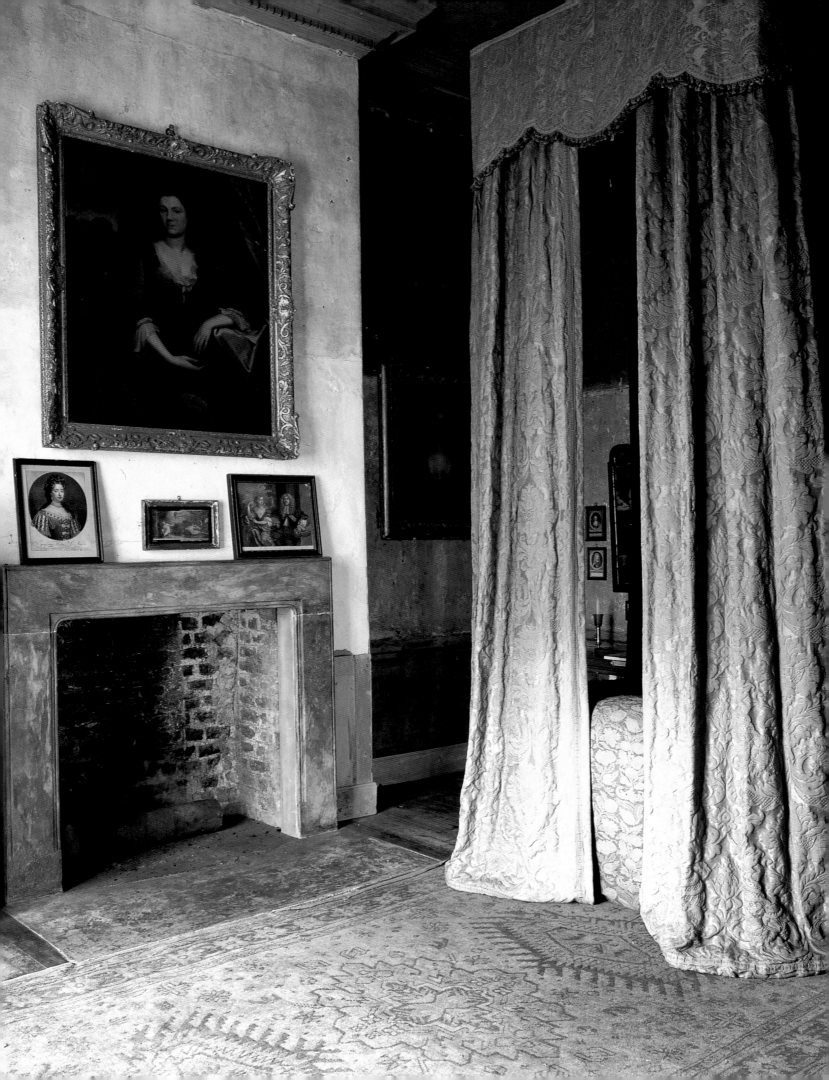

'But darling, what is plumbing!!'

Desmond Guinness, extolling the delights of living in a grand
Georgian house, even a dilapidated one

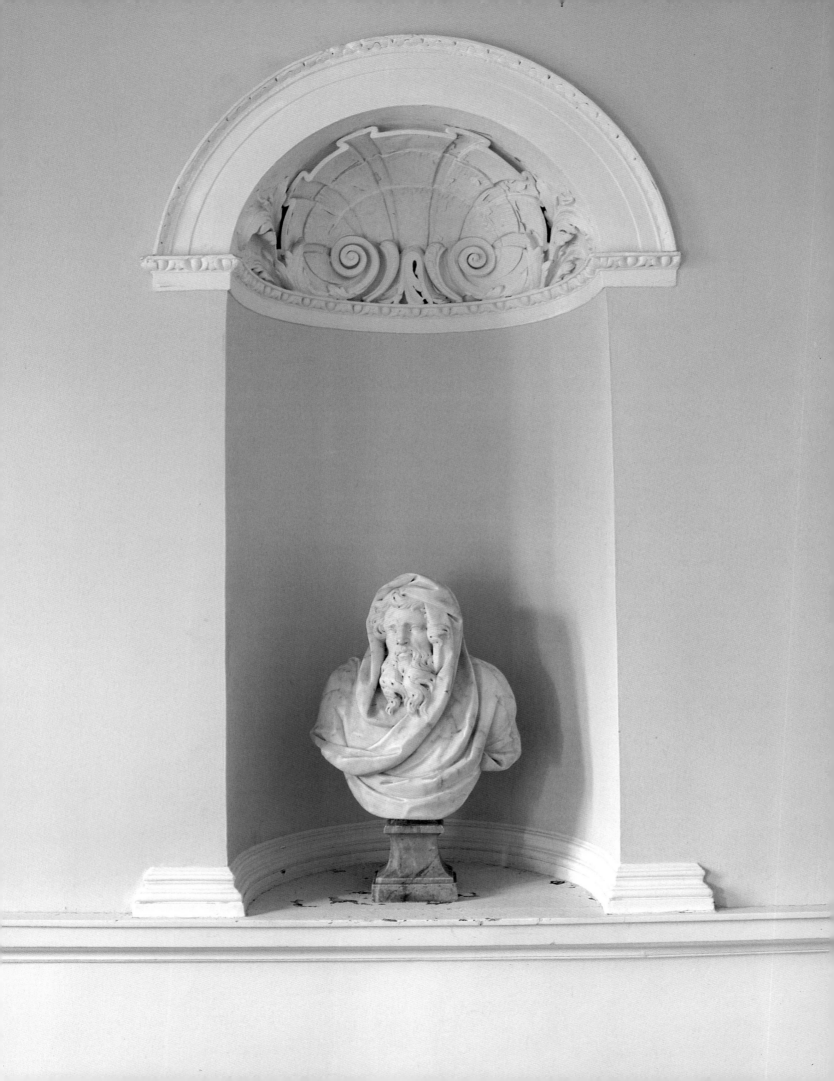

IRISH GEORGIAN

VILLA

The early Georgian villa played an important role in the history of Ireland's architecture. Its smaller and more affordable scale not only encouraged both architect and patron to adopt a more experimental and idealistic attitude, but the villa also established a model that would eventually provide an important link between the grand country house and the modern freestanding home.

The compact, freestanding mansion, however, was not a Georgian innovation. The villa was an established tradition of ancient Rome. Andrea Palladio interpreted this tradition, with its classical ideas of symmetrical planning and harmonious proportions, to create what was acknowledged as the 'mature villa'. The houses he built in the Veneto region of Italy, first brought to the attention of the English-speaking world by the publications of English architect Inigo Jones in the 17th century, became a kind of 18th-century Mecca for English gentlemen and architectural enthusiasts embarking on the Grand Tour.

One architect in particular so perfectly interpreted the lessons left behind by Palladio that he himself became the subject of intense academic interest. He was the Irishman Sir Edward Lovett Pearce. He worked with Galilei on the design of Castletown House (see pages 16–29), but it was elsewhere in Ireland that he would build the house often recognized as the purest interpretation of a Palladian villa outside the Veneto region itself. This house is Bellamont Forest in County Cavan, an architectural delight situated on a hill in an open space of forest surrounded by a succession of finger lakes. It is an exercise in purity and sheer excellence that has been lauded by some architectural experts as a refinement of the work of Palladio.

Enticed by the works of Palladio, Pearce went to Italy for long periods of study, where he was energetic not only in recording Palladio's villas but also in developing links between Italy and Ireland. He provided classical statuary for clients in Ireland and formed important ties with architectural colleagues such as Galilei in Rome, carrying drawings between Galilei (architect of Castletown) and Conolly (patron of Castletown). It is to these connections that modern-day critics such as Sean O'Reilly in *The Georgian Villa* attribute Pearce's deviations from Palladio's precedents. It was once assumed that any change made to Palladio's interpretation of the classical villa was simply the mistake of the local architect, but more in-depth study of the work of

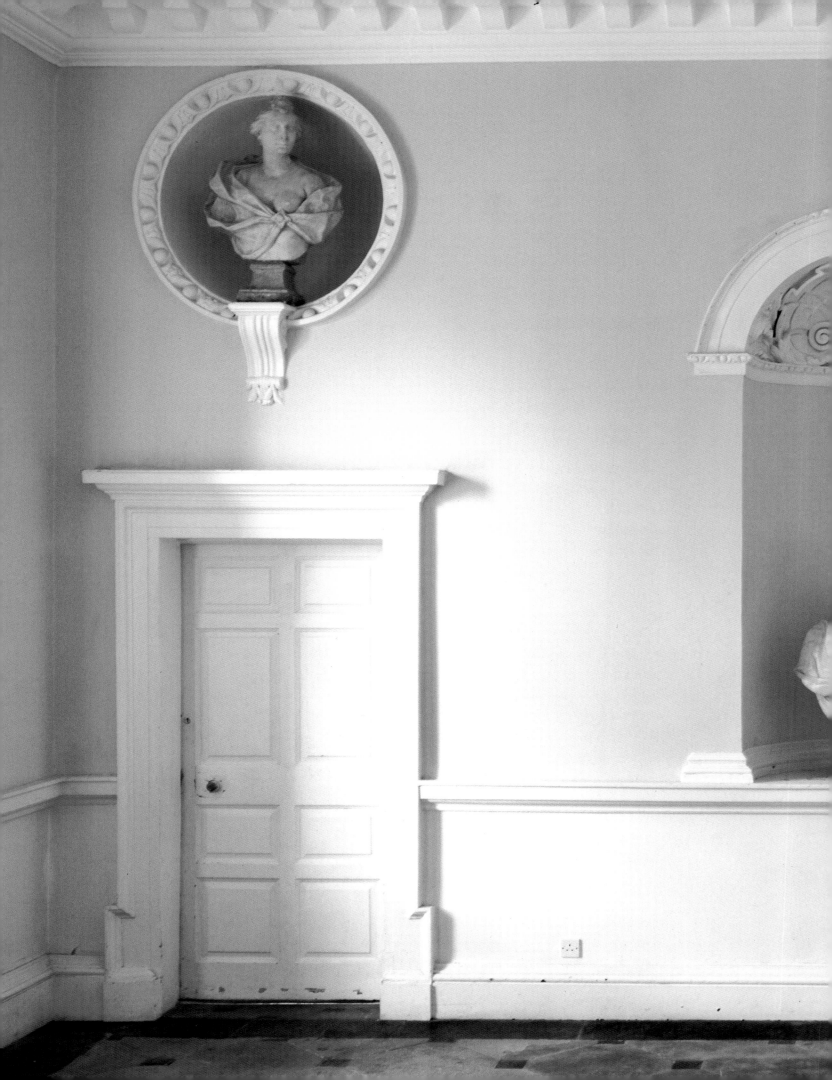

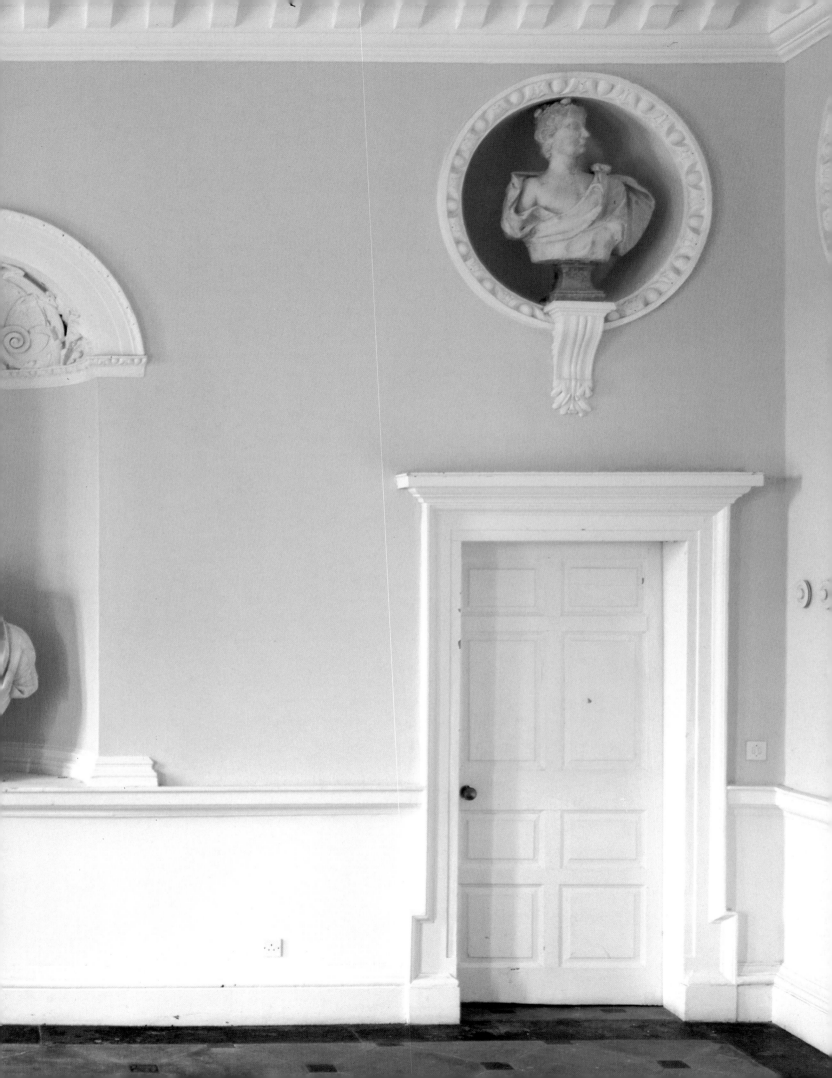

Pearce reveals that this was not the case. Through his own study of architecture in Rome (the Villa d'Este for instance) his knowledge and understanding broadened and he was able to bring back with him not just a thorough acquaintance with the work of Palladio, but also ideas of his own for the adaptation of classical architecture to a climate and country vastly different from Italy.

In this case the original beneficiary of Pearce's intellect and ideas was Thomas Coote, who had been Lord Justice of the King's Bench in Ireland in the 1690s, and who made the decision in the mid-1720s to build himself a fine house. It helped considerably of course that Edward Lovett Pearce happened to be his nephew. Drawing much of his inspiration from Palladio's Villa Rotonda at Vicenza as well as Palladio's Villa Pisani at Montagnana, Pearce designed the house for a forest site on the outskirts of Cootehill, a picturesque town founded by the Coote family in 1660. Unusually for the time, the house was created from fine bricks that have with age coloured to a soft earthy pink. Unlike many grand Irish Georgian houses, Bellamont Forest has managed to survive virtually intact. Its appearance today is almost exactly as it would have been two and a half centuries ago.

Perhaps the most fascinating aspect of the house is its extraordinary setting. From every vista, whichever way you look, there is nothing to suggest that you are in the 20th century: no power lines, no other buildings of any type, not even on the horizon, no highways or even any paved roads, least of all villages, schools or factories. Visiting Bellamont is like being on the vast film set of a Jane Austin dramatization. The only evidence of human presence is a perfectly proportioned, classically detailed, 18th-century Palladian villa. Here then is what must surely be one of the rarest opportunities left in Ireland – the chance to experience fully, without any 20th-century intrusions, an Irish country house in its authentic Georgian environment.

The house, true to the notion of a villa, is almost square in plan and much simpler than most of the Palladian mansions built in Ireland. Missing from view are the

PREVIOUS PAGE (62)
Positioned in a special niche in the walls of the entrance hall of Bellamont Forest, one of Ireland's finest Palladian villas, is a carved marble bust of Neptune in Roman dress, no doubt an acquisition made on the Grand Tour. It was customary in Georgian times to design the interiors of great country houses *specifically to accommodate and feature souvenirs brought back from the proprietor's Grand Tour.*

PREVIOUS PAGES (64–65)
The entrance hall of Bellamont Forest, decorated in subdued neutral tones, demonstrates the symmetry and proportion governing the style that came to be known *as Irish Palladianism. The space, with its traditional tiled stone floor, is almost unfurnished, as it was designed to be. The entrance hall was meant as a transitional space, and originally its only furniture would have been stiff, upright, uncomfortable hall chairs for the odd tradesman waiting to be shown what work was required.*

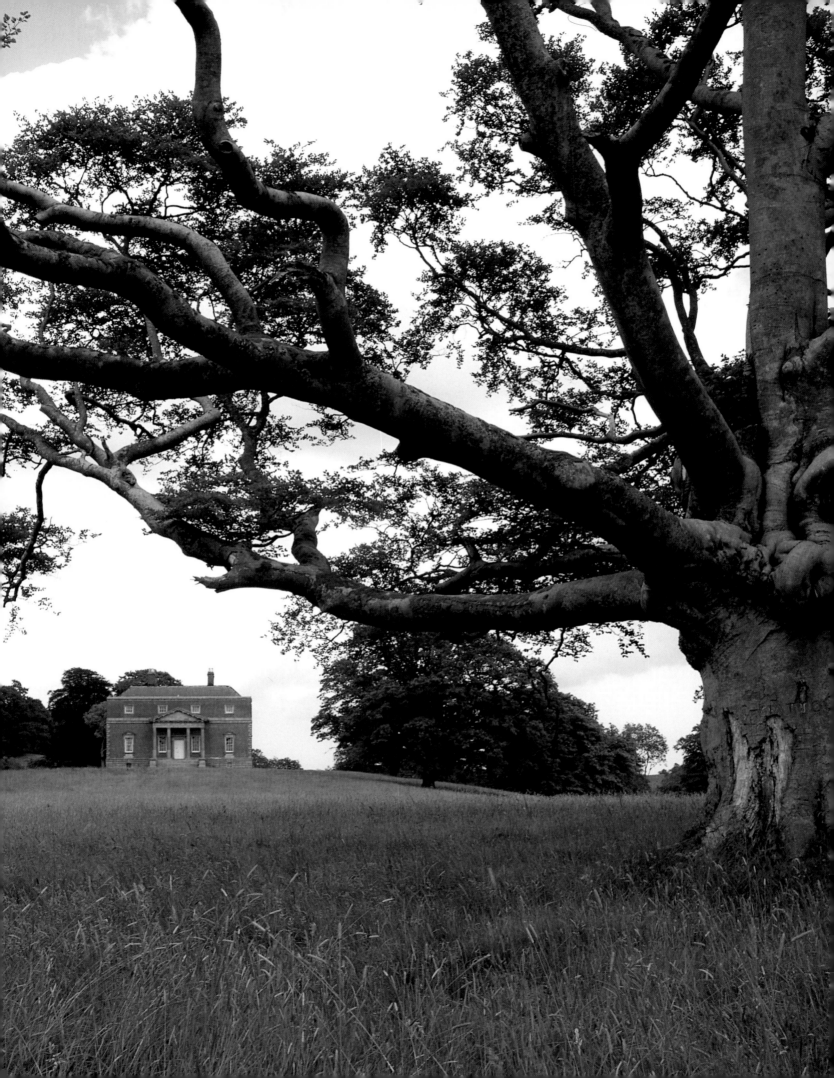

imposing side wings that normally housed the servants' quarters, the stables and often the kitchens. This is an elegant but puzzling omission. Surely such a confident and splendid house would never have done without these facilities? As it turns out, the stables, coach house, estate offices and servants' quarters are all hidden behind a hollow and connected to the house via an underground tunnel, ensuring that the daily routine of Georgian times did not disturb the splendid vistas from the house. The kitchen, as with Marino Casino, occupies the vaulted spaces of the basement.

The elegance of the exterior and the natural beauty of Bellamont's extraordinary location are an appropriate introduction to the interior. Exquisite detailing, grand proportions and spare decoration define a collection of spaces of such charisma that they require no additional adornment. Despite the fact that the villa, by the standards of many Irish country houses, is not particularly large, the architect cleverly used most of the available ceiling height for the ground floor entertaining areas and tucked the bedroom suites into an attic space just under the roof. The bedrooms are cosy, easily heated and of a more intimate nature, making the house, unlike most grand country houses, genuinely practical and comfortable to live in.

Over the past decade Bellamont Forest has experienced a return to its roots. Not only has the current owner – an interior architect of international repute – restored the interior spaces by stripping away all the inappropriate features added in the last century, he has also restored the house to its original lineage. John Coote, an Australian from Melbourne, is a descendant of the original Cootes who built Bellamont Forest and founded the village of Cootehill. On a chance visit in the late 1980s he dined with the then owner, who almost conspiratorially whispered that he was considering selling. John Coote wasted no time in acquiring the property and for the first time since the 1800s a Coote was once more in residence in the big house outside Cootehill.

PREVIOUS PAGE (67)
With its majestic hilltop setting overlooking a series of lakes and surrounded by impressively grand trees, Bellamont Forest is one of the most perfectly conceived Palladian villas outside Italy. Designed by Edward Lovett Pearce for Thomas Coote, it is an inspired exercise in symmetry, restraint and classical elegance, and is perhaps the *purest adaptation of Georgian classical ideals in all of the British Isles. It is also quite unique, for unlike other Irish Palladian country houses it is without the side wings that housed the servants and stables. In the case of Bellamont these are hidden behind the hill, out of sight of the house and connected to the basement via an elaborate tunnel.* OPPOSITE PAGE
The refined and restrained simplicity of the interior of Bellamont Forest has been brought out by an extensive renovation programme undertaken by the current owner, John Coote. All of the decorative excesses of the Victorian and Edwardian periods were carefully stripped away to reveal the purity of Pearce's original design.

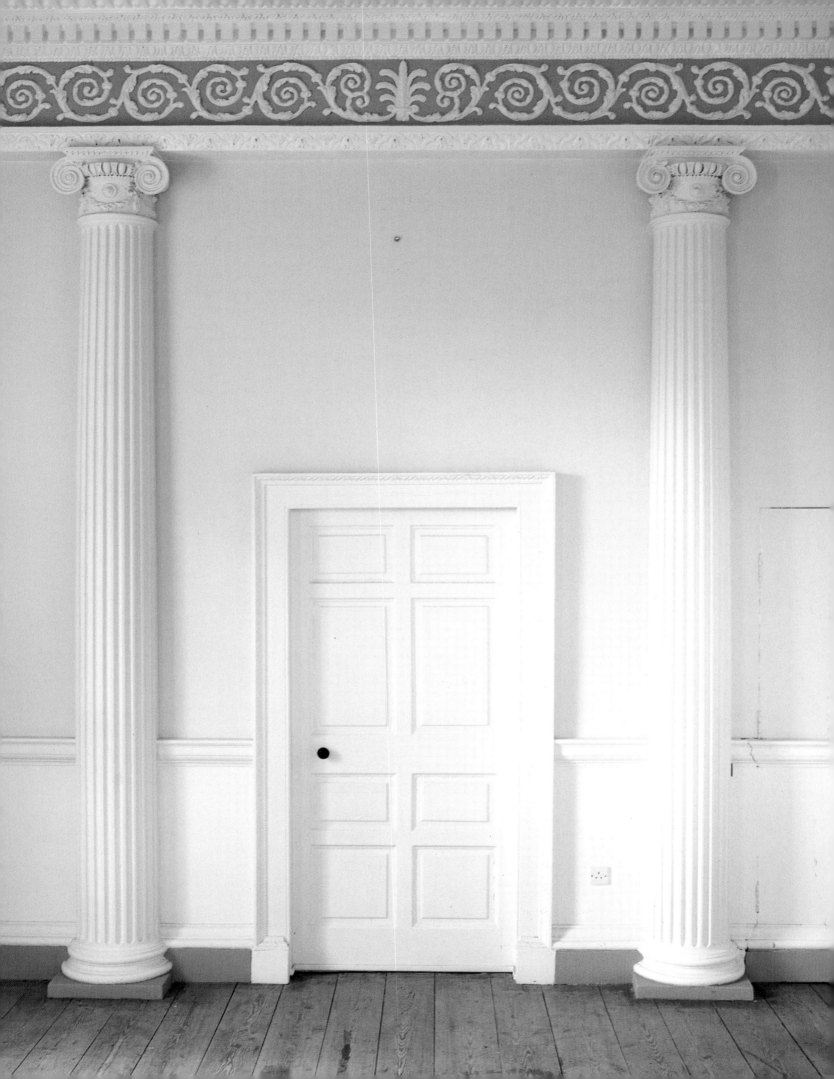

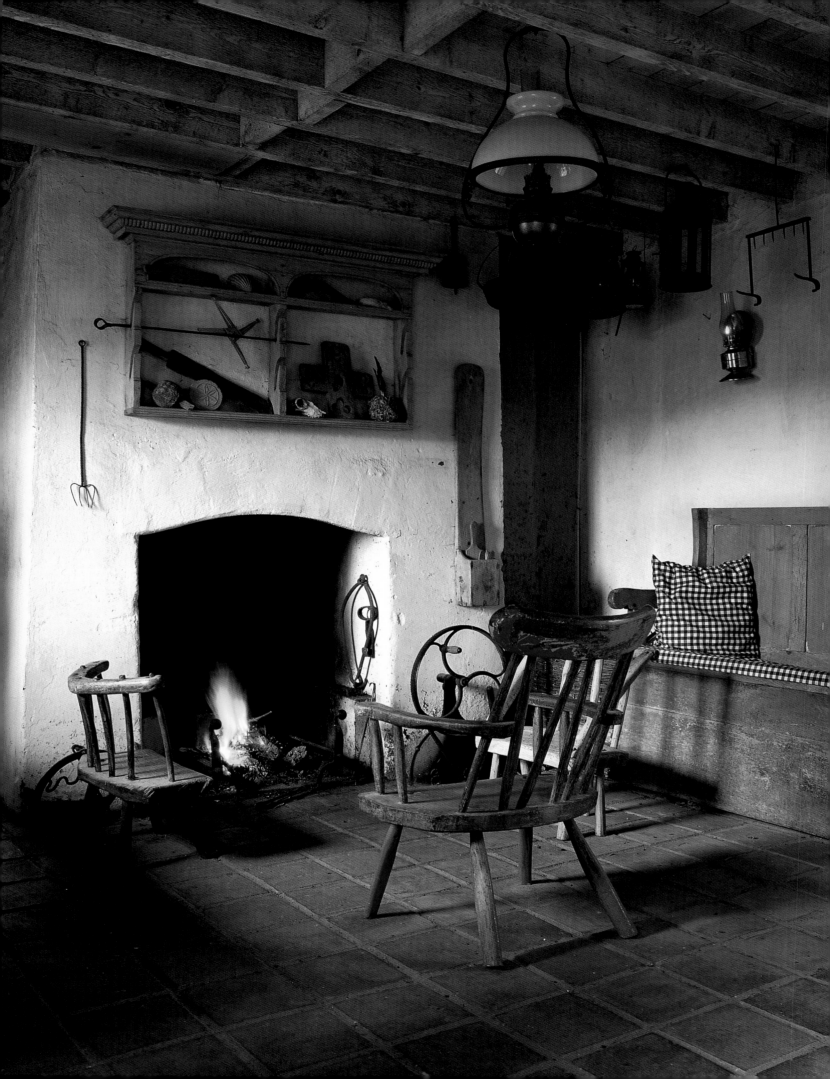

IRISH GEORGIAN
COTTAGE

Captivated by the impressive grandeur of Ireland's great country houses, it is easy to forget that the Georgian influence also extended to the humble cottage. Numerous sketchbooks existed containing plans of simple, symmetrical houses that were utilized by village craftsmen to build their own version of classically inspired architecture. The Georgian influence was in fact more democratic than might be imagined.

Even the great architects of the day concerned themselves with the study of more humble buildings. The provenance of architectural features was of great interest in the study of architecture, and it fascinated people such as Sir William Chambers, architect to the court of George III. Where indeed, he asked, did the habit of building with columns supported by a triangular pediment come from? This was a question that engaged the great minds of the day, and many, including Chambers, were convinced that it was a matter of evolution, that simple columns fashioned from felled trees and crudely constructed supports, perhaps shaped with an axe, eventually led to the refinements attained by the ancient Romans and Greeks.

Other famous architects paid more practical attention to the plight of the ordinary man. John Wood, for example, designer of the Royal Crescent in Bath, drafted plans for simple, affordable cottages in an effort to eradicate the foul and pestilent dwellings that the workers so often occupied. The first of such pattern books devoted entirely to workers' cottages was *Series of Plans for Cottages or Habitations of the Labourer*. Wood's simple cottages, some having only two rooms, were none the less remarkably classical. He insisted on regularity − regarded at the time as the equivalent of beauty − and he would even add blind windows and doors to create the impression of perfect symmetry. These cottages, limitations aside, were convenient and practical. And despite superstition that a south wind brought the plague, Wood also introduced south-facing windows so that the cottage would be warm, cheerful and comfortable.

The average Georgian cottage was of fairly standard layout. The house was the width of the rooms, with two rooms upstairs and two downstairs, located either side of a centrally placed staircase ascending from a corridor that was in line with the front door. This clever design provided a maximum number of clearly differentiated spaces and a source of natural light on at least two sides of each and every room. And from the exterior this plan resulted in a plain but pleasing façade of classical symmetry.

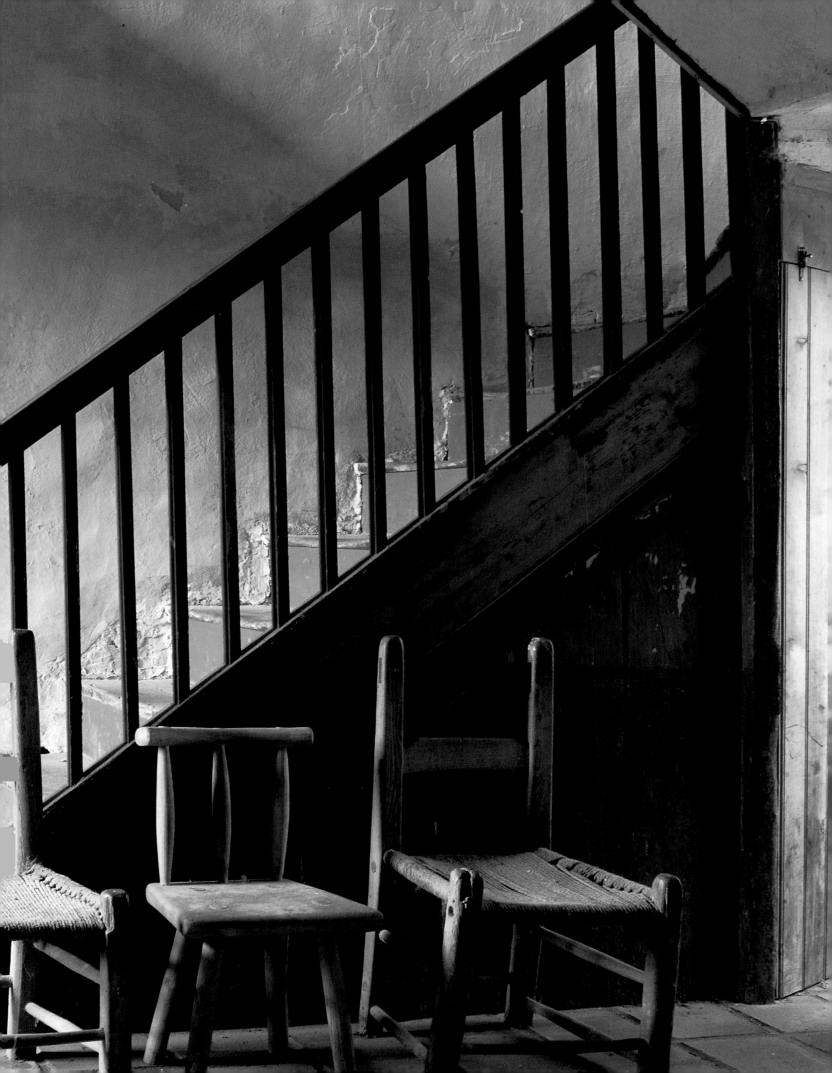

This is exactly the kind of cottage that Patrick Scott, a Dublin-based artist, discovered in the remote hills of County Wicklow. Built in the 1820s in local granite (the same stone that was used to construct Russborough House), it had stood abandoned for some time when he found it in 1963. On a small scale the cottage exemplifies all that is so attractive about the Irish Georgian style. In keeping with the Georgian tradition of allowing nature to complement the architecture, the setting makes the most of the spectacular surrounding countryside. The decoration of the interior is equally sympathetic to the architecture. Over the years Scott has built up a collection of Irish vernacular pieces, traditional ingredients of Irish rural life, to furnish this small farmhouse. At the time that he started to collect this Irish folk furniture it was considered valueless; now of course, the exact opposite is true. Patrick Scott's collection is irreplaceable and a testament to a way of life that has almost disappeared.

The crudely constructed 'hedge' chairs (so named because they were made by 'hedge carpenters'), scrubbed pine dressers filled with traditional blue-and-white spongeware and curtains fashioned from traditional blue-and-white checked horse blankets are of a character that complements the rugged, unadorned simplicity of the cottage. Walls have been whitewashed and the stairs, constructed of pine, are painted in a traditional red made from iron-oxide-rich earth mixed with linseed oil. Even the hearth in Patrick Scott's cottage has reasserted its position, instead of the television, as the centre of indoor life.

It must be stressed that this cottage, which the artist uses as a weekend retreat, was never intended as a faithful reconstruction of Ireland's past – it is simply a wonderful example of how this island's rich and colourful past can inform and enhance a thoroughly modern life. As Deborah Krasner, author of *Celtic Living in Scotland, Ireland and Wales*, comments, it is not surprising that more than one visitor has called this house 'the place in all the world I would most like to live'.

PREVIOUS PAGE (70)
The fireplace is the heart of the Irish cottage. A source of light as well as heat, it was here that all activity traditionally took place, including cooking. But where once most of the Irish population lived in these cottages, very few survive intact today. Perhaps it was never thought that these utilitarian structures might be worth saving. An exception is the cottage

owned by Dublin artist Patrick Scott – an unusually well-preserved example, complete with traditional open hearth.

PREVIOUS PAGES (72–73)
Symmetry and proportion, the predominant ingredients of grander Georgian architecture, were also brought to the simple cottage. The staircase leading from the front door of Patrick Scott's cottage divides the tiny

house perfectly in two, and its simple utilitarian construction forms the perfect backdrop for Scott's collection of Irish folk (or so-called 'famine') furniture.

OPPOSITE PAGE
Piercing draughts from between uncovered floorboards made the bedroom one of the coldest rooms in the house. Curtains around the bed were essential to keep out the winter chill.

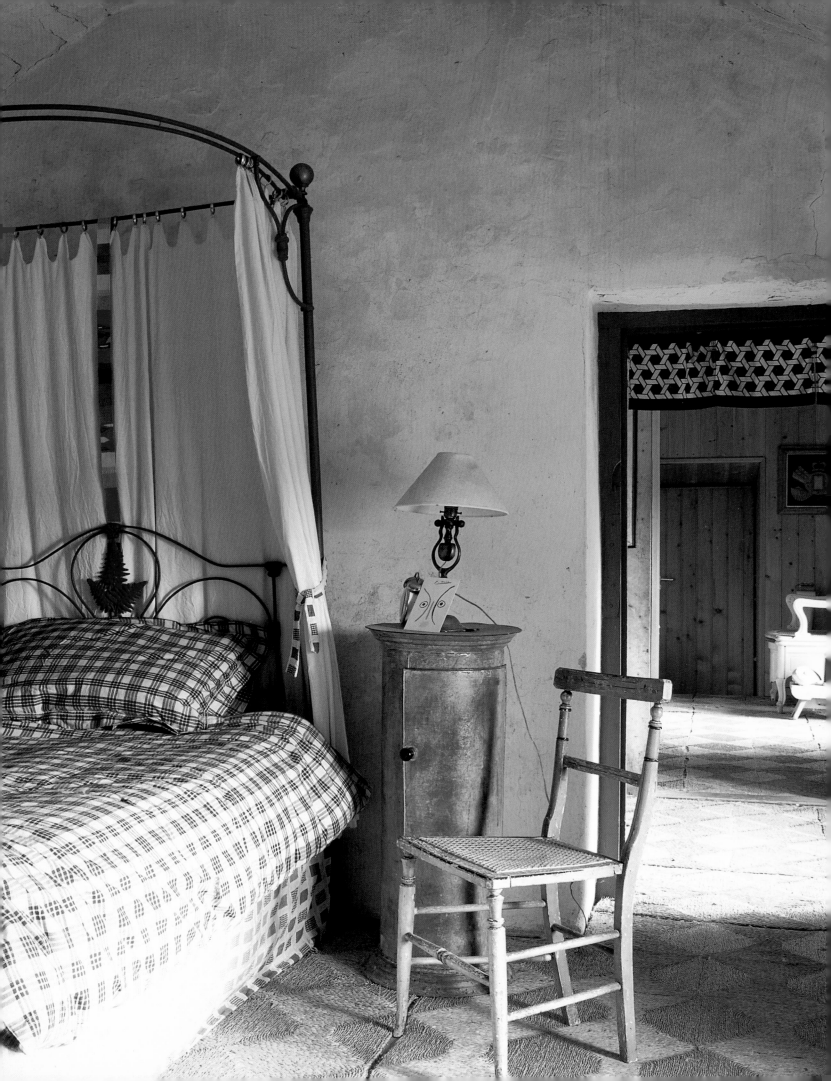

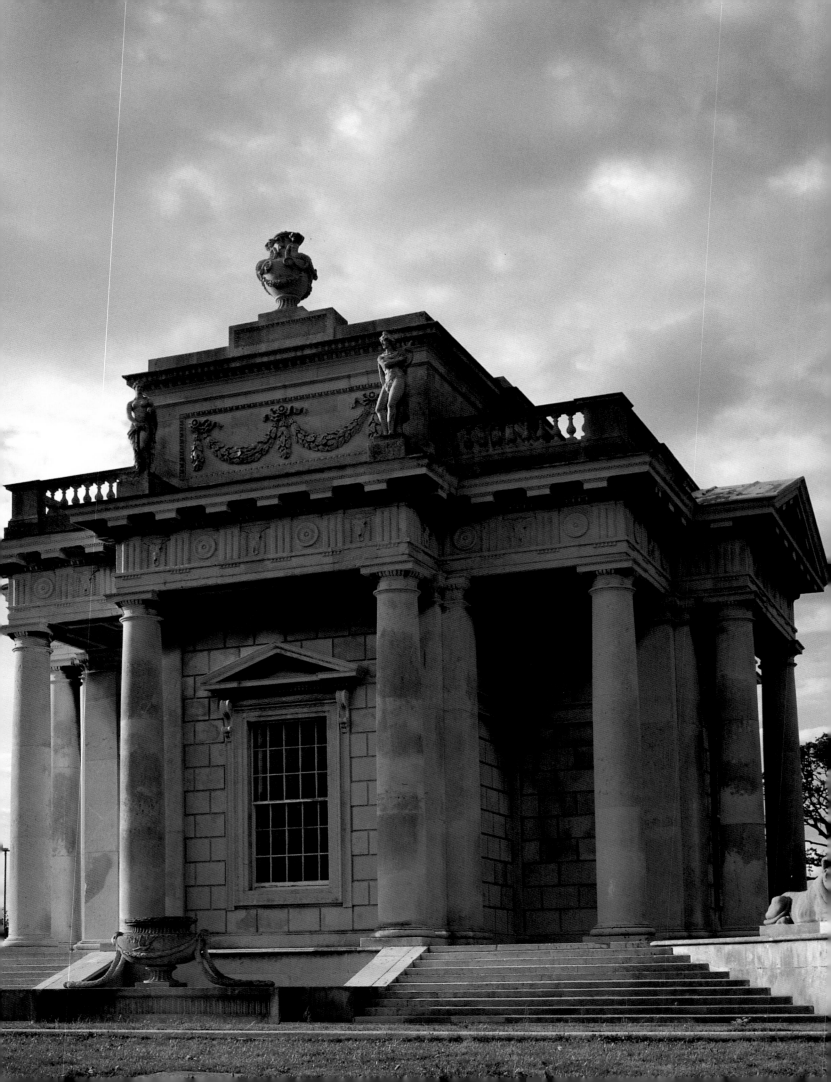

TEMPLE

Towards the latter part of the 18th century, new discoveries at Pompeii and Hercula-
neum − archaeological finds that provided a far more detailed insight into the lives,
art and architecture of the ancient Romans − fuelled enthusiasm for a new style that
borrowed directly and extensively from Roman and Greek prototypes and less so from
the designs of Palladio. Neoclassicism came about as a result of more careful study
and analysis of ancient Rome and Greece, and as a style it contained the right ingredi-
ents to connect the old with the new.

Perhaps the finest example of neoclassical architecture in Ireland, or indeed in all
of Europe, is a temple designed by Sir William Chambers for the Earl of Charlemont
in Marino, County Dublin. The temple was considered the queen of ornamental garden
architecture and any 18th-century architect took the opportunity to design one very
seriously indeed. Chambers was no exception. Like his client James Caulfield (the first
Earl of Charlemont, who had spent nine years of his life on the Grand Tour), Chambers
recognized that the temple stood at the very core of classical design. The Greeks as
well as the Romans had built them in all sizes and invested them with the highest
degree of perfection − they were, after all, symbolic dwelling places of the gods. In an
interesting twist on Palladio, who in the 16th century had first applied the façade of a
classical temple with all its columns and imposing pediment to a house, Chambers
built a house to look like a temple. Exactly why Casino, as the temple is known,
was commissioned is not entirely clear. But in view of the fact that, architecturally
speaking, the nearby Marino house was nothing special, it is perhaps most likely that
Marino Casino presented an opportunity for Caulfield to create something outstand-
ing without incurring the prohibitive expense of attempting the same quality on a
larger scale. Certainly the sumptuous decoration, including working fireplaces in
each room and a large, well-equipped kitchen, would suggest that the first Earl of
Charlemont intended it as a place to receive guests.

Constructed entirely of white Portland stone, the temple is far more complex and
original than its simple neoclassical structure would suggest. Innovation and ingenuity
are everywhere. Although, for instance, it gives the appearance of a grand, single-
storey structure, it is in fact an elaborate three-storey house. The basement level (a
collection of vaulted service rooms that include the kitchen) is not visible from the

exterior, yet it receives plenty of light from openings cleverly hidden behind a massive urn and underneath two staircases. Similarly, the windows of the second floor are well set back behind carved stone balustrades, making them invisible from the exterior. The magic of the illusion continues with the urns that decorate the top of the building, for these are actually chimney pots. Even rainwater drainage is carried away by downpipes concealed within two of the twelve Doric columns.

But the most impressive of all Chambers's illusions at Marino are the 'remarkable shrinking windows'. In order to bring the windows on the inside of the temple into line with the plan and scale of the rooms, Chambers blocked out sections of the overall window dimension (something that is not visible from the outside) with cleverly placed internal walls. As a result, the exterior of the temple benefits from generous and appropriately scaled windows, while the same windows on the inside are of a size more suited to the congenial scale of the rooms. Another 18th-century gadget invented by Chambers for Marino Casino is a substantial sash window hidden above the only entrance. Once the door was open, the window would come down, ensuring privacy but still letting natural light in.

Judging from the copious correspondence exchanged between architect and client over the ten-year period that it took to complete Marino Casino (completed 1769) the process of designing and building was evidently enjoyed by both. Yet sadly Chambers never saw one of his greatest creations, since he never made it to Ireland.

PREVIOUS PAGE (76)
Marino Casino, designed for the Earl of Charlemont by Sir William Chambers, is perhaps the finest example of pure neoclassical architecture in the world. Originally conceived as ornamental garden architecture in the form of a temple, it cleverly disguises an elaborate three-storey interior.

OPPOSITE PAGE
Under construction for more than a decade, the purpose of the temple is clear from the detail lavished on its interior. From the sculpted marble fireplaces to the inlaid marquetry of the parquet floor, no expense

was spared. Marino House, just five hundred yards away, was architecturally speaking nothing special. Marino Casino was built to enable the Earl to entertain in the style expected of a gentleman of his standing, but on an affordable scale.

FOLLOWING PAGES (80–81)
The architect William Chambers used cleverly placed neoclassical shapes to maintain the illusion of a classical garden temple, disguising the fact that the building actually has three storeys. Skylights bringing light to the kitchen (see page 125), which is situated in the vaulted spaces of the basement, are

cleverly hidden behind this massive stone urn carved by Simon Vierpyl, the same stonemason who created the flying staircase at Castletown House (see page 21).

FOLLOWING PAGE (82)
The second-floor bedroom, the only one in Marino Casino, is positioned in the middle of the structure, with its windows sufficiently set back not be visible from the outside. The illusion of the classical temple is reinforced by the neoclassical stone balustrade that encircles the perimeter of the top of the building and disguises the windows on the second floor (see page 76).

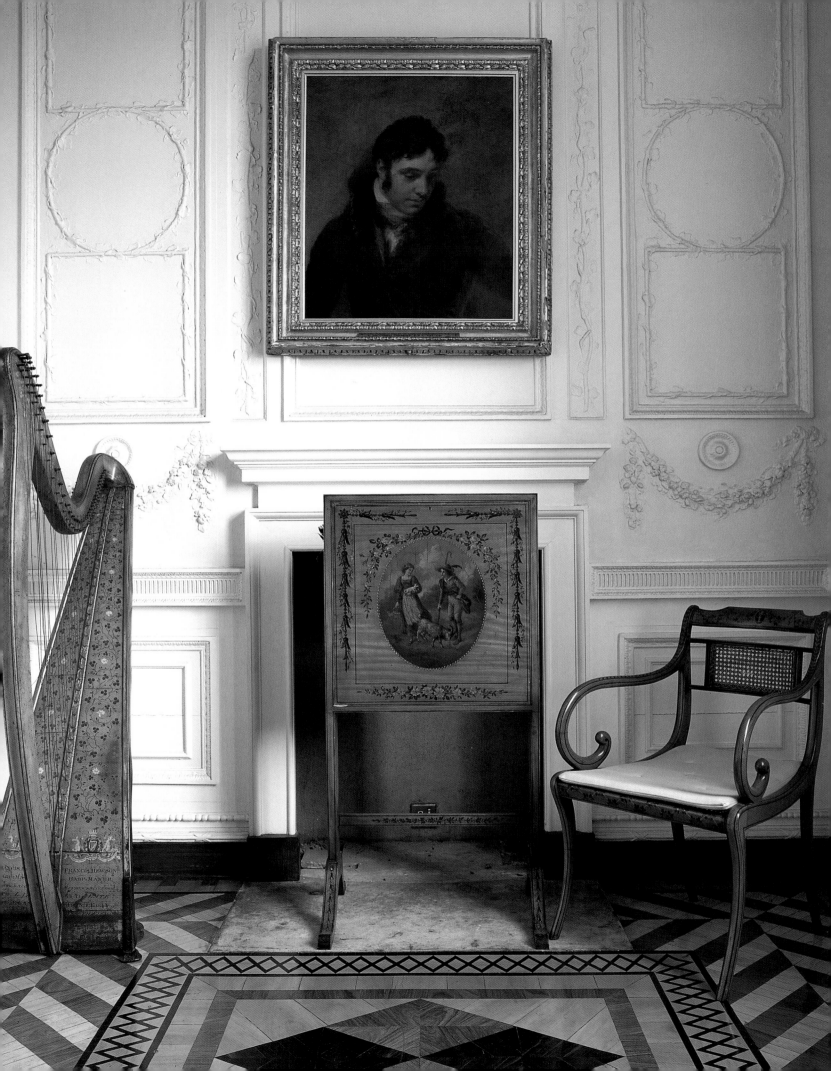

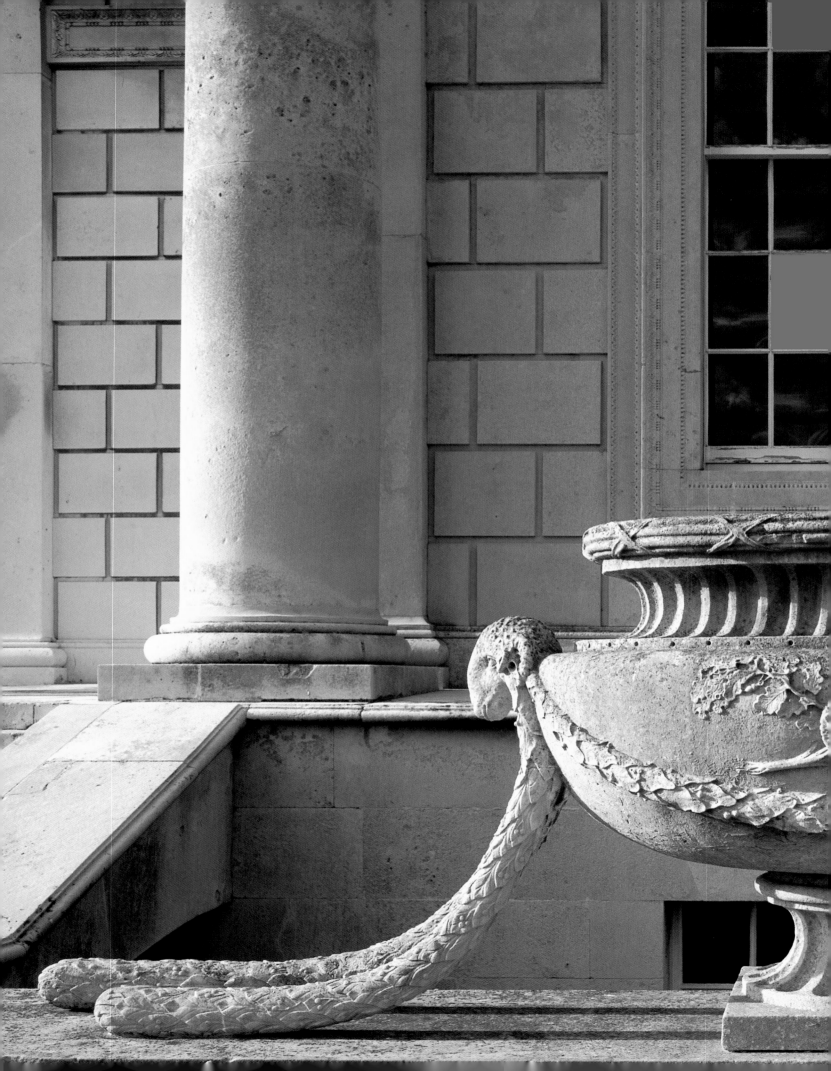

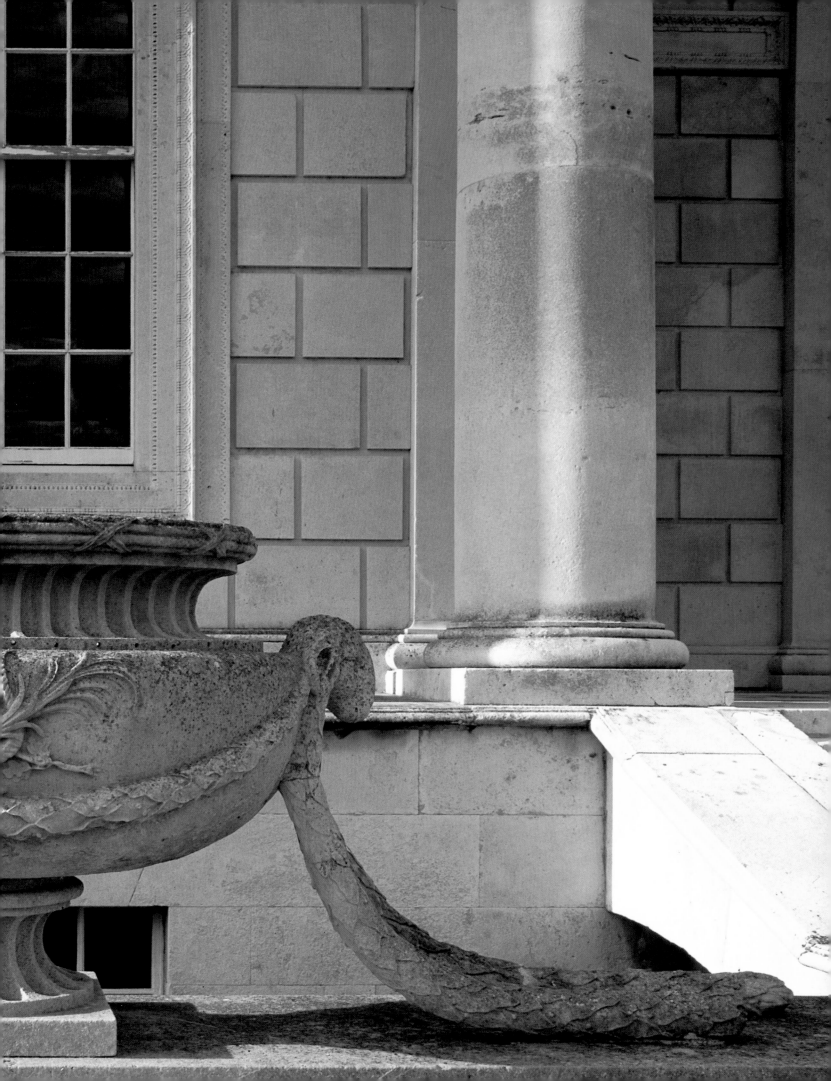

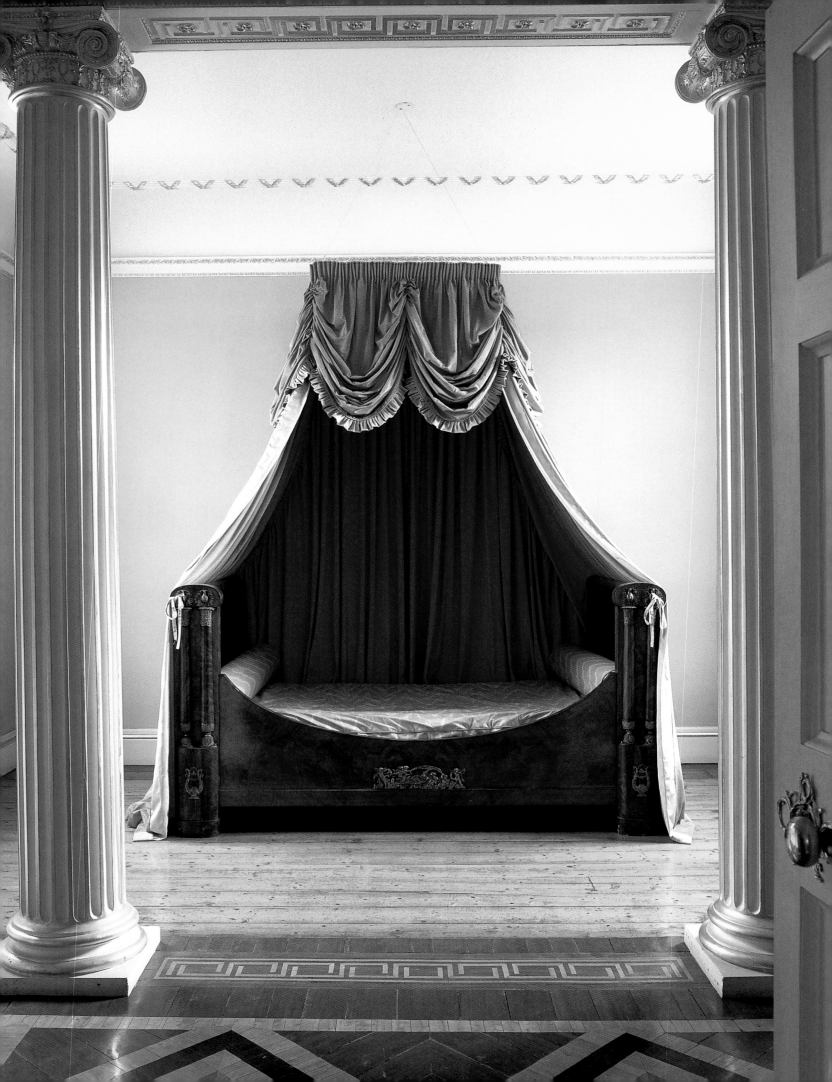

'The enduring success of garden temples may simply be the outstanding effect achieved by placing a beautiful object in a natural setting.'

The Poetics of Space, Gaston Bachelard

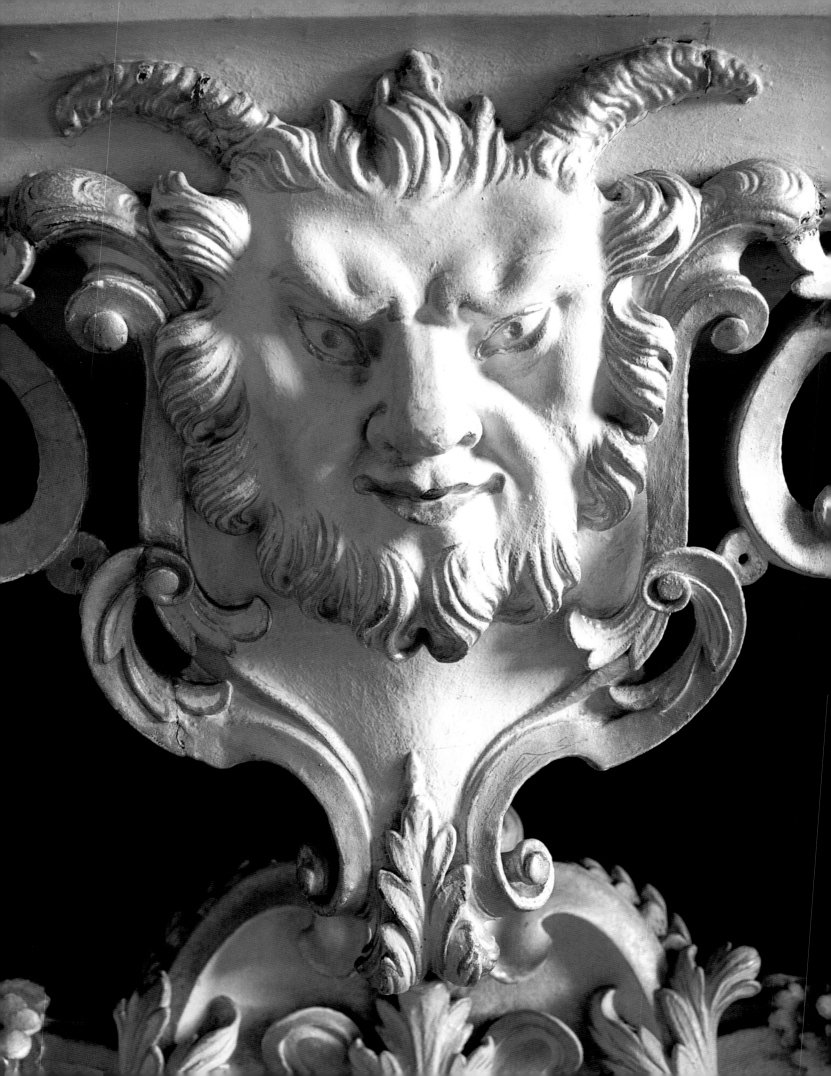

GEORGIAN

BAROQUE

The baroque, a style that originated in Rome in 1620 and reached England in the 1670s, was concerned with the ability of 'the inner parts of houses' to 'induce sensation'. The very essence of baroque was the desire to impress, to exaggerate, to surprise, and even to shock, by means of extravagance, complexity, illusion and scale.

According to conventional chronologies, baroque splendour had a short-lived influence in the British Isles. It was a style associated with the last of the Jacobite monarchs (James II and Queen Anne) and thus with absolutism and the worst of royal pretension. The commencement of the Hanoverian era with the reign of George I has therefore conveniently been seen to mark the termination of the baroque period. In reality, however, not only is there significant overlap, with the baroque influence lasting into the mid-18th century, but there is also the simple fact that the desire to impress, surely one of the most human of desires, can never really be out of fashion. With the benefit of hindsight it becomes clear that in Georgian times the supposedly opposing qualities of extravagance and restraint often coexisted quite handsomely. This is why the seemingly contradictory term 'Georgian baroque' is such a perfect description of Russborough House in County Wicklow, whose powerful combination of strict Palladian architecture with a splendid baroque interior make this one of the finest of Ireland's grand country estates.

The building of Russborough House was instigated by Joseph Leeson, first Earl of Milltown, upon inheriting his father's beer-brewing fortune in 1741. For the task of designing a great house that would mirror his status (in a similar manner to William Conolly's Castletown, pages 16–29) he sought out the services of Richard Castle, one of Ireland's pre-eminent classical architects and a student of Edward Lovett Pearce. Castle, who also had the good fortune to inherit Pearce's practice, set about creating a Palladian treasure that is now recognized as one of the finest classically inspired country houses anywhere in the world. Built in a local silver-grey granite, its majestic setting, true to the very Georgian principle of utilizing nature to enhance architecture, gives the impression of 'a gigantic bracelet laid across a landscape of mountains, lakes, woods and wide open skies.' The drama of its picturesque backdrop in County Wicklow and the imposing stature of its façade, free from the distraction of too many decorative frills, set the scene for what is to come.

Joseph Leeson was a formidable collector of beauty, and no expense was spared in the creation of an interior at Russborough House that would provide a suitable environment for the valuable paintings, tapestries and furniture accumulated by this first Earl of Milltown. His art collection was, in fact, so important that when it was finally bequeathed by the sixth Earl of Milltown to the National Gallery of Ireland in 1902, a new wing was built to contain it. Inside and out, Russborough House has led a remarkably charmed existence. Despite the numerous political upheavals and resulting destruction of aristocrats' property in Ireland over the past two centuries, Russborough has survived intact and, importantly, unaltered. The interior, too, has had the incredible good fortune of seeing one extraordinary collection replaced by another. Russborough was acquired in 1952 by Sir Alfred Beit, owner of one of the world's most outstanding private art collections. Walls are now lined with Dutch, Flemish and Spanish Old Masters, including Rembrandt and Velasquez and, until its recent donation to the National Gallery, a Vermeer. Room after room is enhanced by remarkable furniture and pieces as priceless as they are diverse. An English State Bed made in London in 1759, an 18th-century Soho tapestry by Vanderbank and Marie Antoinette's microscope are among the countless historical treasures that are displayed against a backdrop of 'wild plasterwork ceilings, fantasy frames of oval shapes mounted on walls surrounded by clusters of fruit and billowing plant forms.' As John Fitzmaurice Mills, an authority on the fine arts of Ireland observes, 'at Russborough the Baroque spirit is everywhere.'

PREVIOUS PAGE (84)
The grotesque face of Pan was a popular decorative device, particularly for furniture in the baroque style. Long after the baroque influence had (supposedly) fallen from favour in the British Isles, famous Georgian designers such as William Kent were creating elaborately extravagant furniture – all gold leaf, carving and red brocade – to decorate the interiors of grand Palladian houses such as Russborough House in County Wicklow, which combines strict Palladian architecture with a sumptuous baroque interior.

OPPOSITE PAGE
Designed by Richard Castle to bring light to the top floor gallery on to the bedrooms, this oval skylight was no doubt a homage to his teacher Edward Lovett Pearce, who created an almost identical fanlight for the top gallery of Bellamont Forest.

FOLLOWING PAGES (88–89)
Distinguished by their rich Genoese velvet, the walls of the saloon at Russborough House feature a pair of candelabra by Falconet and an 18th-century English mirror. The paintings are by Dutch and Flemish mas-

ters of the 16th and 17th centuries. The colour is an unusual choice: red, in Georgian times, was the colour designated for dining rooms and libraries.

FOLLOWING PAGE (90)
Four splendid marine scenes painted by Claude-Joseph Vernet (1714–89), set into elaborate plaster mouldings most likely executed by the Francini brothers, are the focal point of the drawing room. Sir Alfred Beit instigated a worldwide search to find these missing paintings when he purchased Russborough House in 1952.

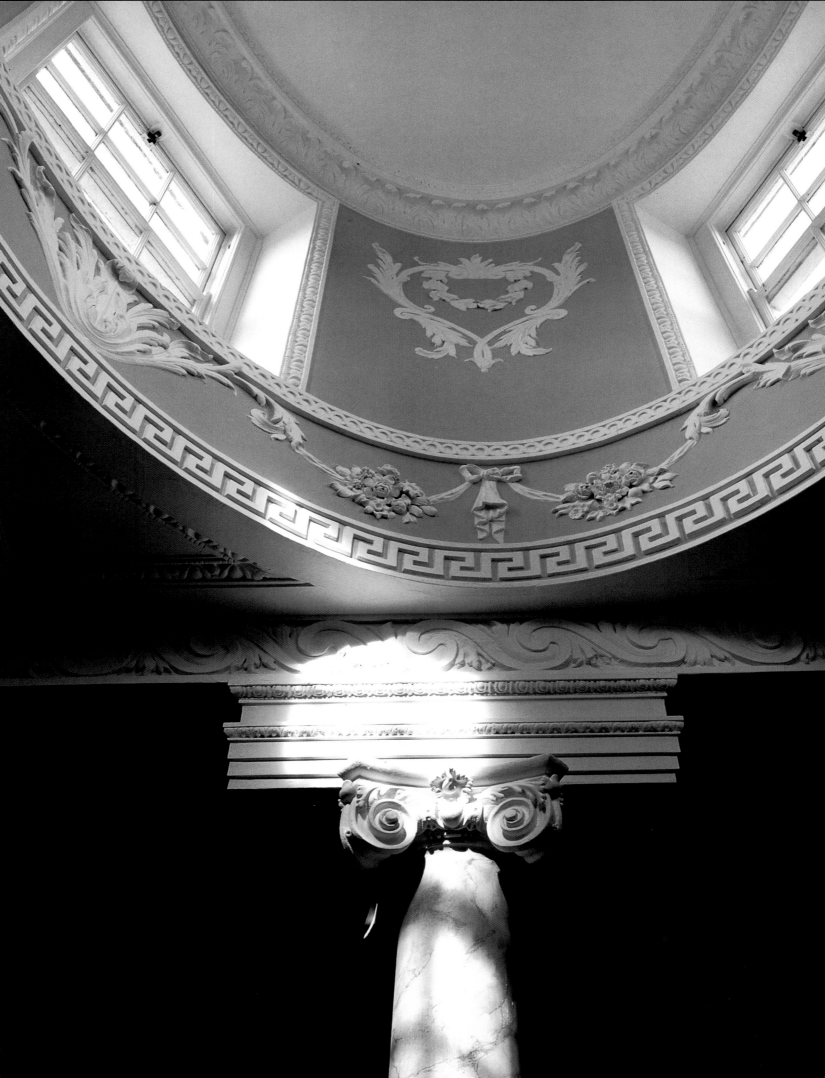

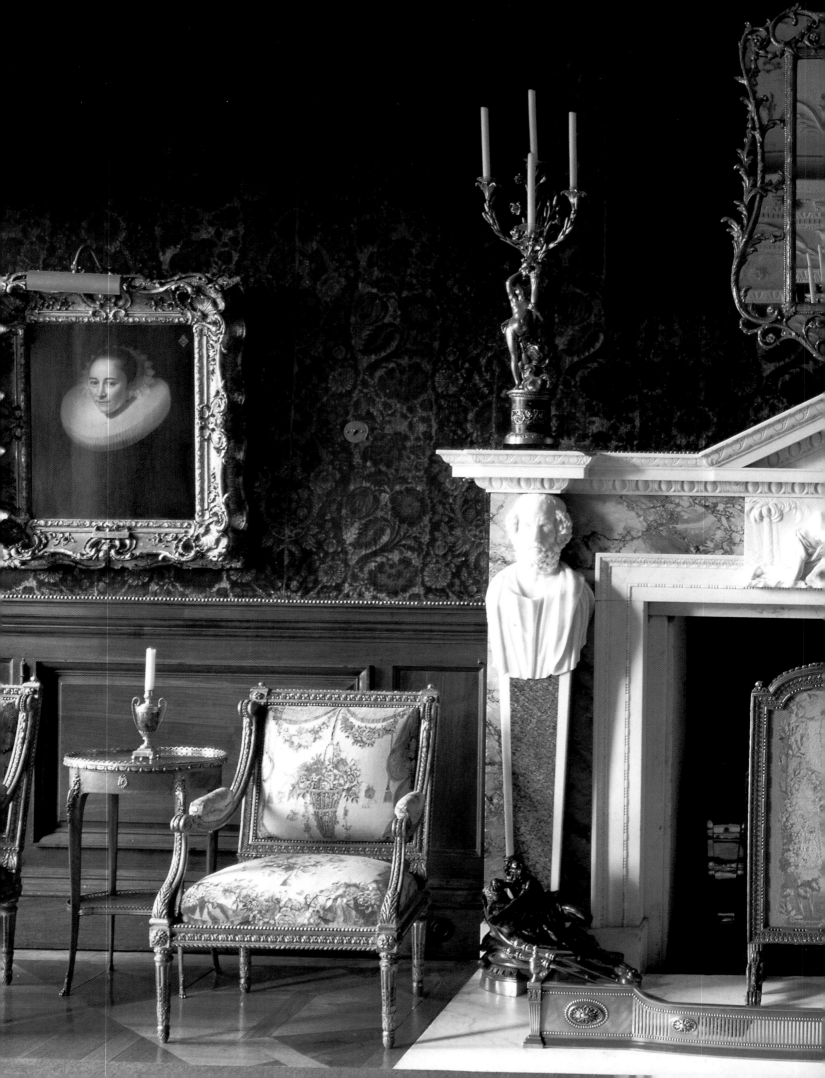

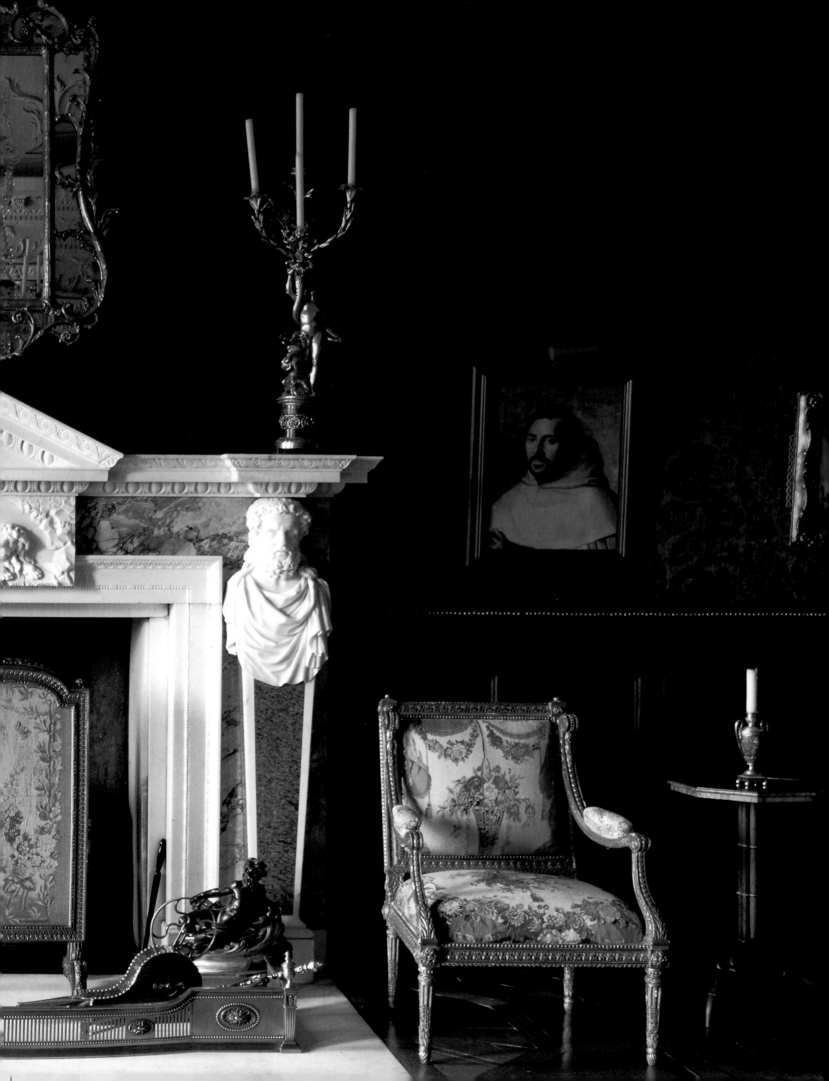

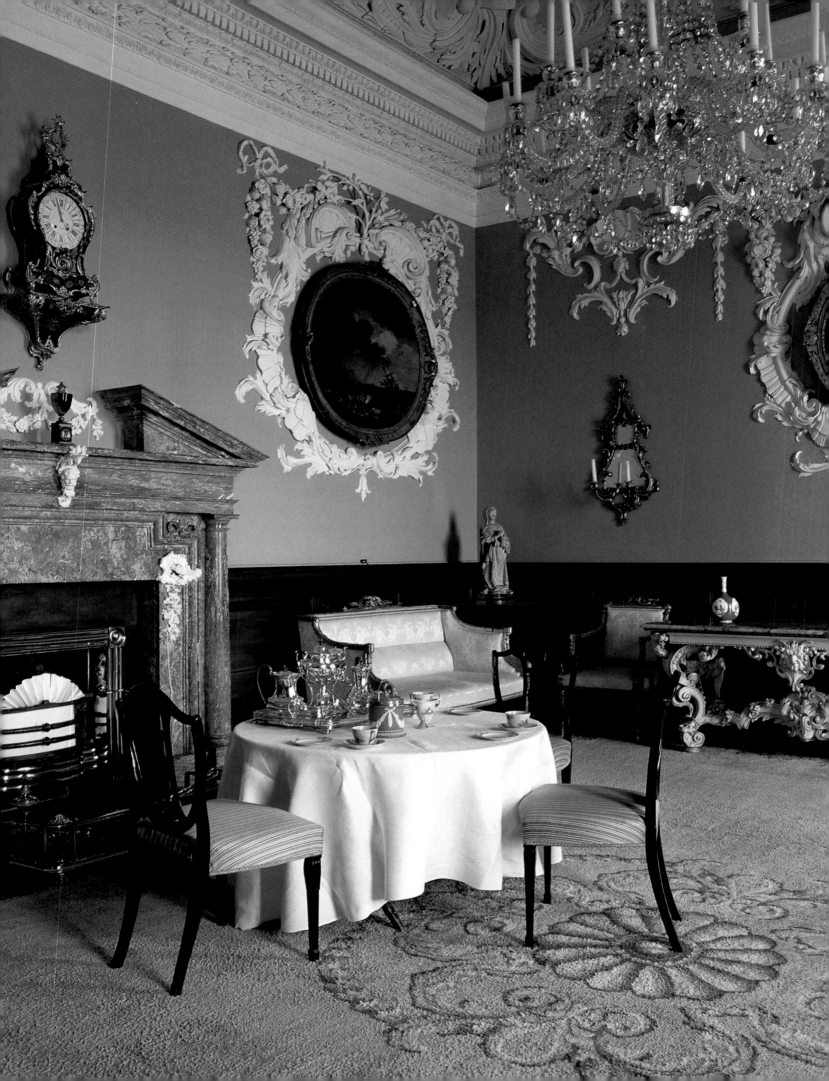

'This stucco represents the ravings of a lunatic, and an Irishman at that!'

The decorator, Mr Sibthorpe, commenting on the exuberant riot of plasterwork
that decorates the stairwell at Russborough House, County Wicklow

1	2	3	4	5	6
7	8	9	10	11	12
13	14	15	16	17	18

PHOTOS IN ORDER OF
APPEARANCE – PREVIOUS PAGES (92–93)

1

A small, round Regency side table complete with a gold palm tree climbed by a small chinoiserie-style man.

2

The important State Bed with matching chairs, armchairs and canapés was made in London by Wilson's of the Strand in 1794.

3

The elaborate scagliola top to a small table features decorative detail and pattern in the neo-classical Pompeian style of the later 18th century.

4

The profuse Francini plaster-work decorating the walls of the staircase hall features garlands, masks of hounds and other tro-phies of the hunt.

5

Often referred to as 'Chinese Chippendale', these dining chairs reflect the chinoiserie influence on the rococo style that was the fashion between 1750 and 1770.

6

Fireplaces fashioned from carved marble in every room indicate the great importance of Russ-borough House.

7

Built of Wicklow granite in the Palladian style, Russborough's façade is decorated with classi-cal imagery.

8

A massive chimney piece in grey marble is decorated with a baroque grotesque mask in carved plaster.

9

The main Palladian structure is flanked by two curved wings decorated with a gallery of niche spaces specifically created for the Earl of Milltown's collec-tion of classical statuary.

10

A crystal candelabra atop the piano in the music room is an early Waterford piece.

11

Entrance to Russborough is via a classical arch and pediment in Wicklow granite.

12

A detail of a chair in the State Bedroom reveals the fine crafts-manship of the furniture and also a corner of the famous Soho tapestry made by John Vanderbank in 1720.

13

This gilded eagle and Greek key pattern adorn an elegant Regency console.

14

The dining room is decorated with a set of six paintings by Bartolomé Esteban Murillo (1617–82) depicting the story of the Prodigal Son. The table-ware includes Sèvres porcelain and Georgian candlesticks.

15

A detail of the bolster of the State Bed in the Tapestry Room of Russborough House.

16

Weathered to a soft shade of grey, carved stone balustrades flank either side of the steps leading to the formal entrance.

17

The typically Irish motif of the 'hunt scene with dogs' adorns the carved marble plaque above the fireplace seen in photo 6.

18

The entrance to the path lead-ing to the Japanese bridge and the greenhouses is marked by a pair of solid granite obelisks.

O

PPOSITE PAGE

Georgian interiors tended to rely for effect on architectural treatment rather than furniture. This rectangular front hall, the formal entrance to Russborough House, features classical busts displayed in sculpted alcoves, a popular architectural device in Irish Palladian houses.

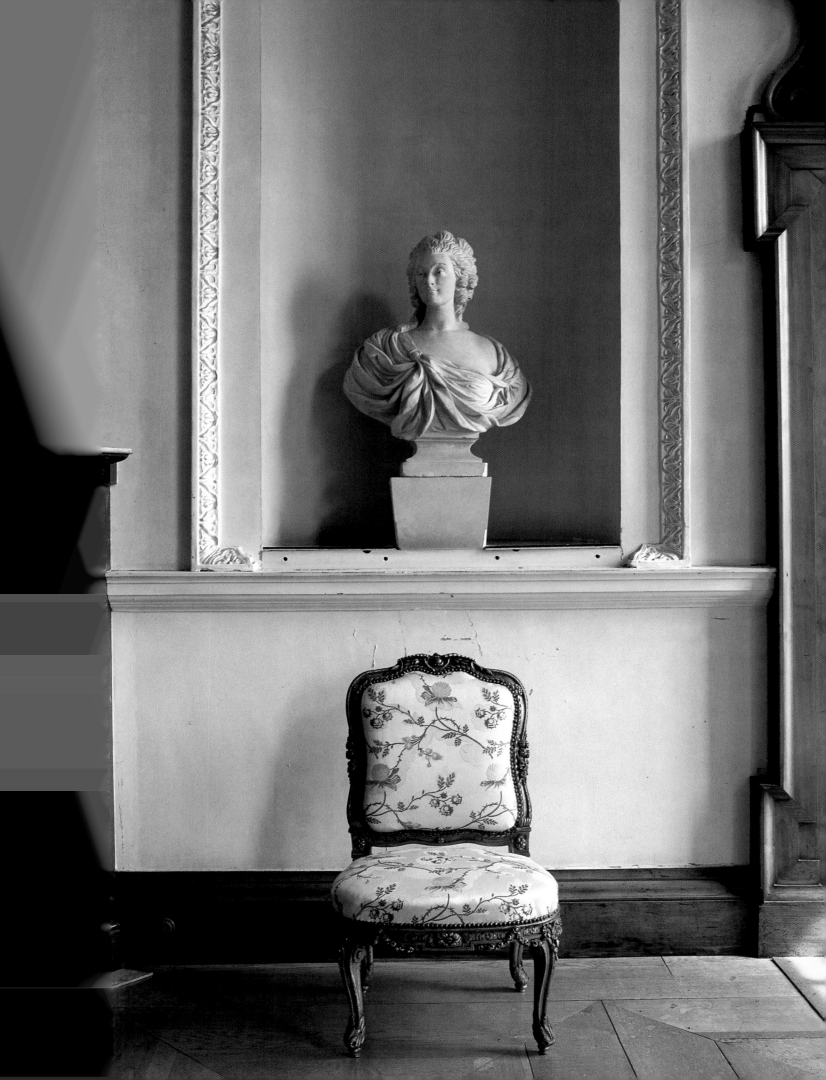

3

COLOURS

Colour was one of the most important contri-butions of Georgian times. Different rooms painted in varying shades of blue, green, red, yellow or pink established its decorative power. In an age when an interior was defined by its architecture rather than its furniture, colour was one of the most vital ingredients.

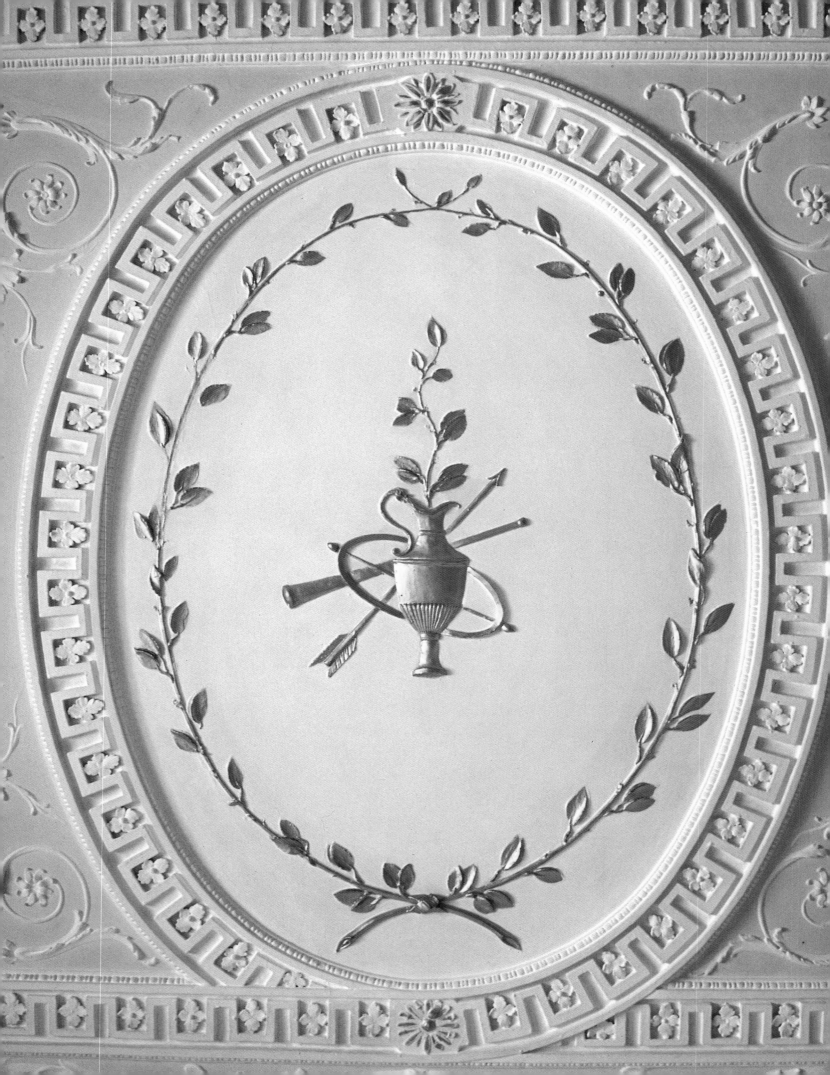

NEOCLASSICAL
COLOUR

It is almost impossible to overestimate the importance of colour in Georgian times. Together with the 'rule of taste' (a strict discipline of classical architectural guidelines that dictated form, proportion and shape), colour was the other ingredient by which meaning, purpose and enjoyment were brought to an interior. Alongside symmetry, colour was also perhaps the most democratic ingredient of the Georgian house. For although the pastor, merchant or farmer could hardly afford elaborate plasterwork, sweeping staircases, marble busts and monumental marble fireplaces in his moderately scaled (but beautifully proportioned) house, he could and did use colour to make the most of his home.

Plain colour suited the temperament of the Georgian era. 'Elegant restraint' described the qualities universally aspired to, and even the most robust architects and designers of the day prescribed to the rule laid down by Abraham Swan that 'there must be sufficient spaces left plain so that the ornament in proper places may be more conspicuous and may have their desired effect.' Plain, however, did not mean devoid of imagination. Property at the time was the criterion by which a person was judged and thus one's house played a terribly important part in defining one's status in society. As a result, attention and money (often exceeding what the owner could afford) were lavished on Georgian houses and close attention was paid to prevailing fashions and influences in the never-ending effort to make the right impression.

In the early part of the Georgian period, rooms were of smaller, more intimate proportions and were panelled throughout in pine timber. This panelling was invariably painted in shades of olive green, blue, buff and brown. Increasingly popular later in the period, no doubt as a result of French influence, was white approaching a shade of ivory, with detail carefully highlighted with gilding. Then in mid-century came the arrival of 'Chinese' taste and with it a tremendous fondness for blue. In shades ranging from sky blue or brilliant ultramarine (made from crushed and heated lapis lazuli), to smalt (a glittering finish made of powdered blue glass that could not be worked with brush or pencil but was strewn on to a base of wet paint to make a warm blue shining surface), and finally to the invention of a synthetic and affordable dark Prussian blue, blue was considered chic. It was introduced, in conjunction with hand-painted Chinese wallpapers, in the most important rooms of the day.

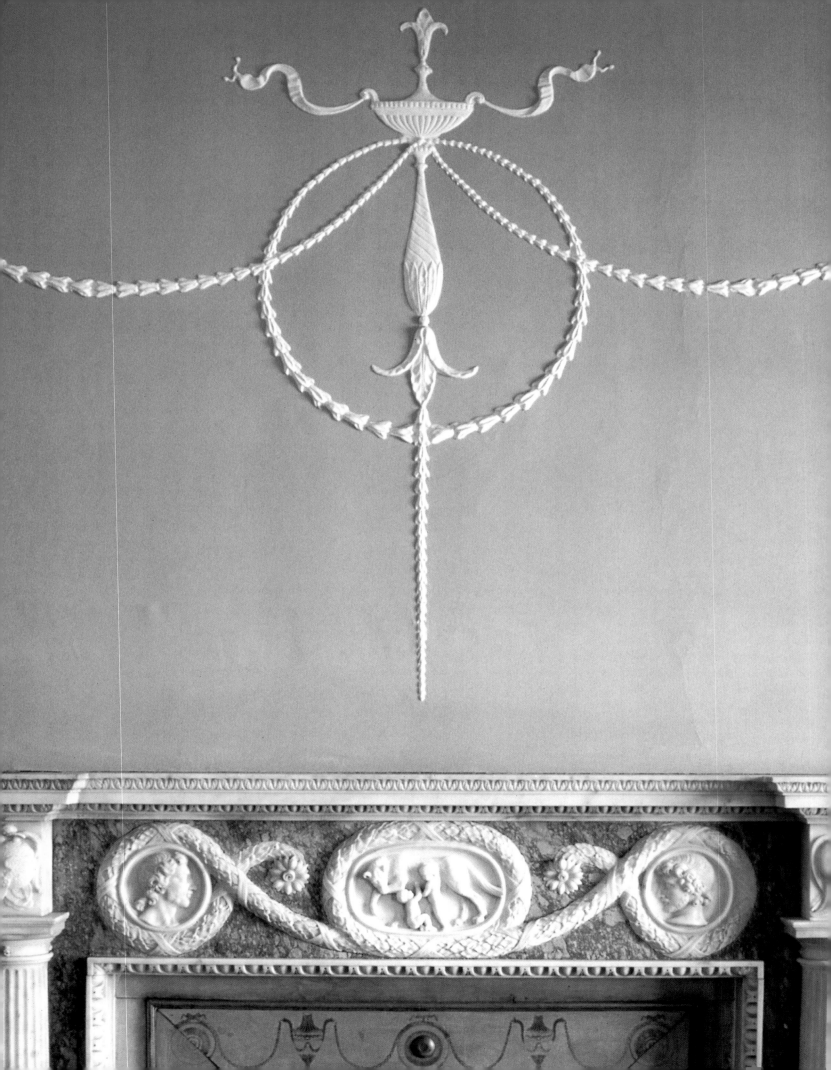

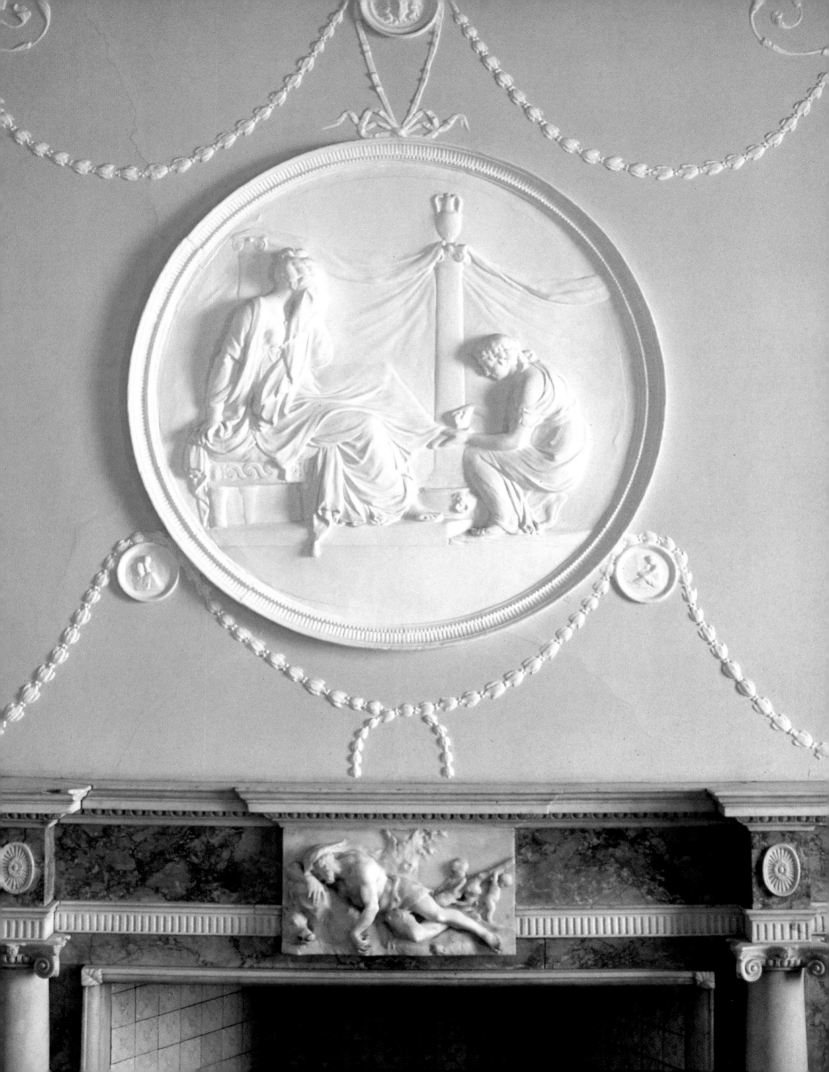

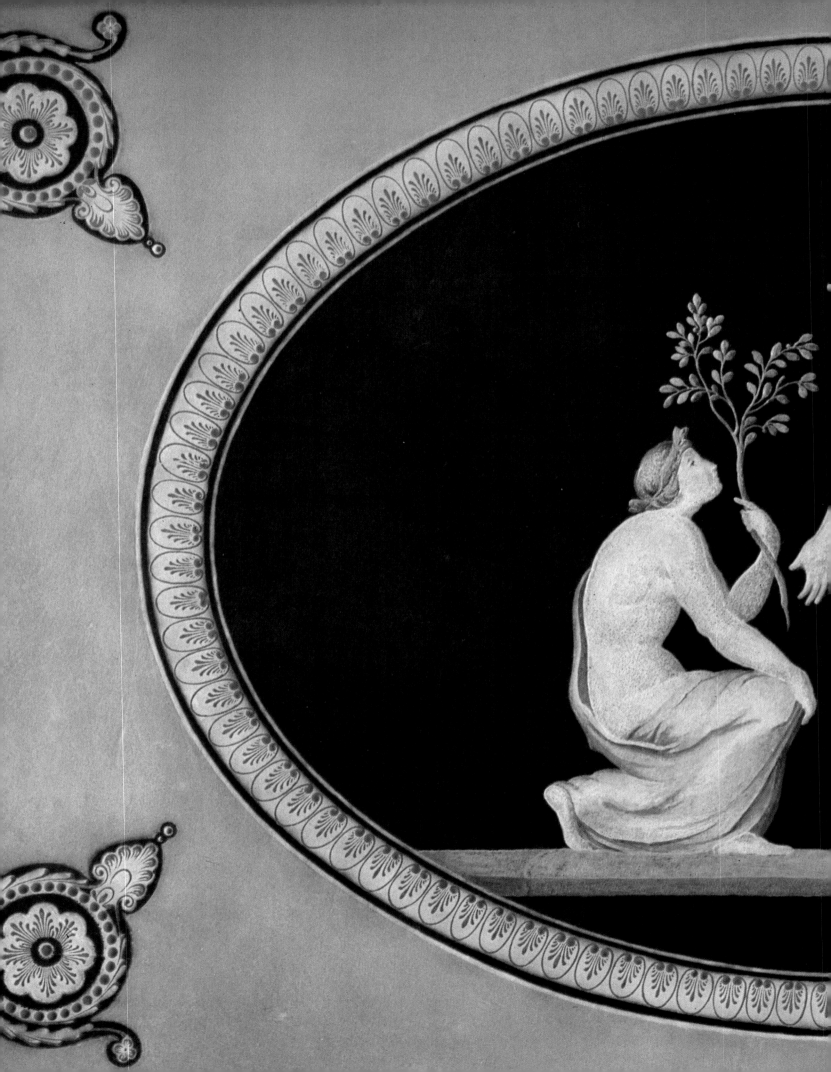

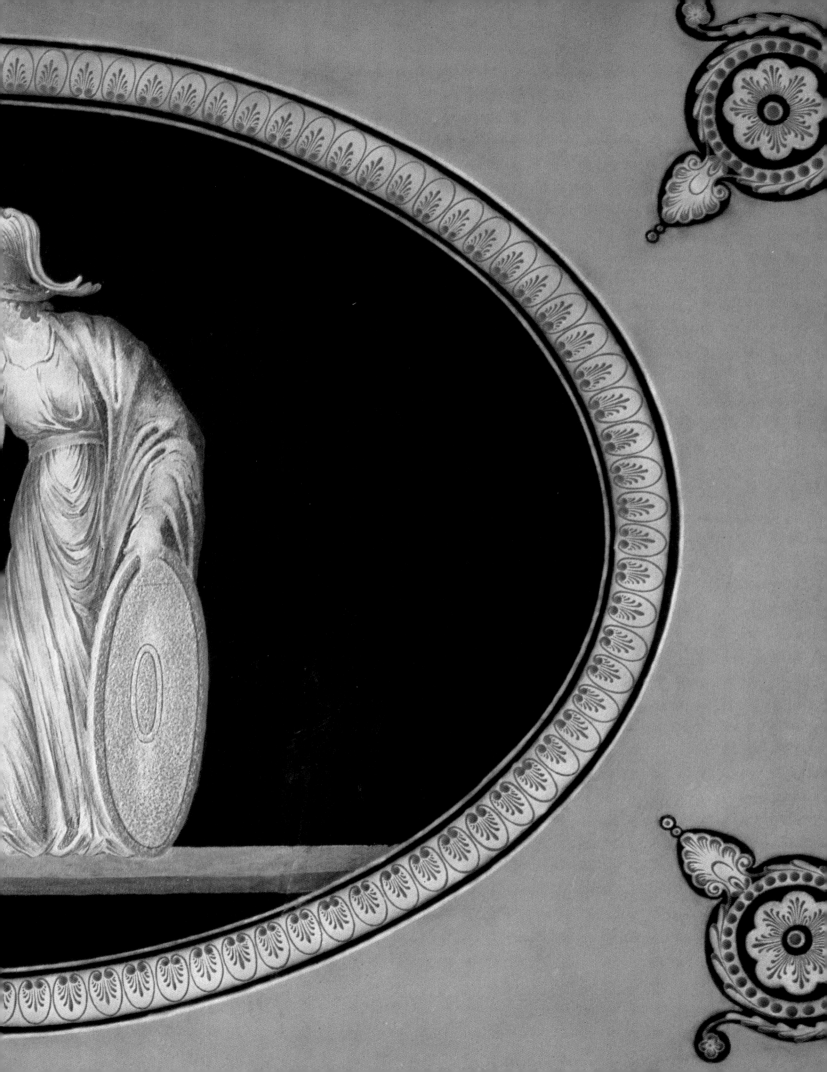

Predictably, fashions changed. The predominant colour in the second quarter of the 18th century was blue, but thereafter the preference was for pea green – a colour constantly referred to in surviving correspondence and a particular favourite of the architect William Chambers, who used it in conjunction with an assortment of 'stone' colours, as well as buff, 'Paris grey' and white. Together with Dutch pink, verdigris, lemon and 'straw colour', these colours stayed in use for most of the Georgian period. None the less, they were considered by some to be dull and predictable. New discoveries amid the ruins of ancient Rome and Greece gave academic sanction to a vibrant new palette of colours, including lilacs, bright greens and blues, bright pink, various blacks and, most characteristically, terracotta brown, which in conjunction with black comprised what was known as an 'Etruscan' colour scheme.

No architect or arbiter of taste was more effective in introducing these vivid neoclassical tones to the Georgian interior than Robert Adam, who used them to create a style that came to be widely copied. Adam applied lilacs, pinks, greens and certain shades of blue to finely finished walls and then accentuated these colours by the application of delicate, white neoclassical decorations in relief. A visitor to one of his newly completed commissions in 1768 noted the application of 'a very faint sea Green Stucco and also a very faint bloom colour, which gives an elegance and a delicacy I cannot describe.' The same effect was exploited with considerable success by Josiah Wedgwood in his jasperware. Indeed Adam's signature use of colour and delicate pattern filtered down to even the most basic townhouse and rural cottage.

PREVIOUS PAGE (98)
The ceilings of Ely House, a grand townhouse in the Georgian heart of Dublin, survive as an example of the elegantly refined Pompeian detailing and soft, subtle shades that distinguished the style made popular by the great 18th-century Scottish architect, Robert Adam.

PREVIOUS PAGES (100–101)
Although soft neutrals were very much part of the Adam style, he was not afraid to apply bright, vibrant shades, such as this lilac and distinctive green. These colours were then enhanced by

delicate white relief decoration in his signature neoclassical shapes such as the ear of wheat, groups of flutes, or the Greek honeysuckle.

PREVIOUS PAGES (102–103)
A plaque featuring a medallion painted in the Pompeian style decorates a fireplace at Castletown House (pages 16–29). The colour scheme was inspired by the discovery of a whole new palette of vibrant colours amid the ruins of ancient Greece and Rome. These included bright blues and greens, bright pinks and, as a contrast, many shades

of black. The most fashionable homes were the first to use these neoclassical colours.

OPPOSITE PAGE
Relief plasterwork was usually painted in different shades of white to bring out the depth in the carving. But these were not the brilliant shades of today's synthetic paints; they were soft whites derived from white lead that inevitably yellowed on contact with sunlight. Whites most closely resembling those of Georgian times are often called 'antique white' on modern paint charts.

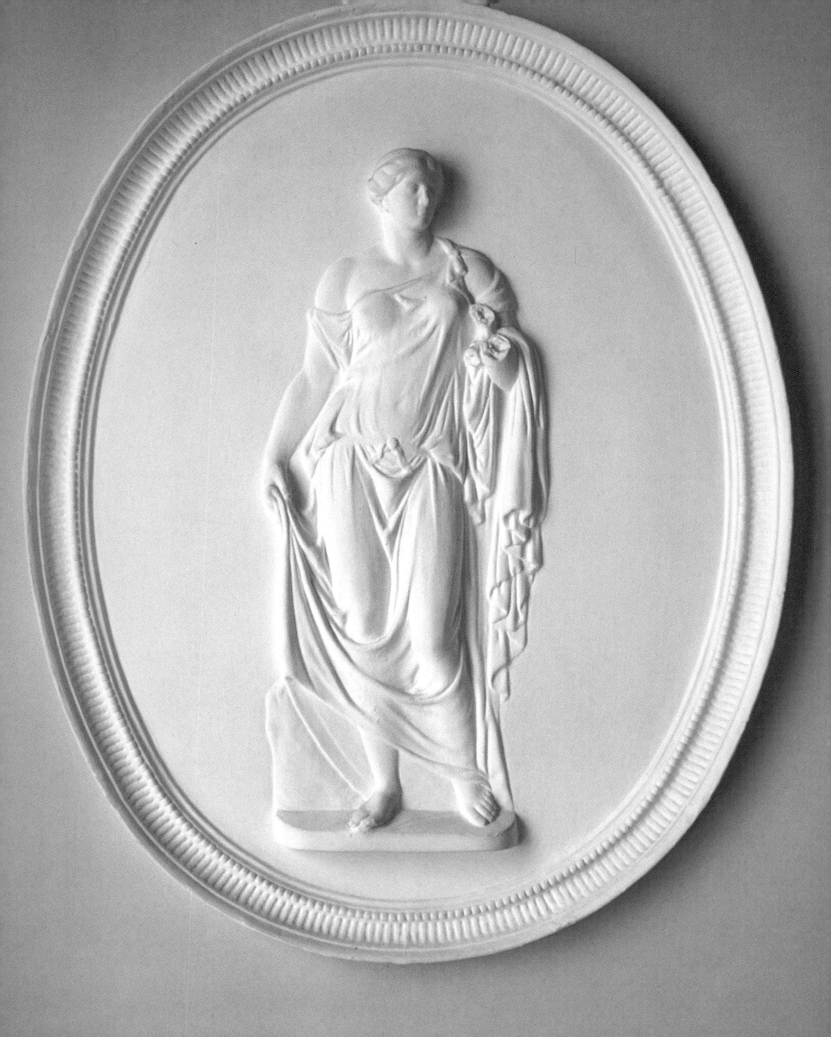

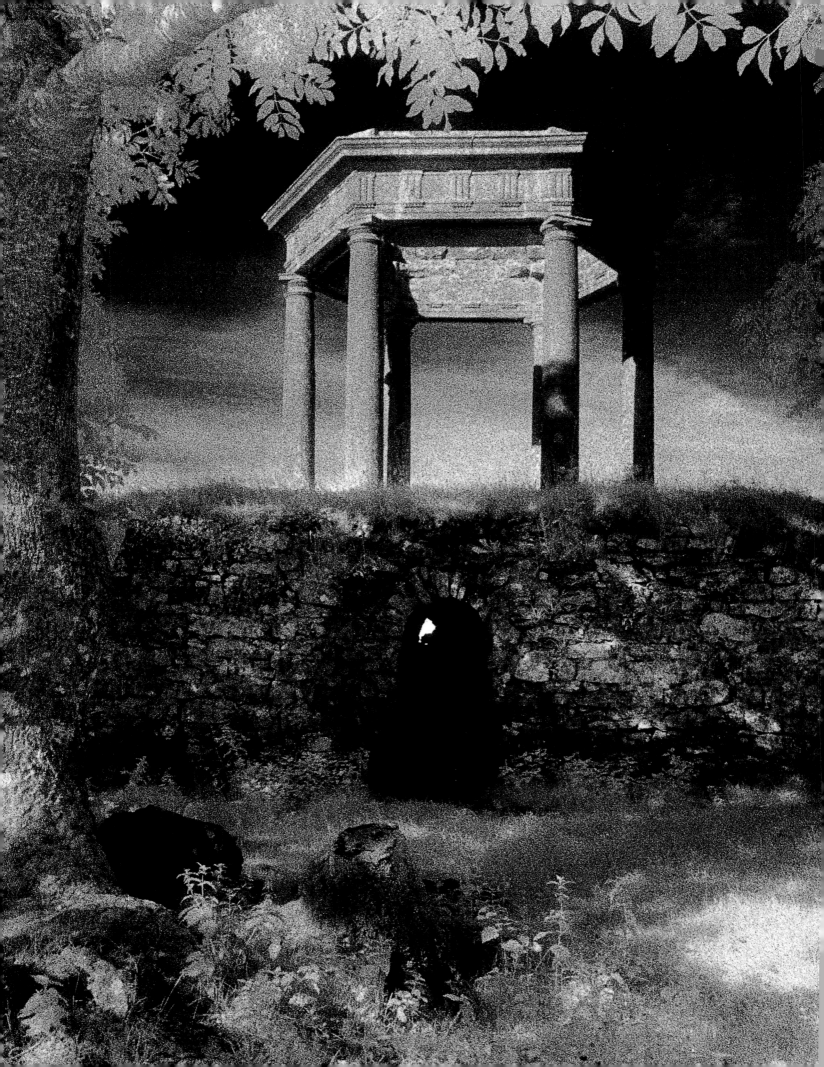

4

INGREDIENTS

Irish craftsmen made some of the most exquisite objets produced in the 18th century. They excelled in glassware, linen, silver, engraving and wallpaper, all of which contributed to the Irish Renaissance, a period of artistic excellence that has recently come to be rediscovered by a whole new generation of Irish artisans.

THE PRINT
ROOM

In Ireland, as in England, the print room was a decorative scheme specific to Georgian times. From the grandest of Ireland's country estates to modest farmhouses, black-and-white prints and engravings were simply pasted on to the walls of a designated room and then decorated with cut-out frames, festoons and ribbons, also pasted directly on the wall to simulate the 'hanging' of the prints.

In every sense the print room was an accurate social reflection of the times. Creating a print room was essentially an idle and time-consuming pursuit, ideal for rainy days, and one that would not have been possible without the small army of servants that looked after grind of daily chores in the average Georgian estate. It was also the first instance in which responsibility for an aspect of the overall decorative scheme passed from the strict realm of the 'professional' to the 'amateur', usually the lady of the house. This was both an indication of the rising rank of women in society (Georgian women had far more freedom and were treated more equally than women a hundred years later in Victorian times), and a beginning in the breakdown of the strict formality that had dictated the design of houses. The very notion of a print room was also tied to the taste of the times – the taste for the 'antique', i.e. for the classical architecture and design of ancient Rome and Greece. No education for a gentleman was complete without undertaking the Grand Tour, and not only did this spur on the general Georgian interest in the classics but it created an awareness of other places, cultures, and their arts. Prints and engravings were a favourite souvenir to bring back to England and Ireland. On his Grand Tour, for example, Louisa Conolly's nephew William, the future Duke of Leinster, became a dutiful curator for the print room at Castletown House, sending on one occasion in 1767 a large batch of prints from Rome. Engravings picked up on the Grand Tour were not just a reminder of a gentleman's youthful adventures but also served as an advertisement for his completed education.

The most famous print room in Ireland, and the only one to survive to the present day, is the print room created by Louisa Conolly at Castletown House. The antechamber to the State Bedroom that her husband, 'Speaker' Conolly, used for morning meetings was the room chosen to make into her print room, and for the next decade and a half (1760–75) Louisa worked slowly and methodically at collecting and pasting prints on to cream-coloured wallpaper. She surrounded each one with borders, bows

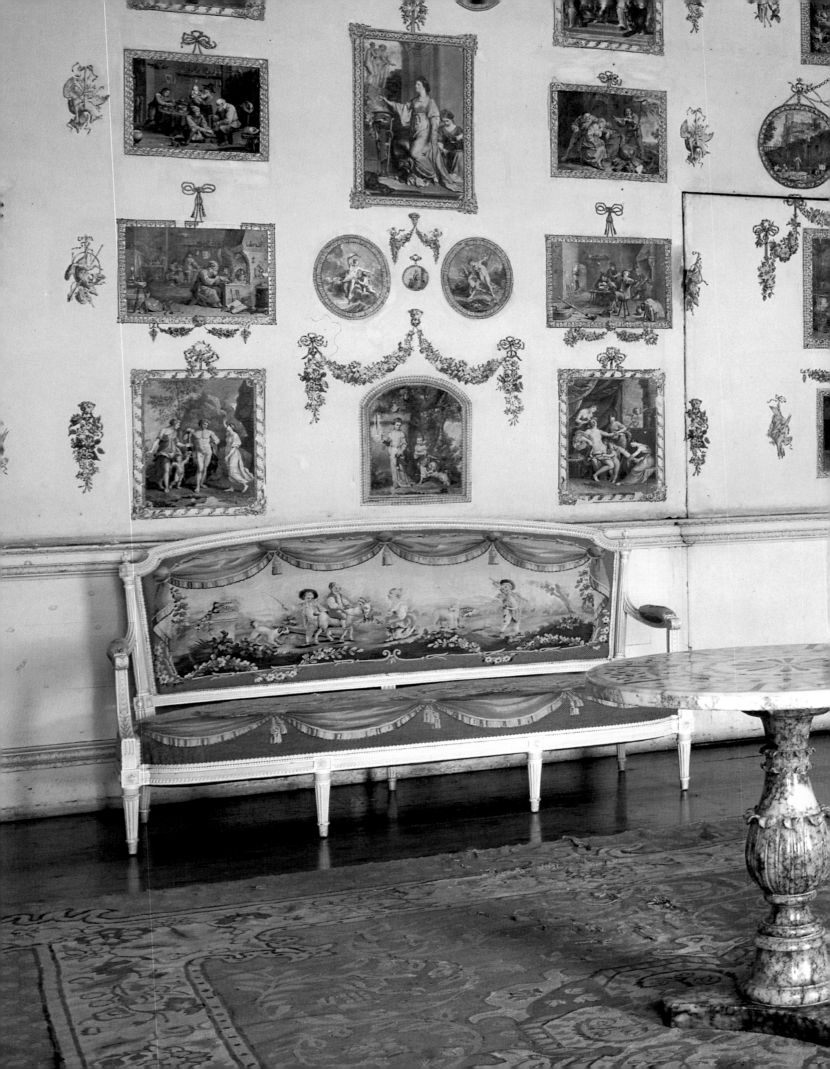

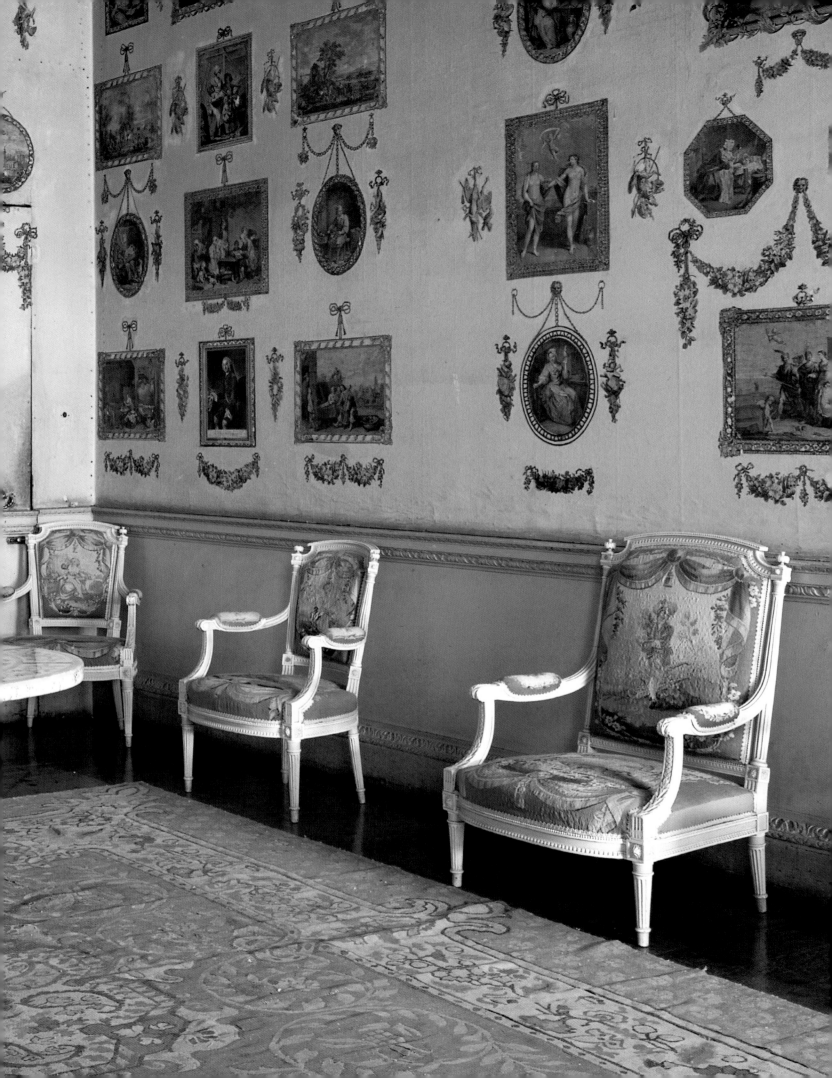

and swags cut out from pattern sheets produced by commercial printers, and then stuck the whole sheet on the wall. It was slow, time-consuming work, well suited to Lady Conolly's interest in drawing and the pleasure she took in planning. And, certainly in Louisa's case, it was not simply a matter of making pretty shapes and pleasing patterns. As Stella Tillyard describes in her book *Aristocrats*, 'Louisa's room was at once an entertainment and an encyclopedia of examples and warnings.' Images of fallen trees, peeled fruit, spilt milk, broken egg-shells, snuffed candles and empty pans, contained in seemingly jolly scenes of hunting parties, family groups and gatherings in the tavern, delivered reminders of death and decay and subtle 'sermons against vanity and folly'. As well as these chastening examples there were also the positive. Arranged around a print of Van Dyck's painting of the children of Charles I (which in itself was part family album, with Louisa's grandfather depicted between Charles's sisters) were *The Death of Seneca*, which extols stoicism, and another *Le Bon Exemple*, which offers an example and lesson in industriousness. As can be expected from the time invested in its completion, the print room at Castletown House also displays great variety, not just in the images themselves but also in their place of origin. From Holland there are Vermeer's *Lady Writing a Letter* and a print after Rembrandt called *The Philosopher in Meditation*. There is a French print entitled *Mlle Souer*, as well as the prints from Rome chosen by her nephew William, and a wide selection of engravings after well-known English artists such as Reynolds.

Although the odd print was chosen simply because it fitted a space (for example a portrait of Pitt the Younger), for the most part Louisa's choices reflected a myriad of influences, priorities and personal experiences. The print room at Castletown House became an autobiographical collage dedicated to Lady Louisa Conolly's life.

PREVIOUS PAGE (108)

The print room was a typical feature of 18th-century Irish country houses. Black-and-white prints, taken from engravings, were pasted directly on to the walls and then decorated with ribbons, tassels and frames cut out from pattern sheets specially printed for the purpose.

PREVIOUS PAGES (110–111)

Louisa Conolly's print room at Castletown is the only one of its kind in Ireland to survive to the present day. It took ten years to complete. The end result is a complex, intricate narrative of biographical, allegorical and moral tales – like a diary cut out and pasted on to the wall.

OPPOSITE PAGE

The dining room of Higgins-brook House (see pages 32–41) is decorated in the manner of an original 18th-century Irish print room. The prints as well as the accompanying frames, ribbons and medallions were supplied by the Irish Georgian Society (see pages 158–159).

THE GEORGIAN

FIREPLACE

The great Georgian houses of Ireland were built for show, not for comfort. No matter how many 'turf boys' circled the house filling and refilling the great buckets to stoke the numerous fireplaces, nothing could warm the corridors. Attempting to heat these houses became an obsession and a binding burden among the landed gentry, a common cross to bear. As Emily Fitzgerald – Duchess of Leinster, lady of Carton House and sister of Louisa Conolly – wrote to her husband in 1773 while staying with her sister at Castletown House: 'You will say what, was the print room cold? No, but the way to it from the apartments we are in at present perishingly so … which shews, my Love, the necessity of having very, very often fires almost all over the house.'

In the case of Castletown, 'having fires all over the house' meant stoking ninety hearths, which in an average year consumed over three hundred tons of coal, not to mention an additional handful of trees. Even a more moderate Georgian house would burn twenty-five tons of coal and three full trees annually. In an age when the cost of keeping up appearances forced most of society to live well beyond its means, not all landlords could afford to take up Emily Fitzgerald's advice. Often only one room was kept warm. Throughout the rest of these leaky, cumbersome and bone-chillingly cold mansions there was no solution other than a few layers of coats. Dorothea Herbert recalled the winter of 1783 in one of her letters: 'the snow was mountainous high and we sat wrapt up in Great Coats for forty-seven days in two parlours.'

If freestanding stoves had been adopted, like those used in the great historic houses of Sweden, these stately Georgian homes would have been far less draughty. Yet they never proved popular. The average 18th-century Irish duke, baron or earl was quite prepared to suffer for style. A visible source of heat was what was wanted, and the fireplace, the centre of everyday life during most of the year, was accorded the lavish expense and decoration suited to its status. How to go about this, however, was not entirely clear, since classical architecture provided no precedent. Such an important opening in the wall was a source of some perplexity to designers of early Georgian houses. How was it to be given a classical treatment without models from antiquity? This question was still being discussed as late as 1756 when Isaac Ware wrote in *The Complete Body of Architecture*: 'those who have left rules and examples for other articles lived in hotter countries; and the chimney (fireplace) was not with them, as it is

with us, a part of such essential importance that no common room, plain or elegant, could be constructed without it. Fancy (preference) is therefore to stand in the place of rule and example in the construction of the chimney piece.'

Yet despite a supposed freedom of preference, a code developed for the construction of fireplaces which has hardly changed over the past three centuries. Somehow the sides of the fireplace have come to represent classical columns, while the mantel shelf is an interpretation of a classical entablature. Architects of the time gave builders minute directions for constructing chimney pieces, all of which dealt with how to incorporate elements of the classical order in the correct fashion. Even when rococo and chinoiserie became strong decorative influences, very few fireplaces deviated from these new guidelines. The most successful compositions were designed by Robert Adam. Boldly classical in derivation, Adam introduced the central plaque that was thereafter much copied, and his grander designs included sculptural elements such as female figures from Greek architecture to support a mantel shelf which had by the late 1700s grown rather wide. He also designed an array of neoclassical decorations that were made with moulds and so could be applied to simpler, cheaper fireplace surrounds of painted wood.

Although the fireplace is no longer so indispensable to the Georgian house, it still evokes the romance of earlier times and serves as an invaluable guide to understanding and appreciating the grandeur and decorative skill of Georgian times. Accordingly, the magnificent chimney pieces made in the late 18th and early 19th centuries have attained a status as antiques in their own right. Although a Georgian house or building itself may be demolished, the chimney pieces are usually rescued and, because of their exquisite craftsmanship in stone and marble, can command healthy prices. Even timber fireplaces, which in Georgian times were a decidedly less prestigious option, are now highly prized.

PREVIOUS PAGE (114)
Elaborate and costly, the imaginative decoration lavished on the chimney piece during the 18th century is a hallmark of Georgian style. In a time before oil lamps and central heating, the importance of the fireplace cannot be overstated. In an effort to translate the lessons learned from the Grand Tour on to a feature that obviously did not have the same importance in Mediterranean architecture, classical torsos, modelled on Roman and Greek originals, were integrated into the design of the 'pillars' that supported the mantelpiece.

OPPOSITE PAGE
*Marble was the material of preference for the fireplaces in grand Georgian houses. This particular example, in a house on Dublin's famous Merrion Square, is framed by the spectacular murals of what are now the Senate rooms of the national University of Ireland. The Italianate landscape paintings, in the 'semi-fresco' technique, are based on the painting of **Il Molino** by Claude Lorraine (1600–82) in the Doria-Pamphili Gallery in Rome.*

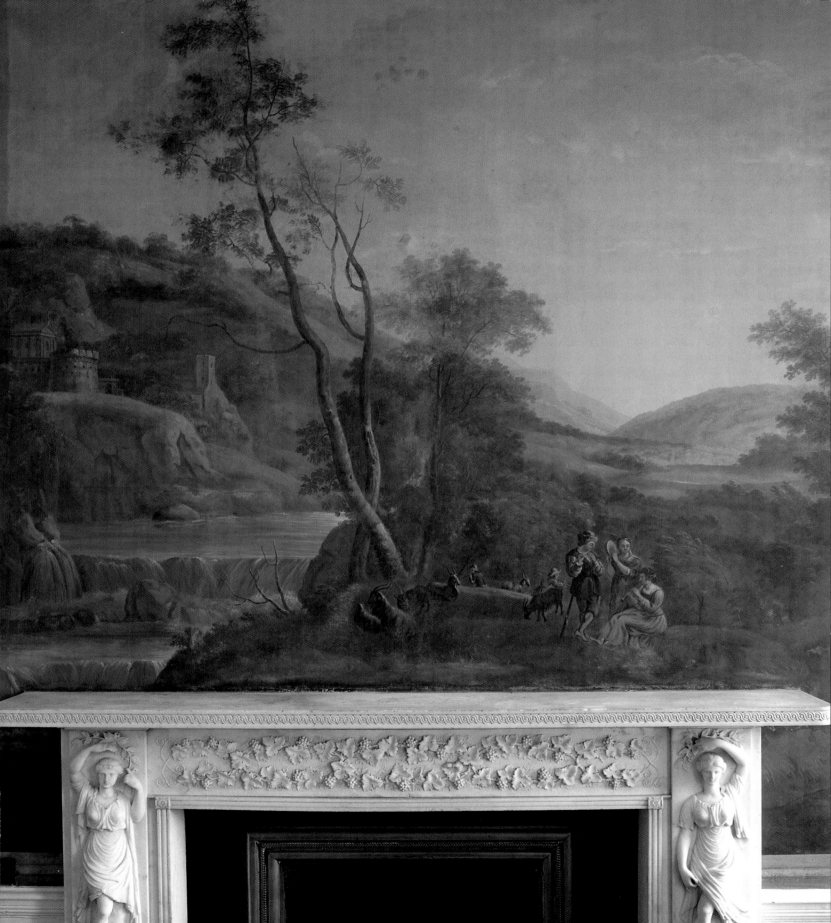

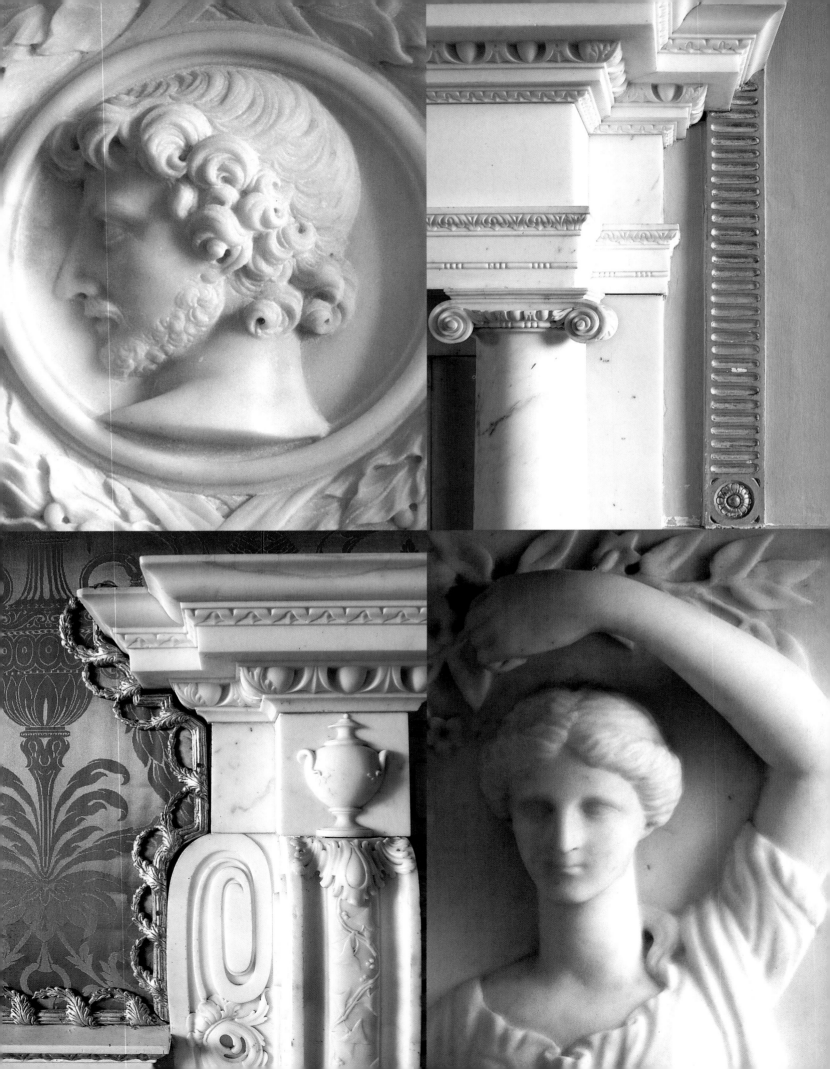

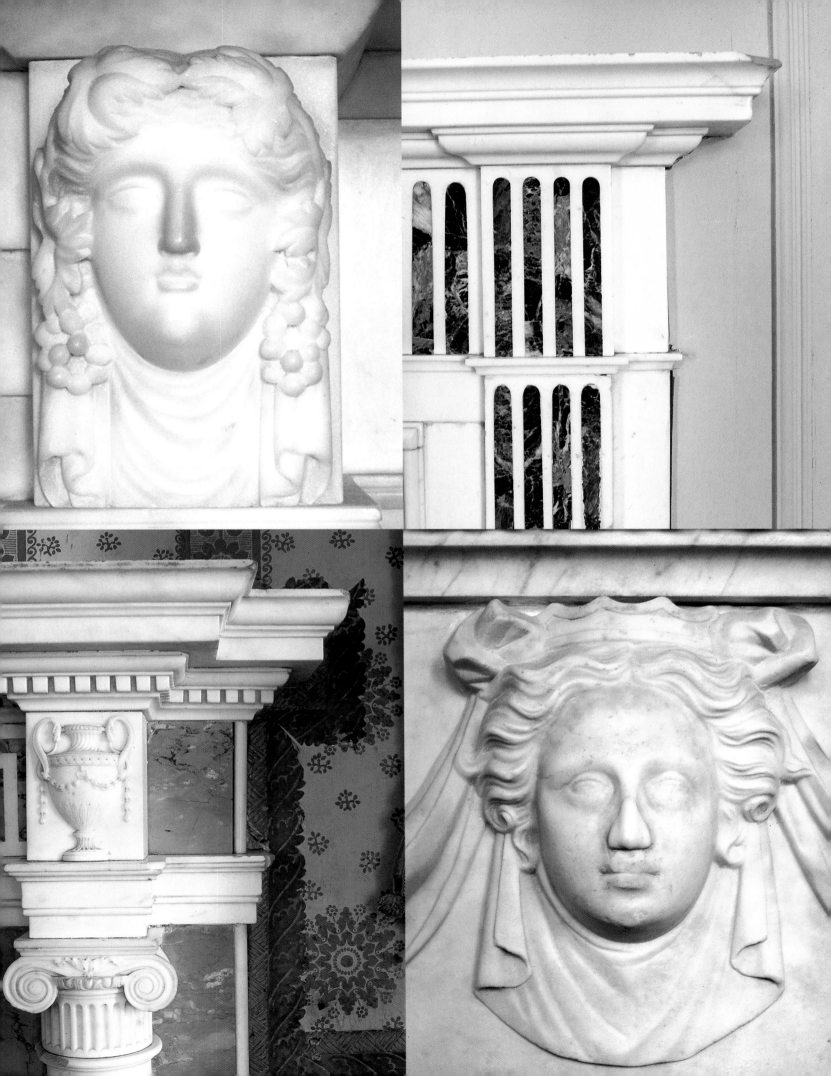

1	2	3	4
5	6	7	8

PHOTOS IN ORDER OF
APPEARANCE – PREVIOUS PAGES (118–119)

The Scottish architect Robert Adam introduced the fashion for sculpted faces and torsos as an alternative to the Georgian 'rule' requiring that a fireplace be flanked by a pair of pillars supporting the mantelpiece.

1

This decorative plaque in the late 18th-century neoclassical style is centrally positioned above a fireplace in Dublin's Ely House.

2

This chimney piece detail belongs to one of the two fireplaces designed in the neoclassical style for the Long Gallery of Castletown House.

3

Another decorative face carved into the marble, this time in Irish style for a chimney piece at Ely House in Dublin.

4

Fluted marble with contrasting inlay in a simpler, early Georgian fireplace at Strokestown Park House.

5

The exquisite detailing incorporated into the marble fireplace of the Green Drawing Room at Castletown House reflects the neoclassical taste of the architect Sir William Chambers.

6

A maiden clothed in the Pompeian fashion adorns a fireplace of the Senate rooms of the national University of Ireland in Merrion Square, Dublin.

7

The fireplace in the library of Strokestown Park House features white marble accented with Sienna marble, complementing the colours of the original Georgian wallpaper (one now reissued by David Skinner in his 'Great Irish Houses' collection, see page 159).

8

A heroic marble face decorates the central plaque of the chimney piece in Dublin's Tailor's Hall, another building rescued by the Irish Georgian Society.

OPPOSITE PAGE

Given the fame of the Marino sheep, it is not surprising that the ram's head, sculpted in plaster, is the distinguishing decorative element of the saloon fireplace in Marino Casino (see pages 76–83). The surrounding gold braid hides the nails that hold the wallpaper to the walls.

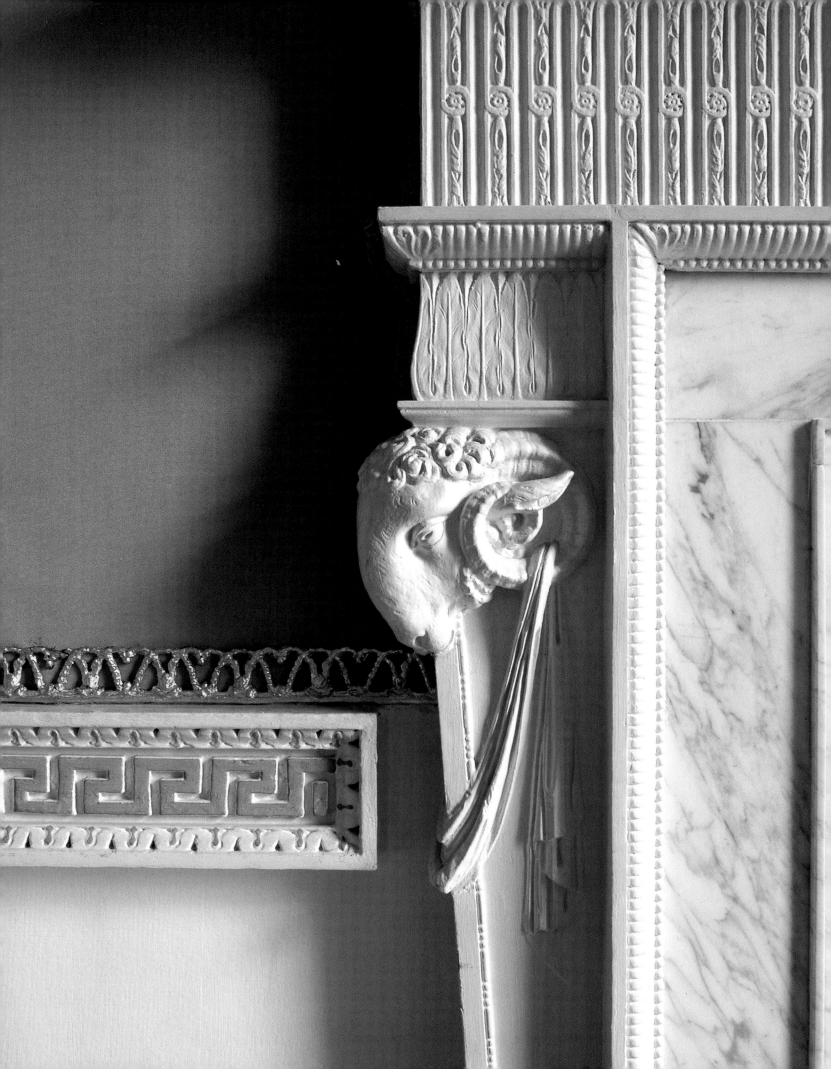

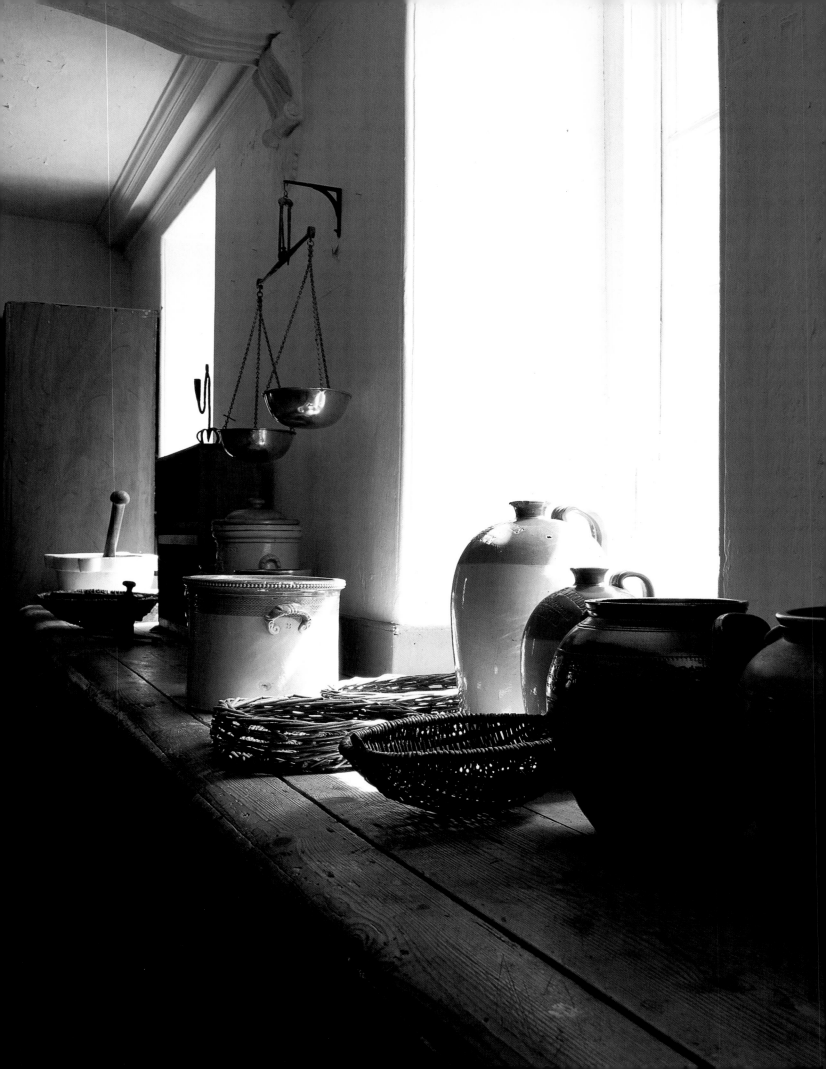

THE IRISH COUNTRY
KITCHEN

However sophisticated the Georgian home may have been, the kitchen, and in particular the cosy kitchen fire, remained one of the focal points of the house. It was the one room that never needed supplementary heating and in the dead of winter many servants would curl up under the huge workbenches to sleep for the night. Order and efficiency were aspired to in the kitchen, yet it remained 'the most cosy and welcoming of environments'. In Oliver Goldsmith's *The Vicar of Wakefield*, the kitchen fire plays a central role. Around it were debated the issues of the day: 'We sate beside his kitchen fire, which was the best room in the house, and chatted on politics and the news of the country.'

The Irish country house kitchen was more like a workshop than a domestic room, just as the house itself was more a factory than a residential estate. The number of people required to operate the offices, the wash-houses, the stores, hot-houses, ice-houses, coal-houses, bake-houses, potting sheds, stables, breweries, granary, tannery and kitchen garden, not to mention the kitchen itself, was, understandably, enormous. In fact the only enterprises in 18th-century Ireland that employed more people than the grand country houses were the army and the navy. Even the largest linen factories of Ireland in those days did not employ more than one hundred people, while houses such as Castletown or Carton had that many engaged just in day-to-day domestic duties, with the number employed often expanding to two or three hundred if a building project of some sort was under way – as there almost always was, given the diversity of independent activities on the estate.

In an ongoing struggle to keep these immense, almost industrial-scale households going, the grand Irish country houses required complex command structures. At the very top, naturally, were the master and mistress of the house, the mistress taking responsibility for everything domestic and the master concerning himself with all matters connected with the land and with transport, such as maintaining the stables. Next came the steward, who as the main household officer was the bridge between the household and the world outside. Directly beneath him were the housekeeper, the butler and the clerk of the kitchen. (The very fact that the kitchen required the services of a full-time manager or clerk is a clear indicator of the extraordinary role played by the kitchen in 18th-century society.)

All entertaining was done at home, and both the quality and variety of the food served, as well as the manner in which it was presented, were considerations that affected one's standing in society. The average Georgian dinner, never served to fewer than ten guests, would comprise a dozen or so courses that included boiled meats (such as boiled calf's head), fish and soups, followed by roasted meats, ragouts and more savoury dishes, and then at least six different offerings for dessert. And even if eating went on for hours (as it regularly did) there was no letting up in the manner that it was all presented. Perhaps the most graphic example of the huge effort that went into display was peacock pie. Made with pheasant (not peacock), this combination of fowl and pastry was served with the magnificent severed head of a peacock at one end and a 'rainbow' of its brightly coloured feathers stuck into the other. A peacock, thus, was butchered purely for table decoration. And the pageantry continued with dessert. Adorning the table might be an enormous sponge cake smothered in chocolate icing and styled to resemble the hairy dark skin of a wild boar. If elegant restraint is the hallmark of Georgian design and architecture, it certainly did not extend to the eating habits of the day.

Despite the fact that a house such as Castletown had its own piggery to supply pork, bacon and ham, its own 'bullock hovel' as a source of fine beef, and a dairy to provide cream, milk, cheese and butter, all this home-produced food was still never enough. An annual production amounting to 1,900 lbs of cheese, 7,934 gallons of milk, 1,496 gallons of cream, 1,454 lbs of butter, 524 lbs of veal and sweetbreads, 160 sheep, 20,400 lbs of oxen, 94 geese, 112 turkeys, 1,301 chickens and 10,460 eggs still did not cover the collective appetite of the enormous number of people dining at Castletown. In addition to the ten or more in the parlour or long room every evening, there were also twelve to be served in the steward's room and a further sixty in the servant's hall. The collective appetite of these eighty-two people who had to be fed on a daily basis is described by Stella Tillyard in her book *Aristocrats* as 'a voracious

PREVIOUS PAGE (122)
The best example of an original Irish Georgian country kitchen is at Strokestown Park House, another one of Ireland's grand Palladian country houses. The style of this kitchen, with its scrubbed pine work surfaces, stone pots, shiny brass pans and practical, spacious layout devoted to the preparation of huge feasts, is much imitated in contemporary kitchen design. *The Georgian concern with neatness and elegance strikes an almost instinctive note of approval today.*

OPPOSITE PAGE
The kitchen of Marino Casino is situated, as Georgian tradition dictated, in the vaulted spaces of the temple's basement (see pages 76–83). Although it is considerably smaller, this kitchen is very similar to that of the much larger Strokestown Park House, and is also little different from the hearth in Patrick Scott's cottage (see page 70). The kitchen is one aspect of Georgian architecture that has the same basic qualities in all Georgian buildings, from the smallest to the very largest and grandest.

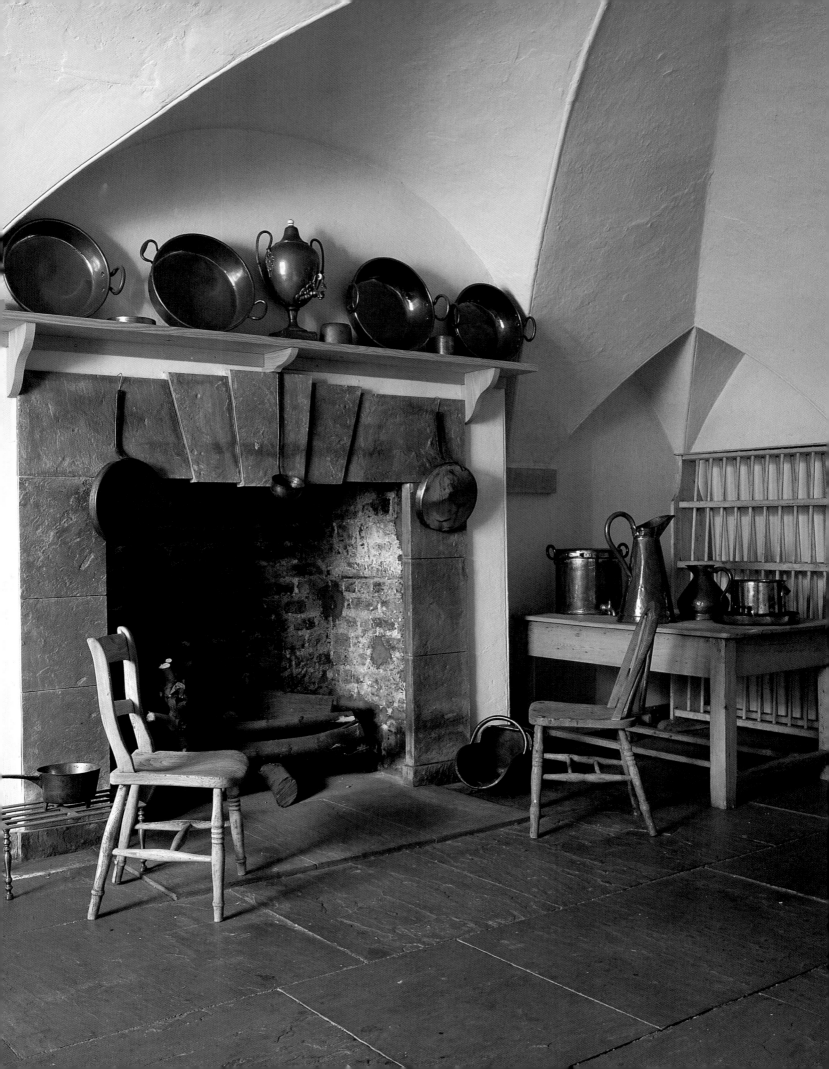

maw, consuming huge numbers of animals, hundreds of tons of fuel and dozens of grocery consignments.' Those foodstuffs that could not be produced at home included sugar, tea, coffee, chocolate, cocoa, currants, raisins, almonds, sago, barley, rice, vermicelli, macaroni, anchovies, mustard, nutmeg, cinnamon, caraway seeds, pepper, white ginger, ground ginger, cloves, allspice, capers, brandy, oil, vinegar, hops, plums, biscuits, split peas, lentils and treacle.

No wonder, then, that the kitchen of the Irish country house was such a large and utilitarian space. Equipped with a multitude of spits and ovens for baking, roasting and smoking, the entire existence of the household, from the social standing of the proprietors down to the feeding of an army of staff, depended on it. The kitchen was one of the most important rooms in the house. Accordingly, no effort or investment was spared in the keeping of a kitchen.

It is exactly this orderly, no-nonsense aspect of the Irish country house kitchen that continues to appeal to this day. Long after the sheer scale of the demands of the grand Georgian house have ceased to be relevant, its kitchen is still the model from which many domestic kitchens take their inspiration. In the same manner that the commercial restaurant kitchen has fostered the penchant for wall-to-wall stainless steel in many modern homes, so too has the utilitarian purity of the Irish country kitchen struck a contemporary chord. Practical floors tiled in stone, scrubbed pine surfaces and faded, time-worn marble tops, combined with the warmth of gleaming brass, the character of handmade porcelain and earthenware containers, and the reassurance of permanent sources of heat (like the Aga cooker), cater to our deepest and most basic association of food with warmth and reassurance.

OPPOSITE PAGE
The kitchen of the Irish country house was of necessity a large and utilitarian space, equipped with a multitude of spits and ovens for baking, roasting and smoking. It often also featured a gallery along the length of one of its walls. This allowed the lady of the house to discuss menus with the chefs and to keep a close eye on the numerous staff engaged in the preparation of the ten or twelve courses served in the typical Georgian dinner, without herself having to set foot in the kitchen. This is the best (indeed the only) surviving example of a galleried kitchen, in Strokestown Park House.

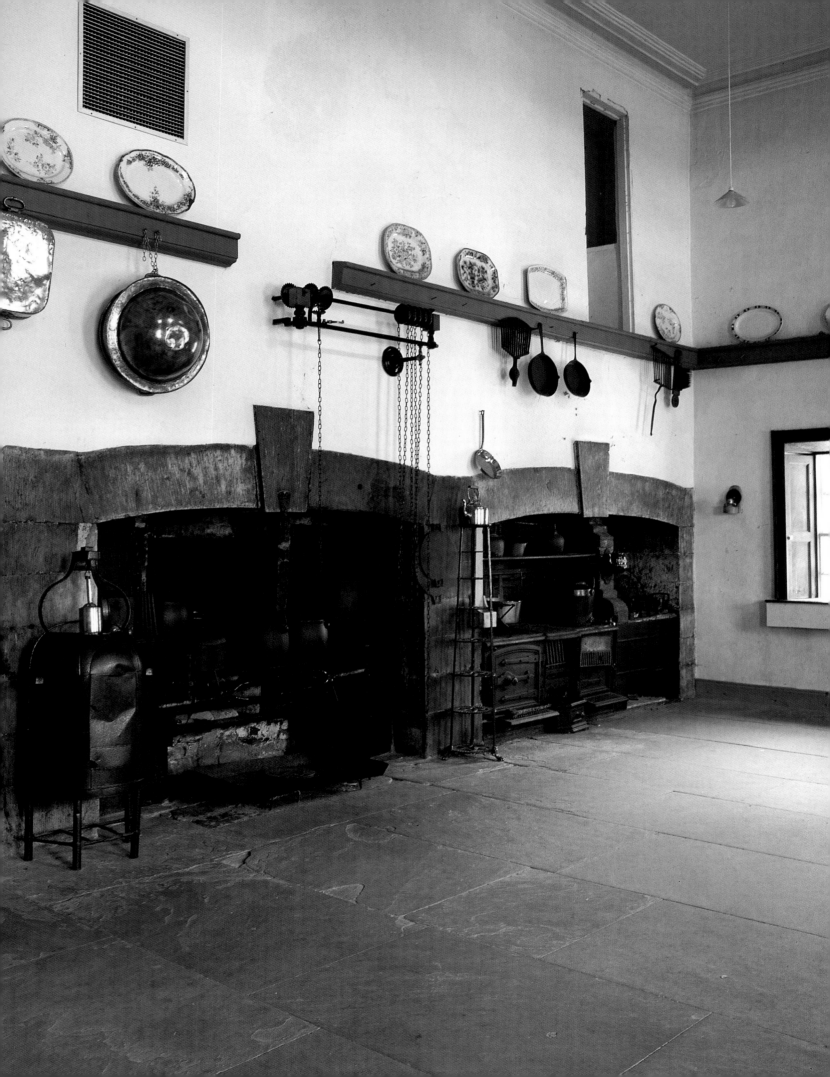

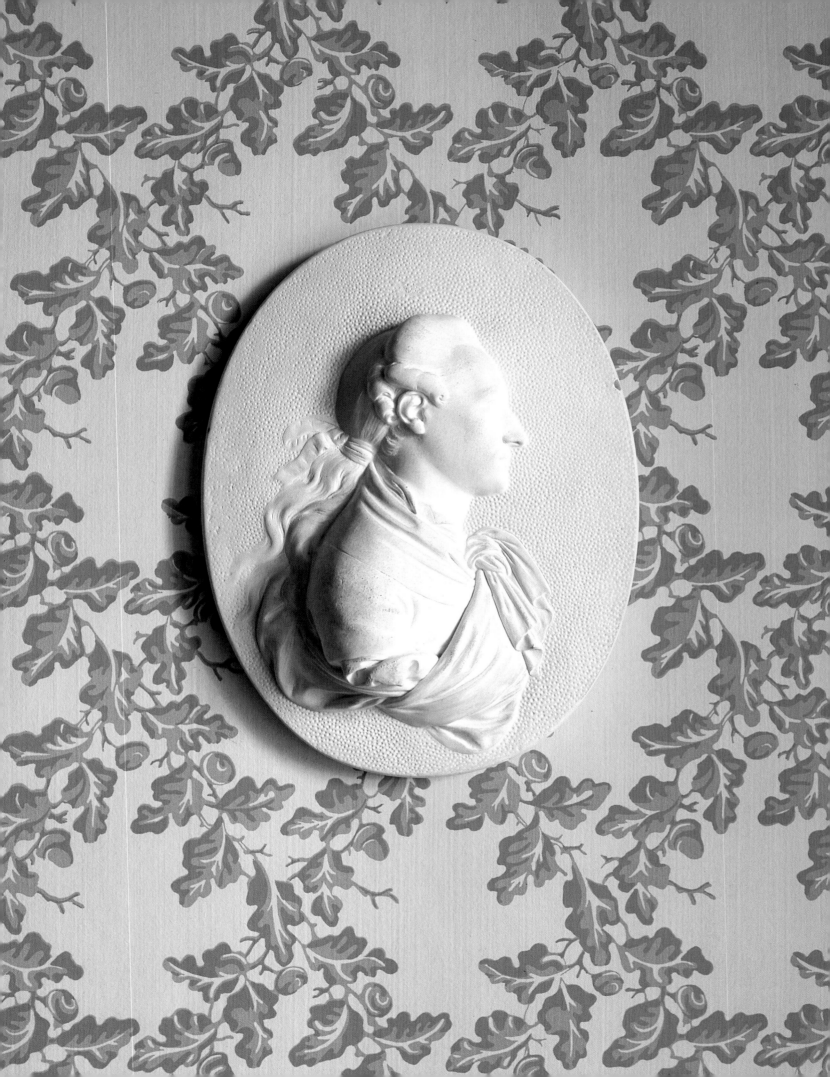

IRISH GEORGIAN

WALLPAPER

Decorating was a serious and dedicated undertaking in Ireland during Georgian times. Countless items of correspondence, particularly between the heads of household of Ireland's grand estates, attest to the fact that the furnishing and decoration of one's house ranked alongside family and politics as the most prominent concerns. The management of an estate was divided into clear sectors of responsibility. While the lord of the manor was responsible for landscape, architecture and transport (namely the procurement and upkeep of horses and carriages), the lady of the house was in charge of all matters concerning the decoration of the interior.

Even with the benefit of wealth and a virtual army of servants, this was certainly no easy task. Clearly, again as evidenced by correspondence of the time, demand for luxury fabrics and printed wallpapers outstripped supply. The India paper room at Carton House for instance, features cut-out segments of highly decorative 'oriental' paper because Lady Emily Fitzgerald, despite badgering suppliers for enough to finish her grand plans, had to improvise to make up for a shortfall.

The British Empire was booming, the pound sterling was Europe's strongest currency, and London, the world's pre-eminent city, set the pace for fashions in home and attire. Eager to keep up with and perhaps even surpass the standards set on the other side of the Irish Sea, the aristocrats of Ireland were all living beyond their means. So lucrative was the interior decoration industry at that point that even the government tried to cash in, introducing a tax on wallpaper in 1712. No roll of painted, printed or stained paper could be applied to a wall without His Majesty's customs and excise stamp on the back. Some of the statistics accumulated by a revenue-hungry government provide a fascinating insight: between 1700 and 1800 forty-nine 'paper stainers' (as they were known) were listed in Dublin, and this at a time when in the whole of England there were scarcely more than one hundred. Given that wallpaper only began to be considered suitable for reception rooms in around the 1730s, and that it was not much in use anywhere in the house before the 18th century, this is a truly astonishing statistic.

Ireland was a major centre of wallpaper production throughout the 18th century. The output of Dublin's wallpaper manufacturers was once so prolific that they also exported to America. Newspaper advertisements told of the exotic variety of styles

'my wallpaper is killing me …
one of us will have to go.'

Oscar Wilde, on his deathbed in a French hotel

available and the superiority of the Irish product. All that is now left of this once-booming enterprise are the fragments uncovered in ten years of conservation work by one Irishman, David Skinner. With a scrap here and a patch there he has reconstructed various papers that would have adorned the great houses of Ireland. As he tells it, he spent 'ten years of his life travelling around damp and crumbling Irish mansions rescuing ancient wallpapers from the ravages of time and climate.' This conservation work involved a good deal of research into original manufacturing technique, including delving into Robert Dossie's 1757 *Handmaid to the Arts*, a kind of Georgian do-it-yourself guide. The step-by-step instructions on the preparation of pigments and the making of wallpaper looked so easy that, as Skinner himself confesses, 'a combination of rash over-confidence and a complete lack of business sense' made him decide to establish himself as Ireland's only wallpaper printer.

Early commissions to print copies of old Irish wallpaper for Kilkenny House and *Áras an Uachtaráin* (the President's official residence) set the direction of his new business. In a dozen patterns taken from historic houses, his 'Great Irish Houses' wallpaper collection recreates the papers that once adorned the rooms large and small of Ireland's most prominent houses. Wallpapers of the 18th century were vastly different from what we know today. Printed by hand using wooden blocks and distemper paints, the pressure resulted in a build-up around the edge of the block, leaving a subtle but very attractive texture. The distemper paints used to apply these patterns (as opposed to the quick-drying, solvent-based dyes used on modern wallpaper) would dry to a soft matt finish. Skinner, conscious of the prohibitive cost of hand-printing with wooden blocks yet determined to maintain the look and feel of 18th-century papers, combined traditional and modern manufacturing techniques. First the paper is 'grounded' with acrylic paints quite similar to traditional distemper. Then the pattern is screen-printed using water-based inks that take longer to dry but leave the desired effect. The result is a faithful recreation of the patterns, colours and, most importantly, the character of 18th-century Irish wallpapers.

PREVIOUS PAGE (128)
Although wallpaper was available from the late 17th century, it was not until the latter part of the 18th century that it became a fashionable alternative to panelled walls or to walls decorated in relief plasterwork. This particular paper is a contemporary copy of a late Georgian

design found on the walls of a bedroom of Castle Coole, a grand Irish country house in County Fermanagh.

PREVIOUS PAGE (130)
Another paper from the 'Great Irish Houses' collection by Ireland's only wallpaper printer, David Skinner, this is a recre-

ation of a stylish 1790s daisy pattern found in a bedroom of a Georgian townhouse in Eustace Street, Dublin.

OPPOSITE PAGE
Dating to c. 1800, this pattern originally decorated the library of Strokestown Park House, County Roscommon.

Catharina II.

1	2	3	4	5	6
7	8	9	10	11	12
13	14	15	16	17	18

PHOTOS IN ORDER OF
APPEARANCE – PREVIOUS PAGES (134–135)

1

A stylized daisy pattern from a bedroom in Dublin Townhouse, also typical of Georgian printed cottons.

3

A Pompeian-style neoclassical border that was found at Clongowes Wood, originally a house but more recently a school (which includes James Joyce among its former pupils).

5

A damask pattern from the yellow drawing room of Birr Castle, County Offaly, a place rented by Mariga Guinness on her return to Ireland in 1982.

8

This pattern of blue roses on a striped background was originally printed in Dublin in 1800 for Fota House, County Cork.

10

A Gothic pattern, printed c. 1800, that was first found in the library of Malahide Castle.

12

The stylized daisy pattern pictured in photo 1 printed in a different colourway.

13

A pink zigzag pattern made in 1760 and originally found in County Cavan.

15

A pattern first found in the library of Strokestown Park House, County Roscommon.

17

'Oak Sprig' pattern, based on a c. 1800 woven fabric found at Woodstock House, County Wicklow.

0 PPOSITE PAGE

Another example of the stylish daisy pattern popular in the late Georgian period. Smaller wallpaper patterns were preferred for bedrooms, whereas the more impressive, bolder patterns were chosen for reception rooms – a reflection of the Georgian preoccupation with proportion.

2, 4, 6, 7, 9, 11, 14, 16, 18

Exquisite decorative details in the form of timber carving, plasterwork and gilding have often outlived the buildings which they originally adorned. Furnishings were sparse throughout the Georgian period, with chairs, tables and desks pushed up to the wall, neatly arranged against a dado rail. The decorative impact of an interior thus depended to a large extent on architectural treatment: mirrors, columns, painted panelling, carved details and fanlight windows were just some of the ingredients that contributed to creating an overall expression of harmonious beauty. The architectural details that survive demolished Georgian houses are testament to the extraordinary quality and craftsmanship of these components.

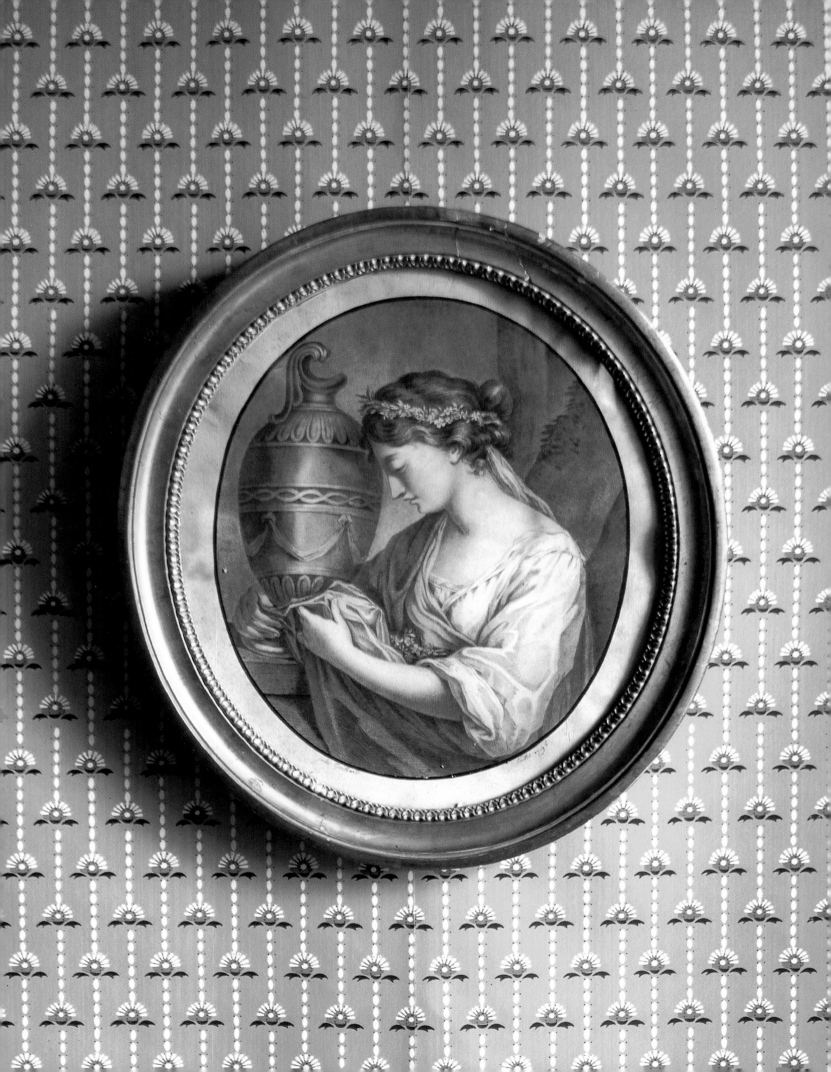

IRISH

MEZZOTINT

During the reigns of George II, III and IV, the English and the Irish could not get enough of portraits. People were fascinated with famous personalities from the worlds of politics, the theatre, the armed forces and even commerce, and portraits were the only way of giving faces to these names. Yet despite the prodigious output of oil portraits, they were almost always privately commissioned, so the chance of seeing one outside of the immediate personal circle of the sitter was next to nil. There were no museums at the time and certainly no commercial facilities open to the public.

The mezzotint was the first engraving technique that could accurately convey the subtlety of flesh tones, so important to the oil portrait. Invented in Holland, the process owed much to the pioneering work of Rembrandt who, frustrated by the inability of etchings and engravings to convey painting technique, experimented with the increased use of dry point, whereby engraving marks are actually drawn right through the metal, leaving a burr on the surface. He discovered that the burrs left by dry point could hold a considerable amount of ink, and from this observation developed the idea of perforating a thin copper plate with thousands of holes, all leaving a tiny burr on the surface. Fewer burrs, conversely, held less ink, so the burrs on a prepared copper plate could be scraped or chiselled away where no colour was wanted (hence the nickname of 'scraper' for a mezzotint engraver). The absence of lines in this 'reductive' engraving technique allowed the subsequent print to convey light chiaroscuro and tonal gradation, much to the delight of the painter, who depended on prints and engravings to convey the quality of his technique and so make his name.

This new engraving technique did have one serious shortcoming: the soft copper burrs could not withstand the force of a printing press and became flattened after only a few prints. The short life span of the plate thus made the mezzotint technique unsuitable to the printing industry. But ironically it was exactly this shortcoming that propelled the mezzotint to such popularity in Georgian England. An English merchant, Richard Thompson, was the first print seller to recognize the real commercial potential of the mezzotint. He knew that portraits were the most lucrative and most coveted aspect of the 18th-century British art scene. He also knew that they were beyond the purse of most and that a high-quality reproduction by a skilled mezzotint engraver was the next best thing.

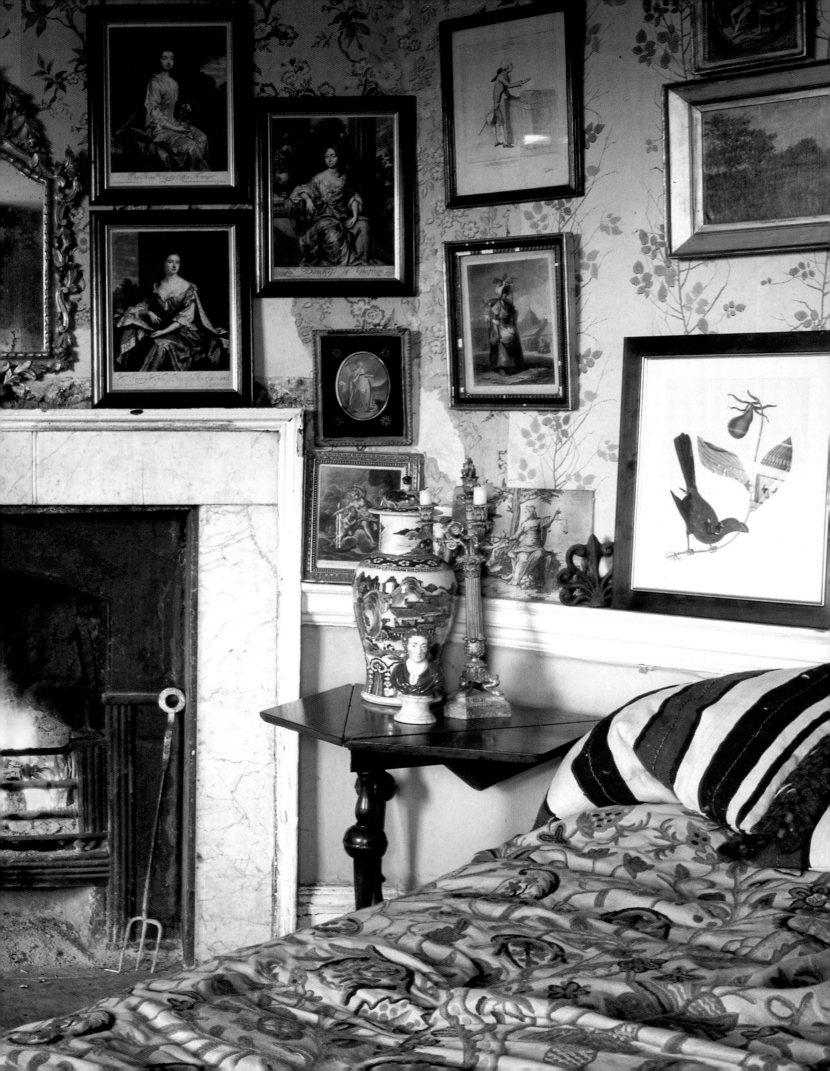

Art, for the first time, became accessible to anyone passing a shop window. A skilfully engraved mezzotint would not only enhance a painter's reputation, it would also spread his fame beyond the closed doors of courts and private salons to the general public. Through the advent of the mezzotint, people became more aware of art. Prints and drawings by Rembrandt and Rubens had circulated in England to an extent, but it wasn't until the most talented engravers took on the challenge of recreating their oil paintings in mezzotint that the real influence of these and other masters was felt. The first engraver with the confidence to take on the task of reproducing the Old Masters in mezzotint was the Irishman James McArdell. In 1752 he persuaded the Duke of Grafton to allow him to engrave a painting by Van Dyck, and the subsequent print confirmed his virtuosity. McArdell formed the core of a cadre of Irish engravers that came to be known as the Dublin Group. Collectively, they elevated the mezzotint technique to new heights, commercial as well as artistic.

The Dublin connection to mezzotint continues today through the efforts of two Dubliners, Ronan Teevan and Liam Fitzpatrick, who established Caxton Galleries, specializing in the works of engravers such as McArdell and Valentine Green. Their expertise and enthusiasm for the mezzotint is equally evident in the Georgian house they are renovating as a showcase for their prints. Located just above central Dublin next to Phoenix Park on Montpelier Hill, this small townhouse is distinguished by the fact that none of its details have ever been compromised by an unsympathetic renovation. Progress has to fit in with their life at the gallery, but even in an unrestored state the house provides a perfect backdrop to their collection.

PREVIOUS PAGE (138)
A mezzotint portrait of the Earl of Charlemont, proprietor of Marino Casino, by Thomas Nugent; an early 18th-century Irish tallboy in oak; and some 18th-century delftware vases – a Georgian still life that is testament to Ronan Teevan and Liam Fitzpatrick's fascination with 18th-century Ireland.

PREVIOUS PAGES (140–141)
The mezzotint print reached the zenith of its popularity towards the end of the 18th century. It was the only engraving method whose shading and depth was *able to imitate the technique of oil painting. As the proprietors of Caxton Galleries in Dublin, Ronan Teevan and Liam Fitzpatrick have chosen to specialize in this particularly Georgian art form. Not surprisingly, the still unrenovated walls of their own Georgian house on Dublin's Montpelier Hill feature a collection of 18th-century mezzotint prints, including (at bottom left) an early 18th-century portrait of Madame Parson, a relation of the Earl of Ross; a large mezzotint portrait of Olivia Fitzgerald (Lady Kinnard); and, to the right and left* *of the fireplace, little coloured mezzotints called Faith, Hope and Charity.*

OPPOSITE PAGE
Behind a pair of Irish chairs dating to 1760 and an Irish 18th-century table is an assortment of mezzotint prints, including an exceptional example of two boys by Valentine Green, one of the best engravers; a print of John Blatchford, Chancellor of St Patrick's Cathedral, by James McArdell (one of the Dublin Group of 'scrapers'); and three of a set of four prints called 'The Four Seasons'.

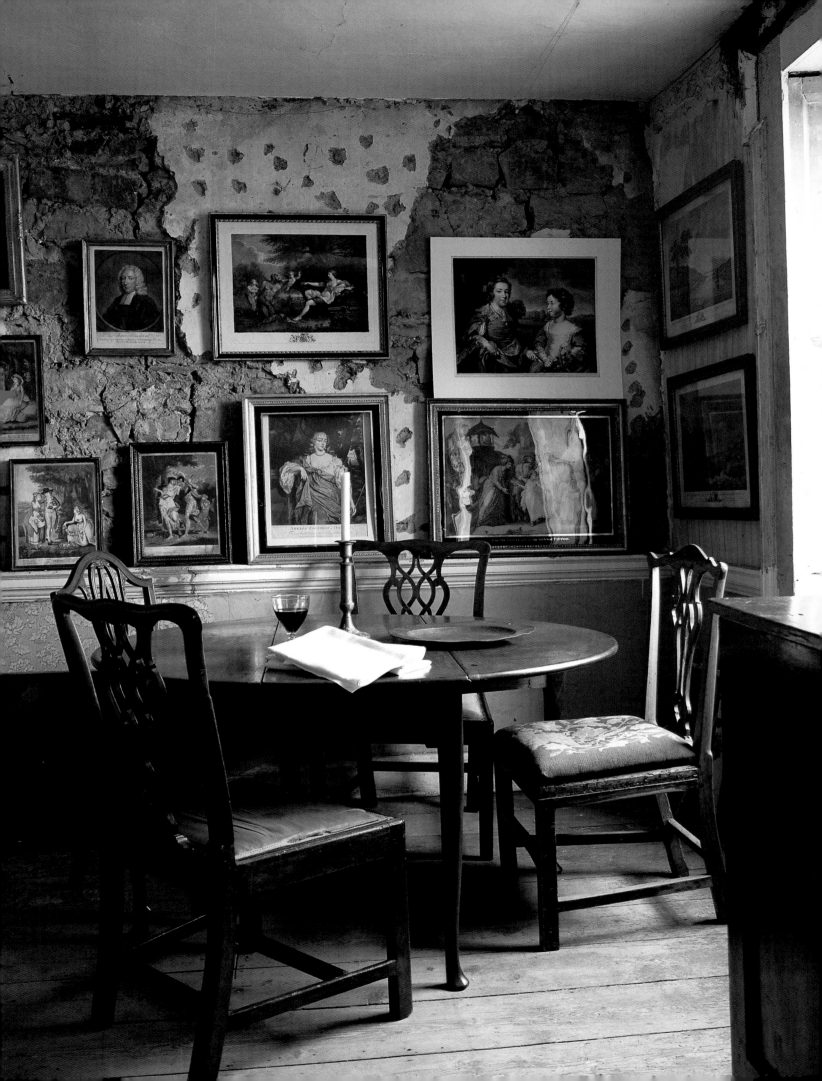

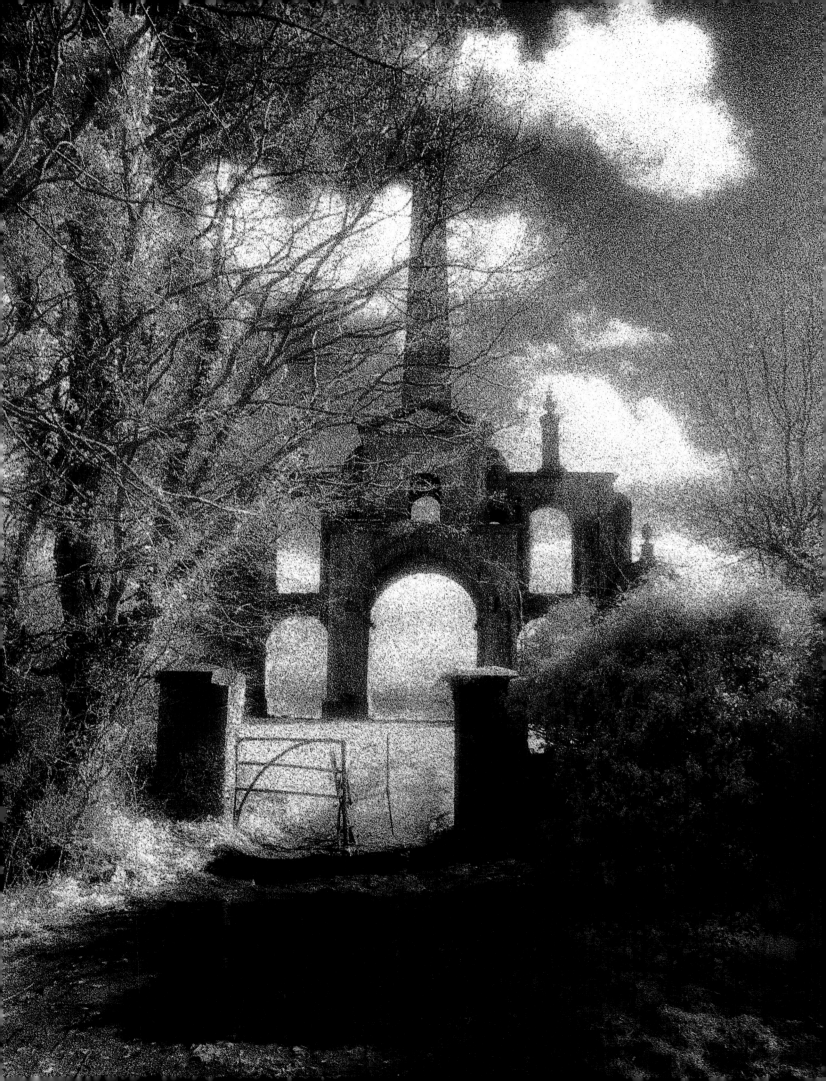

5

VIRTUOSI

They devoted their lives to their castle and to the love of Ireland and its history. The house Desmond and Mariga Guinness created from the virtual ruin of Leixlip Castle became celebrated as the key country house in the British Isles, bringing the boldness and vigour of Irish Georgian decoration to international attention.

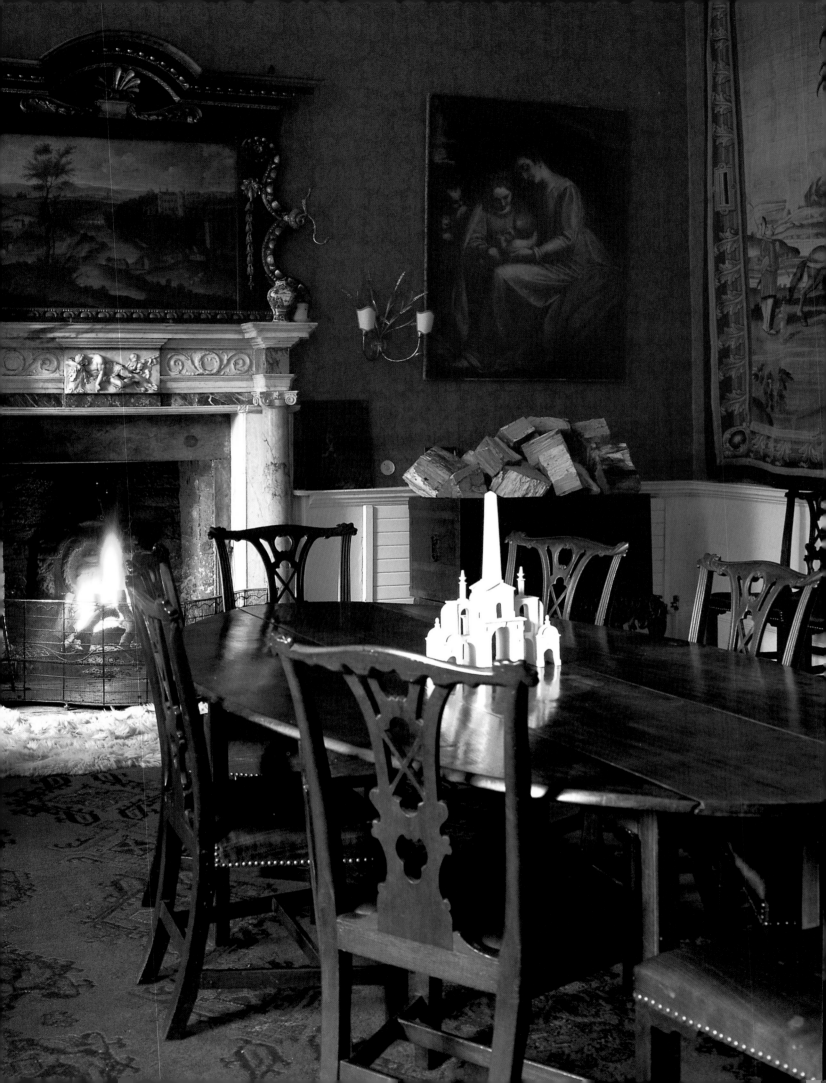

DESMOND AND MARIGA
GUINNESS

When the newly married Desmond and Mariga Guinness decided to settle into a life of farming in Ireland in 1955, they were appalled by the complete lack of interest in Ireland's extraordinary 18th-century heritage. Dublin – perhaps the only European city to have escaped the destructive horrors of World War II, and at the time the most intact Georgian city in the world – was in danger of losing its most beautiful vistas to the greed of property developers and the indifference of people who should have known better. The ESB (Electricity Board of Dublin) even went so far as to hire an architectural expert from London, Sir John Summerson, to justify their heinous intention to knock down Fitzwilliam Street. The best Georgian vista in all of Dublin was, in his considered opinion, just 'one damn house after another'... and thus, tragically, the longest Georgian street in the British Empire was torn down.

But this dangerous and overpowering indifference was not just limited to Dublin's Georgian heritage. In the countryside too, the grand Irish houses were being ignored and one after another were allowed to crumble and disappear. To most citizens of the Irish Republic, big country houses were little more than surviving symbols of Protestant exploitation and this justified their complete lack of interest. Desmond and Mariga saw it altogether differently. If even the Russian Communists were concerned enough to protect and preserve the palaces of the Tsar, they argued, surely Ireland, as an independent state, should have the confidence to preserve all of its history. Ireland's Georgian beauty, in their opinion, belonged to the Irish and however awful the old rulers may have been, this beauty was, after all, created by Irish hands.

In the Ireland of the 1950s and 1960s, they were, in the words of Desmond Fitzgerald, Knight of Glin, 'voices in the wilderness', yet they none the less embarked on a crusade not just to save 18th-century buildings but to awaken people to the destruction of an enlightened chapter of Irish history. They did this by 'living the life'. From the very first moment they arrived in Ireland, when they rented Carton House, ancestral home of the Duke of Leinster, they used their great sense of style to demonstrate how happily one could live in dilapidation, provided it was beautiful.

During the day, they could be found barefoot in jeans, with paintbrush or hammer in hand, helping some friends they had convinced to buy a ruin to make a start on the 'terrifying' task of making it habitable, or they would pile the friends who always

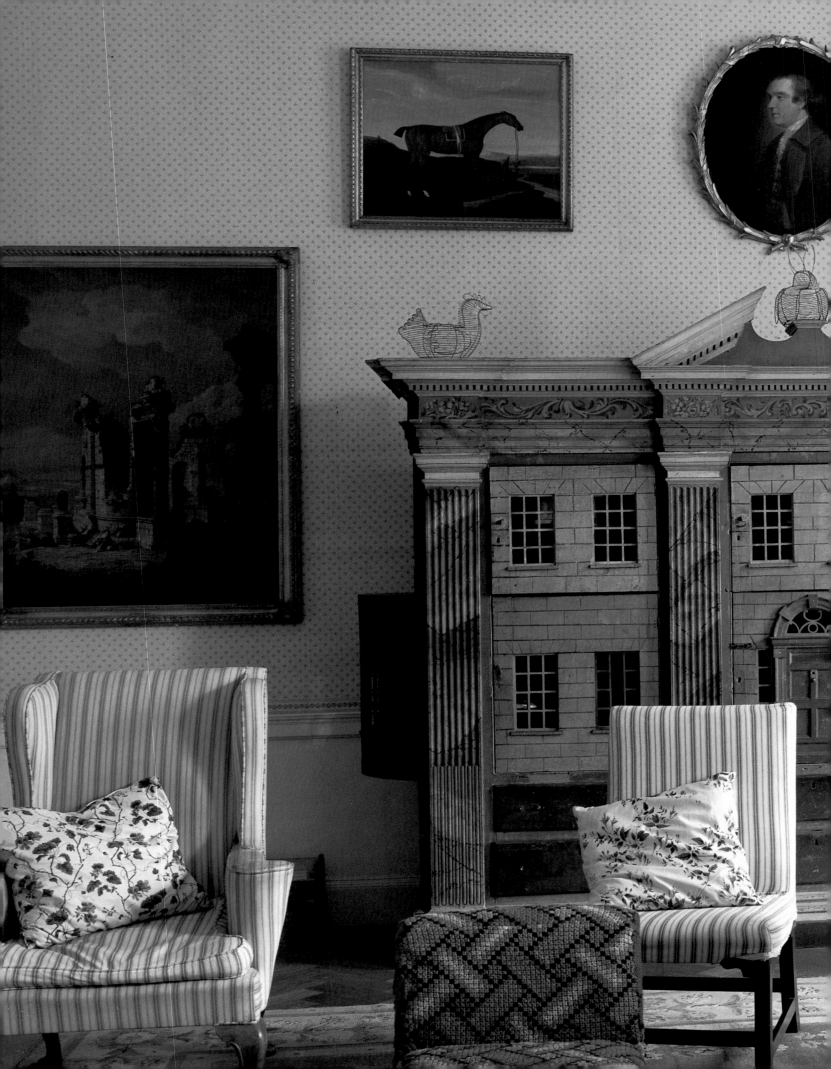

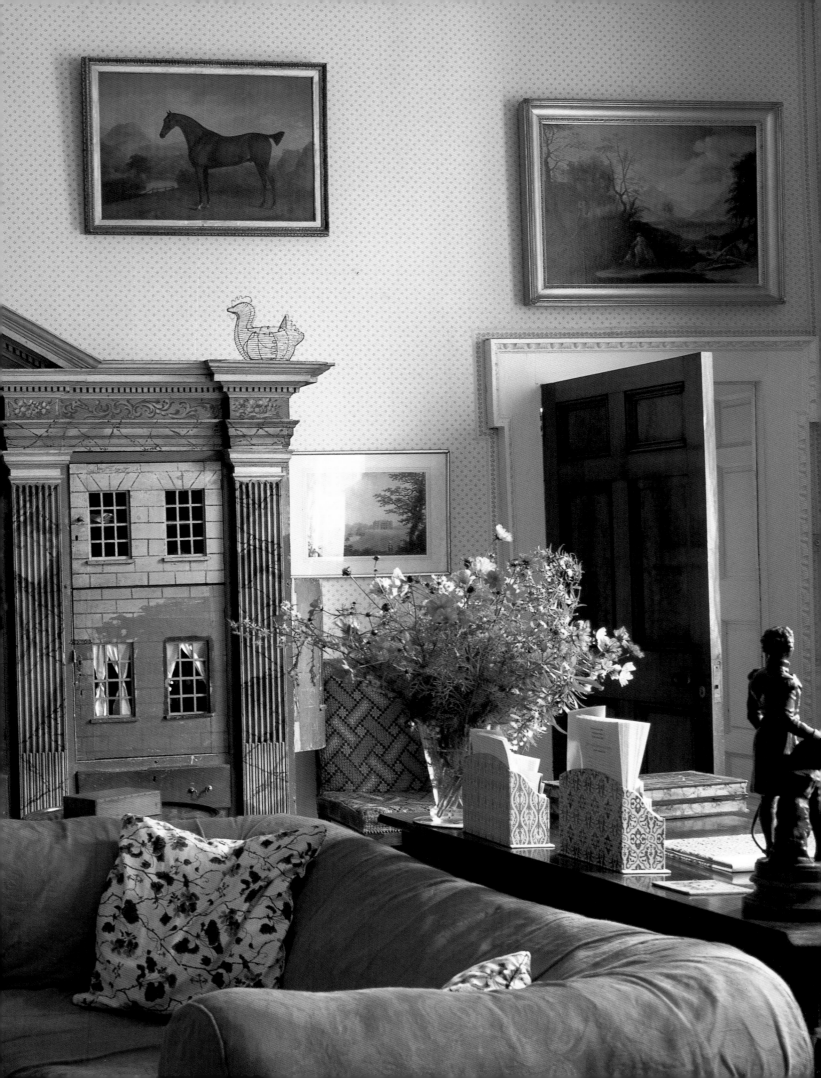

seemed to be staying with them into the car and disappear down a forgotten country lane on yet another whirlwind tour of various follies, castles, houses and gardens of undiscovered beauty. Mariga, a German princess by birth, was especially taken by the soft light, the landscapes, the ruins, and the 'deliciously dotty' people of Ireland. At night they would entertain a collection of dissimilar individuals (Desmond would somehow always gather together one notable, one brain, one title and a talker as well as some Americans) in grand Georgian style around a table covered with fine china, thin crystal, glowing candlelight and silver statuettes. As Olda Fitzgerald recalls, 'Mariga taught us how houses should be lived in and how entertaining they should be. I'd never thought of having a roaring fire, a tiny table, and everyone around it.'

Their enthusiasm for the faded grandeur of 18th-century Ireland was infectious and, against the odds, they achieved a remarkable success. As the Knight of Glin recalls: 'they were a marvellous duo. Mariga had imagination and could draw people into their cause while Desmond had the persistence to concentrate and get these restoration jobs off the ground.' As people started coming around to their way of thinking and the number of their disciples grew it became inevitable that their efforts would take a more official line. So in 1958 came the founding of the Irish Georgian Society. It was a classic Desmond and Mariga occasion: Desmond standing on a chair making a speech and all the people present being served tea by Mariga carrying huge kettles around acres of tables covered with sheets and tea cups.

Desmond was the meticulous one, the one who got things together. Fundraising was his forte. He lectured all over the United States, even persuading several American cities to establish their own chapter of the Irish Georgian Society, and he also published several books on Georgian-related subjects, such as plasterwork, Thomas

PREVIOUS PAGE (146)
Desmond and Mariga Guinness dedicated considerable time and money to the rescue of Ireland's Georgian heritage. The couple's love of the faded grandeur of Irish Georgian is everywhere to be seen. The dining room chairs, purchased from the Malahide Castle sale in 1976, are 18th-century Irish Chippendale. The model on the Irish hunt table is of the obelisk at Stillorgan, County Dublin, designed by Edward Lovett

Pearce as a memorial to his kinswoman Lady Allen in 1727.

PREVIOUS PAGES (148–149)
A gigantic Georgian doll's house (used as a cupboard) dominates the drawing room of Leixlip Castle, a Georgian interior that typifies the unpredictable 'decorative wit' that Mariga Guinness gave to her interior schemes. Paintings include **The Ruins of Palmyra** *by James Canter,* **Racehorse** *by Butler, an oval portrait by*

Reynolds of the Earl of Charlemont's brother Francis Caulfield, and another **Racehorse** *by Charles Towne of Liverpool.*

OPPOSITE PAGE
The moss green front hall features another monumental doll's house, this one believed to have originated in County Cork. The large painting of an Arab horse and groom is by John Wootton. The collection of antlers, of German origin, comes from Powerscourt House, County Wicklow.

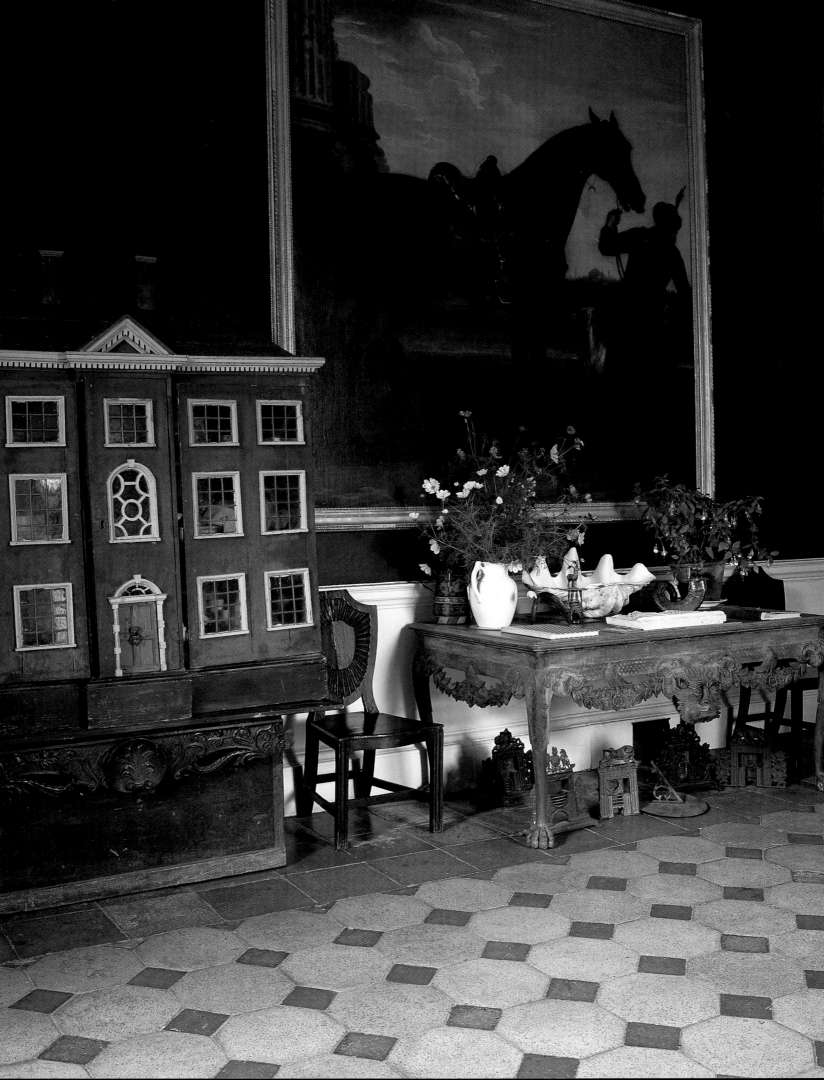

Jefferson, Palladio, and of course the grand houses of Ireland. Mariga, on the other hand, gave the rather dryly named Irish Georgian Society a much needed spirit of passion. She had the charm and energy to initiate things – to get volunteers to help her paint a wall, scrub a floor or polish a bannister, and she had the Tom Sawyer knack of making it all fun. She was famous for her picnics, always of the working variety, where a day spent washing the walls of the print room at Castletown was rewarded with an interlude of home-cooked chickens on the lawns. As her son Patrick recalls, 'she was always the first to pull on her jeans and lead by example.'

The Irish Georgian Society thrived. But there was much more to this attractive young couple's contribution to Irish culture than the rescue of Georgian architecture. They almost singlehandedly brought Castletown, arguably Ireland's finest country house, back from the brink; they fixed the Conolly Folly after it was damaged by lightning; they restored Dublin's Tailor's Hall to its former glory. And the list goes on. But even more extraordinary is that they (and especially Mariga) brought a whole new style to Ireland, a style that still today is synonymous with the complete country house, in Ireland or for that matter in England.

In 1958 Desmond and Mariga Guinness bought Leixlip Castle and did it up with their own hands. It was a large, rough-looking and neglected medieval pile of stone, and even the couple's most ardent supporters wondered if they could be happy here. Their bedroom had been used for storing oats and for most of the first winter they were without a front door because they considered the existing one unsuitable and another had yet to arrive. In the beginning guests had to sleep on mattresses on bare floors. But undaunted, Desmond and Mariga started to fill their castle with extraordinary and beautiful things. Canopied beds, oil paintings, rare china plates and sea shells arrived from auctions, markets and other shopping junkets and were, according to friends, 'all arranged by Mariga, in the same magical way.' As David Mlinaric recalls, when asked to define good taste she replied: 'I think it is the putting together of things so that people admire them.'

Long before the term 'shabby chic' was coined, Mariga had forged a style that combined fantasy with history and the grand with the laid-back, all in a natural and seemingly uncontrived manner that belied the careful thought and planning behind it.

OPPOSITE PAGE
Following the 18th-century fondness for print rooms (see pages 108–114), the library at Leixlip Castle was decorated according to a scheme devised by Nicola Wingate Saul in 1976. All of the prints adhere directly to the walls, in true Georgian fashion, and were taken from engravings based on the decoration of the Galerie des Glaces in Versailles by Jean Baptiste Masse in 1755. The plasterwork dates from the mid-18th century and the carpet, originally from Castletown, is a French Savonnerie.

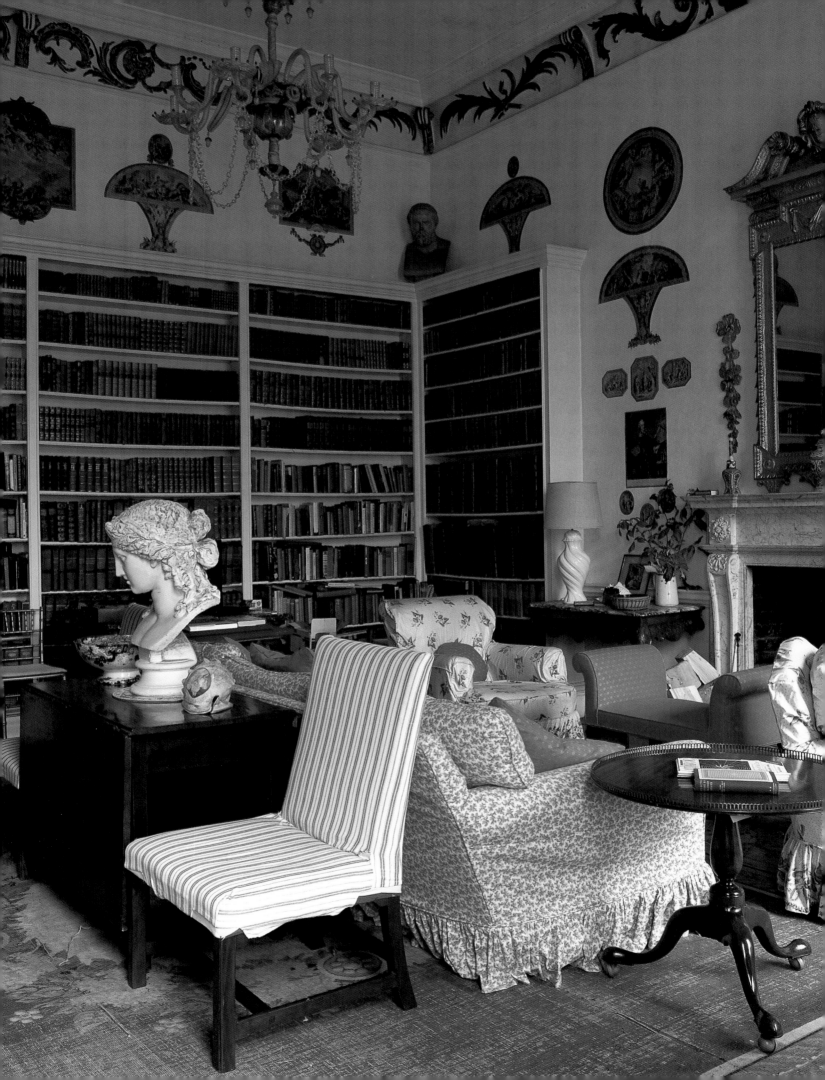

Desmond's views on restoration – that 'a certain amount of shabbiness is an appropriate characteristic of an old house in any country, particularly Ireland' – were brought to life by Mariga's talent for arranging unlikely and occasionally unpromising objects in a stimulating way. They never spent much money on sofas, chairs or curtains, preferring instead to look for furniture that was well-used but cheap, and (certainly very unusual for the time) leaving it unrestored. Everything seemed rather magically eclectic and unpredictable, yet it was unified by a sense of scale and a sense of history. Ludwig Bemelmans, a guest, summed it up perfectly: 'The boldness and vigour of Irish decoration, combining rustic strength and 18th-century elegance, give fresh life to the rooms – there are huge canvases in carved frames of shabby gilding, fireplaces where fossils are sprawled across mouldings (chimney pieces in Kilkenny stone), great consoles where eagles' beaks hold garlands of black mahogany … all garnished with Chinese pots, marble busts and sparkling Irish silver.'

When Nancy Mitford visited Leixlip she wrote that this château fort, furnished in the 18th-century manner, was the epitome of civilized taste. Mariga would often refer to this when describing her work, and more accolades were to follow. Diana Vreeland used the famous photographer Horst to document Leixlip castle for her book *Vogue's Book of Houses, Gardens, People* (which featured Mariga wrapped in an Irish shawl on the cover). But Mariga was most proud of John Cornforth's book *The Inspiration of the Past*, published in 1985, in which he described Leixlip castle as 'undoubtedly the key country house in the British Isles in the late 1950s and 60s.

All the things we today take for granted as belonging to the style of a country house – the eclectic mix of objects and furniture, the grand with the relaxed, the appeal and real character of a certain amount of shabbiness, in short exactly as Nancy Mitford described our image of 'civilized taste' – owe a lot to the pioneering spirit of Desmond and Mariga Guinness. Although it now seems rather credulous to credit two people with having saved a national heritage and launched a much-imitated style, as the Knight of Glin reminds us, 'it would not have happened otherwise'.

OPPOSITE PAGE

To furnish Leixlip Castle Mariga rarely missed an auction and her remarkable knowledge of ornament and furniture, cultivated by travel and her personal experience of palaces all over Europe, contributed to her flair and her ability to choose the right piece for the right place. Every bedroom at Leixlip is filled with antiques spanning four centuries, and each has its own distinctive colour scheme and atmosphere. A stately canopy bed in the master bedroom stands on yet another of the priceless rugs collected by Desmond and Mariga, this time an Aubusson.

FOLLOWING PAGE (156)

A copper empire bath occupies a stately niche in the master bedroom. The atmosphere of faded grandeur is enhanced by well-worn antique French rugs, oil paintings in slightly shabby frames, original tea-stained upholstery, and chairs covered in simple, practical slip covers.

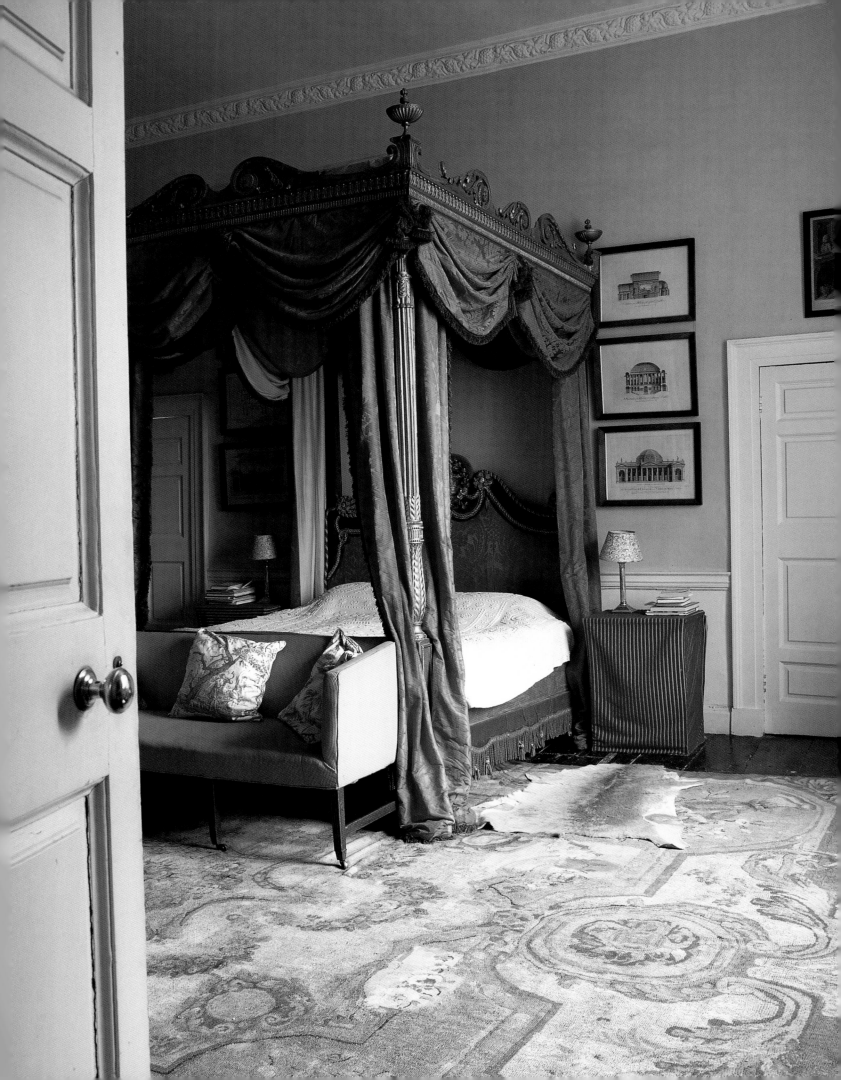

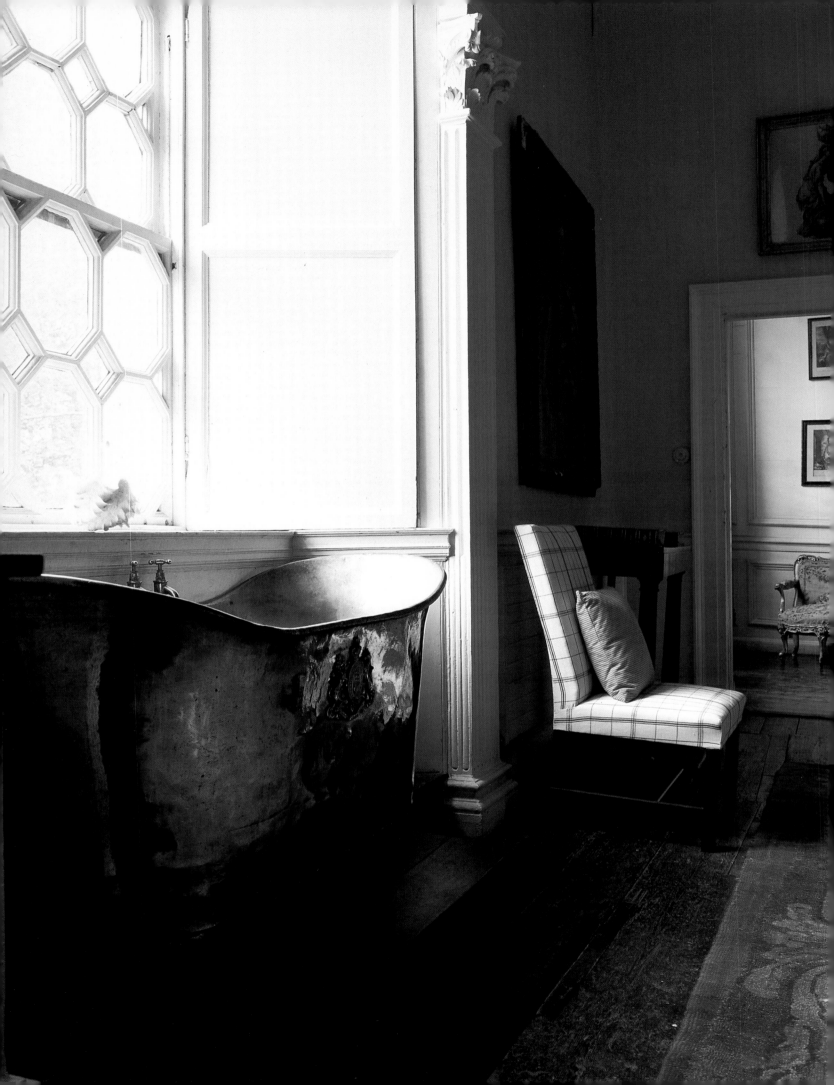

ACKNOWLEDGMENTS

My sincere thanks to Barbara and René Stoeltie not just for their superb photography but also for their help and encouragement in making this book a reality.

I am also grateful to the many people in Ireland who took the time to share their knowledge and expertise. These include Jim Reynolds of Butterstream Gardens, Ronan Teevan and Liam Fitzpatrick of Caxton Galleries, David Skinner, creator of the 'Great Irish Houses' wallpaper collection, and especially Patricia Oliver, National Chairwoman of An Taisce, who not only helped tremendously in organizing official permissions to photograph various national architectural treasures but also very generously gave me access to various passages from her forthcoming book about Mariga Guinness.

Thanks to all the people who allowed us to photograph their homes. These include Michael Casey and his wife Aileen, Ronan Teevan and Liam Fitzpatrick, Timothy Hennessy, John Coote, Desmond Guinness and Patrick Scott. And thanks also to Deidra Rowsome for organizing photography at Russborough, Joanna Cramsie at Castletown House, Patrick Kirwan for Ely House, and Declan Jones for Strokestown Park House.

Finally, thanks to Simon Marsden for his black-and-white photographs that introduce each chapter. He has captured successfully the mystical and enchanting quality of Ireland that is so hard to put into words.

BIBLIOGRAPHY

Cruickshank, Dan and Peter Wyld. *Georgian Townhouses and their Details.* London, 1990.

Fitzmaurice Mills, John. *The Noble Dwellings of Ireland.* London, 1987.

Harris, John. *The Palladian Revival.* London, 1994.

Howley, James. *The Follies and Garden Buildings of Ireland.* New Haven and London, 1993.

Kinmouth, Claudia. *Irish Country Furniture 1700–1950.* New Haven and London, 1993.

Maurice, Craig. *The Architecture of Ireland.* Dublin, 1982.

McLaren, Duncan. *In Ruins: The Once Great Houses of Ireland.* London, 1997.

Parissien, Steven. *Adam Style.* London, 1992.

Reeves-Smyth, Terence. *Irish Country Houses.* Belfast, 1994.

Somerville-Large, Peter. *The Irish Country House: A Social History.* London, 1995.

Tillyard, Stella. *Aristocrats: Caroline, Emily, Louise and Sarah Lennox, 1750–1832.* London, 1995.

Wax, Carol. *The Mezzotint: History and Technique.* London, 1990.

ADAM

COLOURS

At the height of the Georgian period a fresh approach to architecture, design and decoration was introduced by the Scottish architect Robert Adam. The 'Adam Style' drew inspiration from the direct study of ancient Greece and Rome (as opposed to its interpretation by Palladio), and its technique of ornament had immediate appeal. Adam's elegant neoclassical forms were enhanced by soft, sophisticated colours, including grey, olive, verdigris, sky blue, lemon, 'Dutch pink' and straw. Farrow and Ball, a London-based specialized paint boutique, offers a range of 'Adam' colours and other Georgian shades.

Tel. 0171 351 0273
Fax 0171 351 0221

PRINT

ROOM

Print rooms, fashionable in the mid-1800s, were an expression of the free-spirited frivolity of the rococo approach to decoration. Prints or engravings were simply cut out and pasted directly on to the wall. Ready printed borders, swags, bows and cords could be bought to 'hang' the prints. These large-scale 'collages' were assembled on the wall by the lady of the house or in some cases by her decorator. The exquisite print room at Castletown House, created by Lady Louisa Conolly, has survived largely intact to this day. The Irish Georgian Society produces a range of prints and borders to enable you to create your own print room.

Tel. 00 353 1 676 7053
Fax 00 353 1 662 0290

IRISH GEORGIAN

SILVER

Beeswax candles and tea were expensive luxuries in the Georgian period, meriting equally luxurious silver candlesticks and tea services. To light a grand Georgian house with beeswax candles for an evening's formal entertaining would have cost the host, at today's prices, an astonishing four hundred pounds. The silver candlestick became one of the most sought-after status symbols of the fashionable Georgian interior, and the silverware produced in Georgian Ireland was of superb quality. L&W Duvallier, based in Powerscourt Town House, Dublin, deal in the finest Irish silver, with particular emphasis on Georgian silver.

Tel. 00 353 8853 5313

IRISH

CHIPPENDALE

*Thomas Chippendale's **The Gentleman and Cabinet Maker's Director** (1754), a book of furniture designs in the Gothic, Chinese and 'Modern' (or rococo) taste, was an immediate and unqualified success. Irish craftsmen took advantage of abundant demand to evolve a distinctly Irish signature. Irish Chippendale pieces feature grotesque masks representing creatures from Irish folklore. Although extremely rare, Irish Chippendale pieces do occasionally come on to the market. When they do they can usually be found at James Adam, Ireland's leading auctioneer, or at O'Sullivan's, Ireland's leading antique dealer.*

James Adam, Tel. 00 353 1 676 3885
O'Sullivan's Antiques, Tel. 00 353 1 454 1143

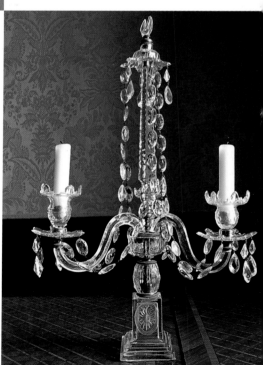

ARCHITECTURAL

SALVAGE

Throughout the Georgian period, furnishings were sparse. Chairs, tables and desks were all pushed up against the walls, neatly arranged against a dado rail. The decorative impact of a Georgian interior thus relied to a large degree on architectural treatment: mirrors, columns, doorknobs, painted panelling, carved details and fanlight windows. Classical shapes and proportions were adopted by craftsmen of all disciplines, and the architectural details that have survived demolished Georgian houses are testament to their exquisite workmanship. Architectural Salvage and Supplies Ltd in Dublin stock a fascinating range.

Tel. 00 353 1 677 3557
Fax 00 353 1 677 3318

IRISH

MEZZOTINT

The mezzotint was the first printing technique to produce images with sufficient tonal gradation to convey the richness and technique of oil painting. The very best engravers were known as the Dublin Group, and included James McArdell (1728–65), still recognized as history's finest practitioner of the art. This cadre of Irish engravers or 'scrapers' elevated the technique to new artistic heights, daring to reproduce paintings by such great artists as Van Dyck and Reynolds. Ronan Teevan and Liam Fitzpatrick continue this tradition at Caxton Antique Prints, Dublin, which specializes in the mezzotint, particularly works by the Dublin Group.

Tel. 00 353 1 453 0060

IRISH GEORGIAN

WALLPAPER

Ireland was a major centre of wallpaper production throughout the 18th century. An 1836 government survey recorded 46 licensed wallpaper manufacturers in Ireland at a time when there were not more than 100 in all of England. These papers were hand-printed with thick distemper paints, giving them a texture, character and depth lacking in modern manufactured wallpapers. His work as a paper conservationist inspired David Skinner to launch his 'Great Irish Houses' range of wallpapers. Combining traditional and modern techniques, these represent a commercial revival of Ireland's rich decorative heritage.

Tel. 00 353 1 627 2913
Fax 00 353 1 623 2780

IRISH

CRYSTAL

Waterford, like Dublin and Limerick, was originally a Viking settlement, but it was not until the relative peace and prosperity of the 18th century that the real urban fabric of Ireland began to develop. The glass manufacturing facility established at Waterford during the Irish Renaissance has long been synonymous with fine crystal. Chandeliers made with cut-glass drops, first produced in the 18th century, were known as lustres or 'fire lustres'. Waterford Crystal, closed for over a century, is once again producing crystal, and although chandeliers are no longer part of their retail business, they can make pieces on a custom basis.

Tel. 00 353 51 373 311
Fax 00 353 51 378 539

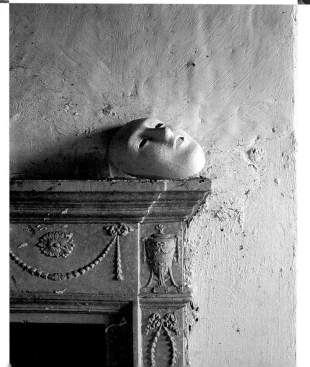

FIREPLACE

SURROUND

Fireplaces were the focal point of Georgian social life, a source of light as well as warmth. Yet there were no classical precedents for their decoration. In the words of Sir Isaac Ware in 1756: 'fancy is to stand in place of rule in the construction of the chimney piece.' The solution arrived at is still in use today: the sides of the fireplace were made to represent classical columns and the architrave bridging them a classical lintel. Some Georgian fireplaces do survive as simple yet supremely elegant examples of the mason's craft. Originals are available from O'Sullivan's Antiques, with branches in Dublin and New York.

O'Sullivan's, Dublin, Tel. 00 353 1 454 1143
O'Sullivan's, New York, Tel. 001 212 260 8985

*'The true paradises are the
paradises we have lost.'*

Marcel Proust